TRANSPARENT
WATERCOLOR

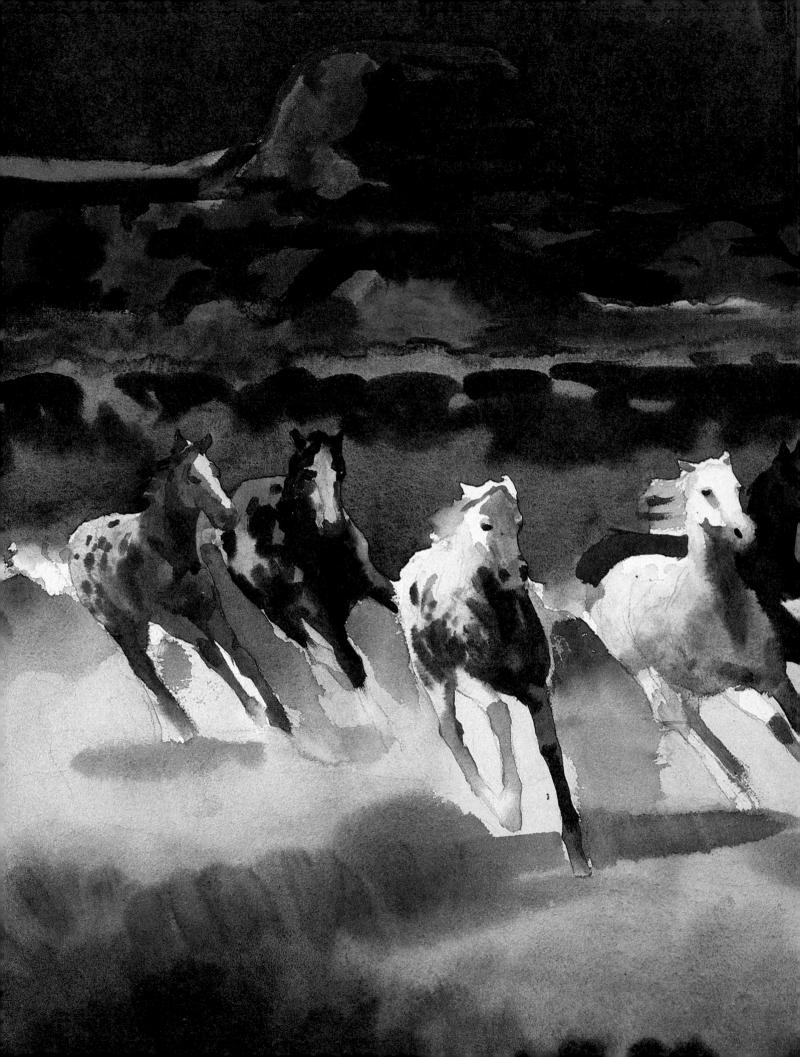

TRANSPARENT
WATERCOLOR

BY EDWARD D. WALKER

North Light Publishers

Published by North Light,
an imprint of
Writer's Digest Books,
9933 Alliance Road,
Cincinnati, Ohio 45242.

Manufactured in U.S.A.
First Printing 1985

Library of Congress Cataloging in Publication Data

Walker, Edward D., 1946-
 Transparent watercolor.

 Bibliography: p.
 Includes index.
 1. Watercolor painting—Technique. I. Title.
ND2430.W35 1985 751.42'2 85-11627
ISBN O-89134-163-3

Book design by Carol Buchanan.

To My Wife, Elizabeth

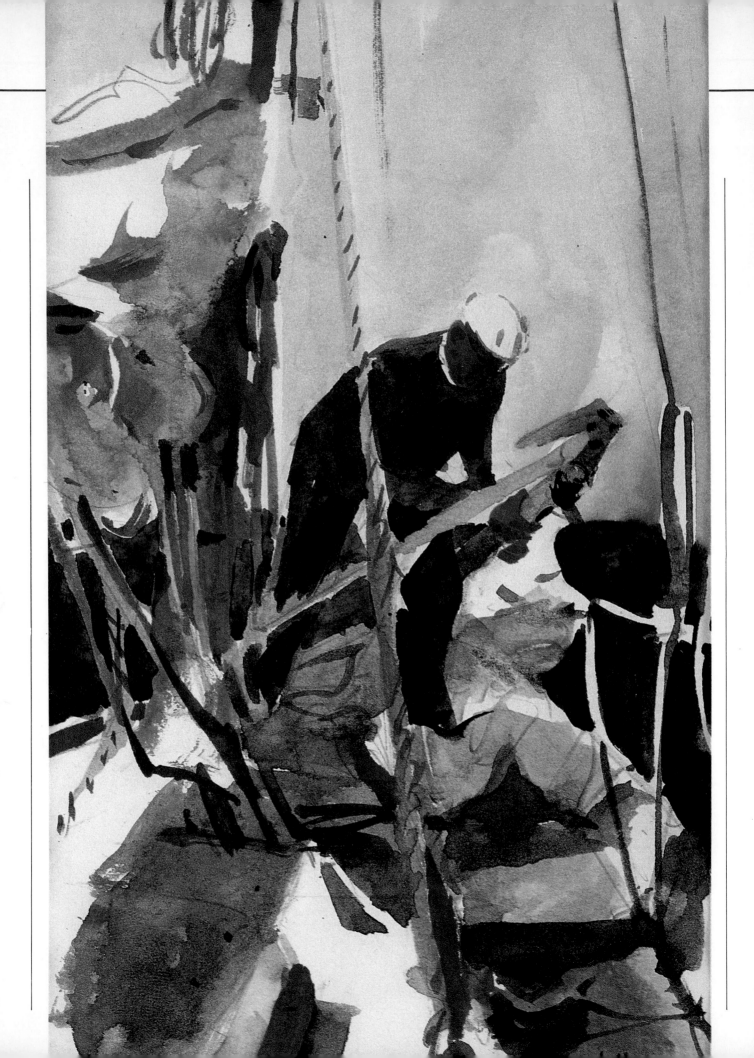

CONTENTS

I owe a debt of gratitude to the many owners and collectors of my watercolors who so readily lent their paintings to my care for the photography work. My appreciation to the skillful photographer George Selland, along with gratitude to Stuart Selland and the staff for prompt and special photography work.

To the most important art dealer in my career, Comfort Scott, I offer a note of thanks; to Hazel M. Walker, who typed the manuscript, I owe a debt of thanks for scholarly guidance in this endeavor and parental guidance through life's vicissitudes.

Thanks to my family, Elizabeth, Melody, and Courtney, who are the constants in my life, in particular for their patience with the time required for this book, the pursuit of as-yet-unwritten books, and the ever-present next painting. My heartfelt appreciation to you all.

INTRODUCTION

Among the various mediums used for painting, transparent watercolor has a luminosity that sets it apart from all others. Light passes through to the white paper and reflects back to the viewer with a translucent quality that gives watercolor its characteristic glow. The white of the paper is used by the artist as white paint would be used in opaque painting—to lighten the hue. Using less pigment and more water lightens the values, as the added water works along with the paper to lighten the colors. The darks are then built up in the opposite way—by increasing the amount of pigment and decreasing the amount of water, or by overlapping the washes. The brilliance these techniques allow is unique to the medium of watercolor.

Applying water-diluted pigment to the paper with no subsequent overlapping of washes after the initial ones are dry gives the greatest clarity of color. This approach to watercolor I call the *Direct Method*.

Artists work in many different ways; there is no procedure in watercolor that is inherently superior to any other. *The Direct Method* means that I continue to work on a given area while it's still damp. I apply the washes and do the brushwork in these damp passages until the area is finished. Then I start immediately on an adjoining area, working it until that one is completed, and so on. With this technique there is not the step-by-step build-up of washes so often seen in demonstrations.

For this book I have selected a number of my recent watercolors; each is accompanied by an explanation of how—and why—I painted it in a certain way. I do not wish to overemphasize my style of painting or my method of working. Other elements are also important: the selection of the subjects, the idea, the compositional arrange-

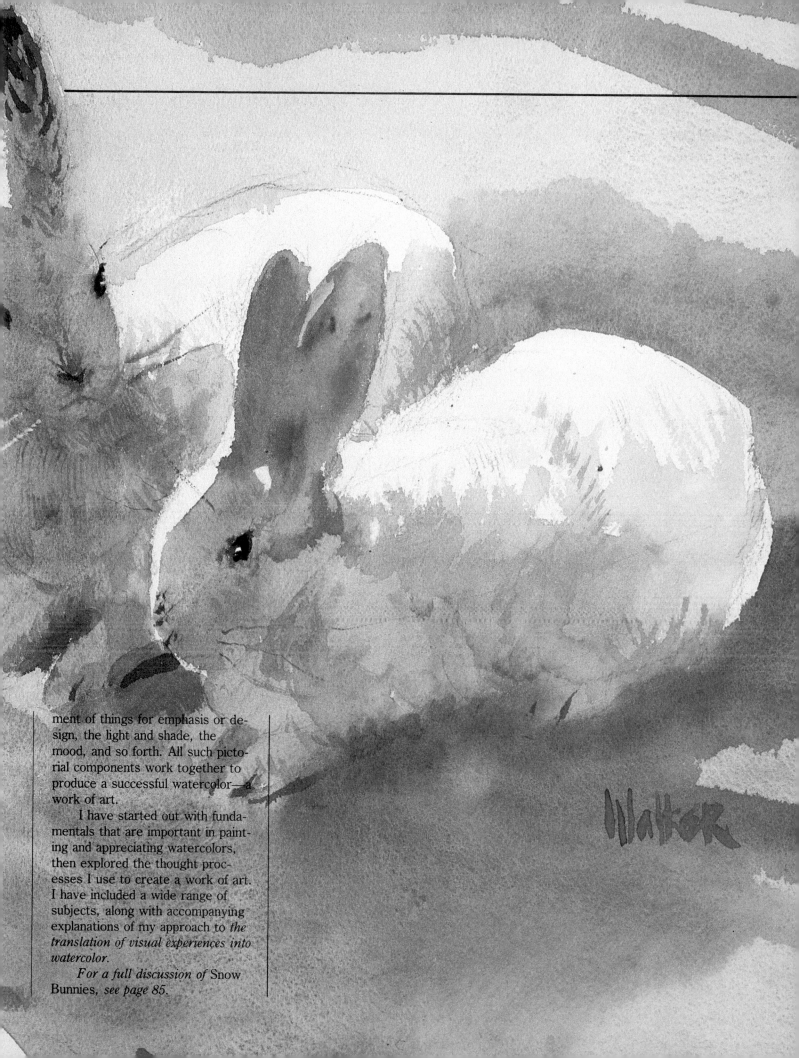

ment of things for emphasis or design, the light and shade, the mood, and so forth. All such pictorial components work together to produce a successful watercolor—a work of art.

I have started out with fundamentals that are important in painting and appreciating watercolors, then explored the thought processes I use to create a work of art. I have included a wide range of subjects, along with accompanying explanations of my approach to *the translation of visual experiences into watercolor.*

For a full discussion of Snow Bunnies, *see page 85.*

1·WATERCOLOR MATERIALS

Working in watercolor requires only a few basic supplies: paper, paint, brushes, water container, mixing pan, drawing board, paper towels, pencil, and eraser, and, of course the desire to paint! It's a good idea to keep supplies simple at first and add to them as you go along.

Prices of materials generally reflect their quality. *Student Grade* is fine for the student. However, if you feel you are ready to produce paintings that will be framed and preserved for years, you are ready to use *Artist's* or *Professional Grade* materials.

BRUSHES

You should have both round and flat brushes made of either sable or natural hair and nylon. For rough brushing techniques, have a few ox-hair brushes as well.

A professional-grade brush should have a good point and a slight spring to it. The sable brush will outlast most of the others with normal use, so it is a good investment to have at least a few. Some of mine, throughout the years, have had a four-year life span. I've always felt it takes some twenty-five to thirty paintings to break in a brush (so that the tip is slightly worn).

Many watercolorists will tell you their favorite brushes have helped pull them out of difficult passages in their paintings. These brushes become old friends. The time to retire a favorite brush from regular use is when it loses a great deal of its hair and its resiliency, and becomes frayed (don't we all, in time?). Don't throw away these distinguished performers. Use them for textural effects.

ACRYLIC AND OIL BRUSHES are handy to have in your supplies for removing watercolor paint from paper. They may be used to create

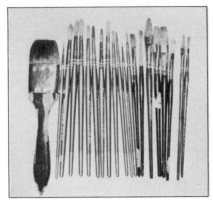

My current selection of brushes. The 1½" brush on the left is an ox-hair, the middle 12 brushes are natural and synthetic combined bristles and the eight to the right are red sable.

special effects or to correct mistakes, and are available in natural or synthetic (nylon) bristles.

ROUND BRUSHES provide a point for accuracy and for making lines. They hold more water than the flat brushes. Round brushes range in size from the smallest, No. 000, to the largest, No. 14. A good selection of round brushes would include a No. 4, a No. 7, a No. 8, a No. 10, and a No. 12.

FLAT BRUSHES are excellent for broad washes. Also, their square shape has made them a favorite of many watercolorists, who like the angular quality of their natural strokes. Flat brushes range in size from ⅛ in. to 1½ in. I find that ⅛ in., ½ in., ⅜ in., and 1 in. sable brushes provide me with all the variation I need. The flat brush I use most is an ox-hair 1½ in. wide that I use for large, flat washes.

PALETTES

Standard watercolor palettes are round or rectangular mixing trays with color wells around the edges. They are readily available in art supply stores in a variety of shapes and sizes. Most palettes are made of plastic, aluminum, or tin. A pa-

lette should be neutral in color; white is the color preferred by most artists.

The type of palette you use is a matter of choice. A porcelain enamel butcher's tray, a plate, a kitchen tray can all serve as palettes. Some artists use a large piece of glass with a white paper under it. I use a muffin tin. I place the tube colors on the rim; the deep wells provide ample mixing containers for large washes.

PAPER

SKETCHBOOKS. Most standard sketchbooks can be used for watercolor paintings if you use water sparingly. If you use large pools of wet pigment the paper could shrink and buckle when it dries. This can be avoided by sponging up overly wet areas with tissues or a cloth. To avoid such problems in the first place, you should use a better grade of paper that can be clamped or stretched to resist buckling when dry.

BOARD. Illustration board or watercolor board used by commercial artists can be used with interesting results. Some contemporary styles go well with its hard surface. For most fine art purposes, however, paper is preferred.

WATERCOLOR BLOCKS are sketchbook-size pads available in high-quality, handmade varieties. They are excellent for use in sketching on location, since they don't require the artist to take a drawing board along for support.

WATERCOLOR PAPER. It is very important to use a paper that will not yellow or disintegrate in time. It is for this reason that the highest quality paper available should be used by the serious painter.

Handmade, acid free, 100% rag content papers made from linen or cotton fibers are the best. Arch-

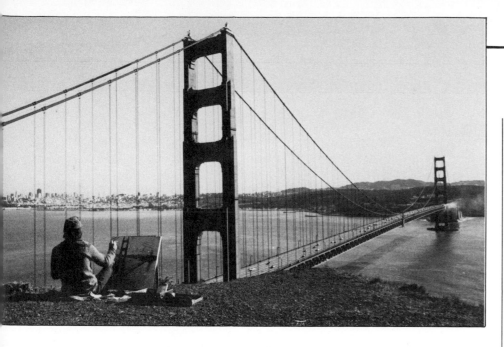

Here, I am working on location at the Golden Gate Bridge, San Francisco.

es, Morilla, and Bockingford are acid free papers that will resist yellowing. Arches, from France, is one of the most popular of these quality papers. I used J. Whatman's Handcrafted paper for years until it was discontinued in 1962. The mill is back in production, so that distinguished old English watercolor paper is available again. J. Barcham Green Mill, also located in England, produces the handmade Royal Watercolour Society, R.W.S. Cotman paper. It has a lovely warm, white, irregular surface.

When my stock of Whatman ran out years ago in Australia, I used the English T.H. Saunders paper with good results. It is slightly more absorbent than Arches. You might want to experiment with different papers to find the qualities best suited to your approach to painting.

I use mostly Arches 140-pound and 300-pound cold-pressed watercolor paper. Strathmore's Gemini and Aquarius II papers are also excellent. I use 90-pound Strathmore paper for working up drawings and quick watercolor idea sketches.

These handmade papers are available in hot pressed (smooth), cold pressed (semirough), and rough textures. The rough papers have a slight "tooth." There are various sizes available but the most

common is the full sheet—22 by 30 in., the Imperial size. Other sizes, such as quarter sheet (11 by 15 in.) and half sheet (15 by 22 in.), are cut from the Imperial.

There are larger sizes, called Elephant and Double Elephant. Still larger are 30- by 40-in. sheets, and rolled sheets from Arches are available in 140-pound, 43½-in. by 10-yards.

Watercolor sheets come in various weights. I've had the best results with 140-pound and 300-pound weights. The weight refers to pounds per ream, or 500 sheets. Therefore "140-pound paper" indicates that a full ream—500 sheets—weighs 140 pounds. Paper lighter than 140 pounds tends to buckle with the application of watercolor, and paper over 300 pounds I find to be too absorbent.

Sizing, a gelatin or glue coating on the paper's surface, controls absorbency. The sizing can be reduced by wiping the paper with a wet sponge or paper towel. Many watercolorists find it favorable to stretch their paper, reducing the paper's resistance to watercolor by removing some of its sizing. Stretching also reduces buckling and facilitates the handling of washes across the surface. To stretch watercolor paper, either submerge the sheet in a bathtub or otherwise soak it thoroughly; the sheet will

then expand. Wipe it with a wet sponge to remove excess moisture, then staple or tape the sheet to a heavy plywood board. Use 2-in.-wide gummed paper tape and have it cut before you start so the paper can be fastened immediately. As it dries it will buckle, but it will flatten out when dry.

Generally, I elect *not* to stretch my watercolor paper. It seems to me I achieve more transparent darks when working on unstretched paper.

OTHER TOOLS AND MATERIALS

PENCILS. A 2B pencil is excellent for preliminary drawing because it is easier to erase than a B and smudges less than a 3B or 4B.
ERASERS. I like the kneaded type, a soft, putty-like eraser that can be molded to pick up small areas without disturbing those lines you want to retain.
SPONGES. A large natural sponge can be used to prewet the paper before painting. Smaller sponges are useful for stamping, producing textural effects.
PAPER TOWELS. Convenient and handy for picking up excess watercolor. They are generally easier to use than cloth rags.
ATOMIZER. Use to spray water over the pigments on your palette

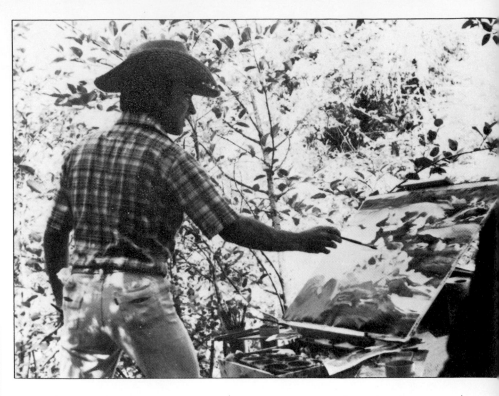

Here I am painting a demonstration for a Yosemite watercolor workshop on a river bank.

The muffin tin is resting in the open drawer of the French easel. To the right of this is a scrap of watercolor paper where my colors are tested before I apply them to the painting. I've used a small brush for most of this directly painted watercolor, finishing one section before moving along to another area. The middle left section of the painting remains as unfinished white paper at this stage. It will soon be worked wet-in-wet and brought to a finish to complete the painting in a single two-hour session.

to keep them moist. An atomizer is especially valuable to take on location, where the direct sun may be hitting the palette.

TAPE. Masking tape is useful for securing the paper to Masonite board. Because I don't prestretch the paper, it must expand somewhat while I'm painting. I tape completely around the perimeter of the sheet and allow the sheet to expand and ripple during painting. After it dries it will shrink back to its original size and become flat.

RULER. A 24-in. wooden ruler is useful for checking the level of the horizon in your painting. You can also use it to guide your brush when you make straight lines. Lift up the edge of the ruler, which is parallel with the line you wish to draw, and run the brush along the ruler. The ruler acts as a support for the brush. It also serves as a steady support for your brush hand when you wish to paint over a wet passage.

DRAWING BOARD. I find most drawing boards heavy. I also find they become slightly warped after use. Therefore, I prefer to use a piece of ¹/₈-in. Masonite a few inches larger than my paper as a rigid, lightweight support.

EASEL. French easels, though expensive, are the most convenient for location painting. They fold up and can be used whether the artist is standing or sitting. (I started out with a simple drawing board that had a folding support in the back to prop it up. I sat on a cushion on the ground. Now, I use a French easel.)

TABLE. My studio table is just a small captain's desk with a 30- by 40-in. plywood sheet resting on top. It's inclined at about a ten-degree angle. I paint both standing and sitting—standing for large washes and sitting for detail.

RAZORS. A single-edged razor is handy for scraping textures into watercolor washes.

On 140-pound or 300-pound paper it is possible to use a razor to recover an area of white paper. After the wash is dry, cut through the top surface of the paper in the shape of the white area you need, being careful not to cut deeper than halfway through the paper. Gently peel off the top layer of paper.

BLOTTERS. A blotter is handy for picking up the excess of a wash.

MASKING FLUID. Art supply stores sell a variety of block-out solutions. Paint the masking fluid over an area you intend to leave white. After it dries, you can brush washes freely over the surrounding area without having to be careful to avoid the white area. After the washes have dried, rub off the masking fluid and you have a clean white area. Rubber cement can also be used this way.

TOOTHBRUSHES are good for splatter effects. See the chapter on textures (page 72).

ACRYLIC AND OIL BRUSHES. These can be used for lightening or removing an area of watercolor. Lightly scrub a little clear water over the passage you wish to alter. Dab the area with a tissue to pick up the excess. Continue the process until the desired lightness or removal is accomplished. Be careful not to disturb the natural grain of the paper. If you scrub too hard, the grain will become rough.

SALT AND SAND. Salt or sand sprinkled into a damp wash will produce interesting textural blotches. Special effects such as these should be used sparingly. If overdone, they look gimmicky.

ART BIN BOXES. These are similar to fishing-tackle boxes. They are made of hard plastic and are light and easy to carry. They

vary in size anywhere from six to thirty-eight compartments. Mine has three trays and eighteen compartments.

PAINT

PAN WATERCOLORS have the pigments arranged around the tray in hard cakes that are moistened with water. They come complete with their own mixing trays. These are excellent for watercolor sketches or when traveling. They're easy to carry and come in boxes small enough to fit into a shirt pocket. Some renowned artists have used pan watercolors; however, they are difficult to use when laying a flat wash in a large area.

TUBE COLORS are most commonly used and are satisfactory for large washes. They are easier to mix than pan watercolors. Be sure that you replace the caps so the color remains fresh.

ARTIST'S GRADE OR STUDENT GRADE? Student Grade colors are less expensive but have a thinner concentration of pigment. When I started out I used them because of the cost factor, but I soon discovered that I needed to mix them with some of the Artist's Grade colors in order to achieve the results I wanted. For instance, the Student Grade burnt sienna and manganese blue are weak in appearance, lack evenness when mixed, and generally do not handle as well as Artist's Grade. Such factors can have a bearing on the effectiveness of your work. Professionals have a responsibility to the public and to posterity to build permanence into their paintings. They should use high grade materials in their paints and every other phase of their picture production.

COLORFASTNESS refers to the stability and relative permanence of a color. For instance, Payne's gray lightens as it dries and will fade slightly in time, so it is not as colorfast as a sturdy lampblack gray of the same value. The symbol *AA* on a tube of paint indicates the highest degree of permanence.

PERMANENT WATERCOLOR PIGMENTS

WHITE. Chinese white (zinc white); titanium oxide; titanium pigment.

BLACK. Ivory black; lampblack; Mars black

RED. Cadmium light; alizarin crimson; cadmium scarlet; scarlet lake; pure iron oxides (Indian red, light red, Mars red); cadmium medium; cadmium deep; maroon; phthalocyanine (thalo) reds; permanent rose.

YELLOW. Winsor yellow; new gamboge; cadmium pale; cadmium medium; cadmium deep; cadmium orange; Mars yellow; yellow ochre; transparent ochre; raw sienna; cobalt yellow; strontium yellow.

BLUE. Ultramarine (all shades); cobalt blue; cerulean; manganese; thalo blue.

GREEN. Viridian; chromium oxide; green earth; thalo green; cobalt; turquoise; ultramarine green.

VIOLET. Cobalt violet; manganese violet; Mars violet; thalo violet.

BROWN. Raw umber; burnt umber; burnt sienna; alizarin brown; burnt green earth.

WASH VARIATIONS

FLAT WASH. A flat wash is an area of watercolor which is uniform in tone. The first step in laying a flat wash is to tape the edges of the paper to the board. This will allow the paper surface to expand and then shrink back to its original

flatness. To lay the flat wash, tilt the top of the board up to a 10- to 15-degree incline. This allows the wash to flow downward and yet avoid drips.

Next, select a large brush, say, 1½ in., and load it with watercolor. Then, working from top to bottom, move a puddle of color mixture across the paper, left to right. Lift the brush and continue to bring the mixture down and across. As you draw the brush across the paper, pick up the paint from the previous stroke. As the mixture thins out, reload the brush. Be careful not to let the wash thin out too much before you reload. Gently shake out the extra drips from the brush onto a towel before returning to the paper to continue the wash. At the end of the wash, wipe off the brush with a paper towel and with the semidry brush, pick up the excess pool of water that collects at the bottom. This avoids any "runback" which might dry as an unsightly ring.

Sky detail, Reflections in Honfleur.

A large flat wash was applied across and down the sizable area of sky. Then the painting immediately was turned upside down, allowing a granular effect to form. This simple, flat sky of ultramarine blue and ochre gives relief to the otherwise active composition, and is appropriate to the clarity of the high noon light.

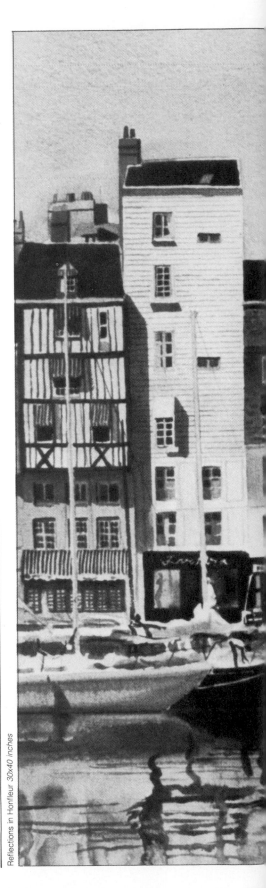

Reflections in Honfleur *30x40 inches*

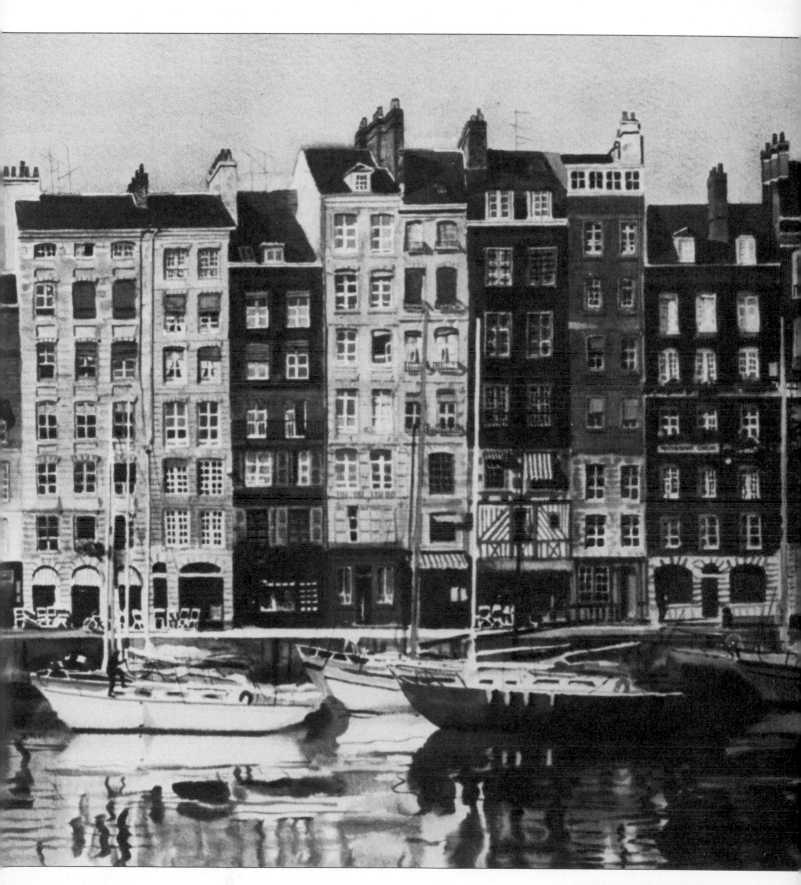

Detail of bridge stonework, Dinan.

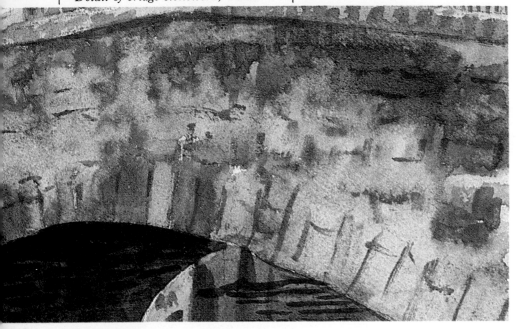

Dinan's stonework was depicted by the overlay method; small, descriptive strokes were applied over a base wash.

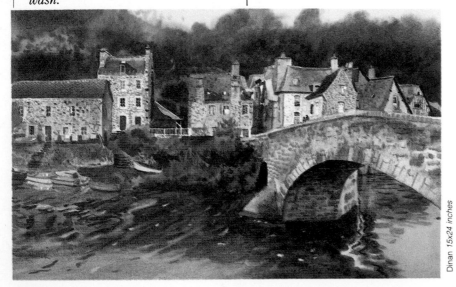

Dinan *15x24 inches*

LAYERED WASH.

Lay a flat wash or graded wash. After it dries, overlap it with another wash to achieve a layered effect. The overlapped wash creates a darker tone. To produce still darker values, add a third or fourth tone.

Watercolor tends to "muddy up" with too many superimposed washes. The fewer the overlaid washes, the cleaner and brighter the result. My direct-approach method requires very sparing use of the layered wash.

WET-IN-WET.

When you apply a wash to a *dry* watercolor paper surface, the *edges* of that wash will be sharp, definite, and hard—like the flat wash or layered wash examples on page 16 and at left.

However, if you apply a wash to damp watercolor paper you create a *soft* or *blended* edge.

To paint a wet-in-wet passage, prewet the paper with clear water, using a large brush or sponge. Lightly wipe off the excess water with a paper towel so the paper is evenly damp, not wet. Flow a loaded brush of pigment (mixed with very little water) onto the damp surface. The result is a soft, blended tone. Modulations of the brush, with only a little water and more pigment, onto the damp paper will give soft-edged strokes.

Draw freely with the brush and indicate tonal shapes while the paper is still damp. Once the paper has dried, you can rewet the surface for additional wet-in-wet effects.

Combining wet-in-wet with other techniques is an excellent way to introduce a look of spontaneity into a watercolor.

Cat in Flower Box *is an example of wet-in-wet blending.*

Cat in Flower Box *30x22 inches*

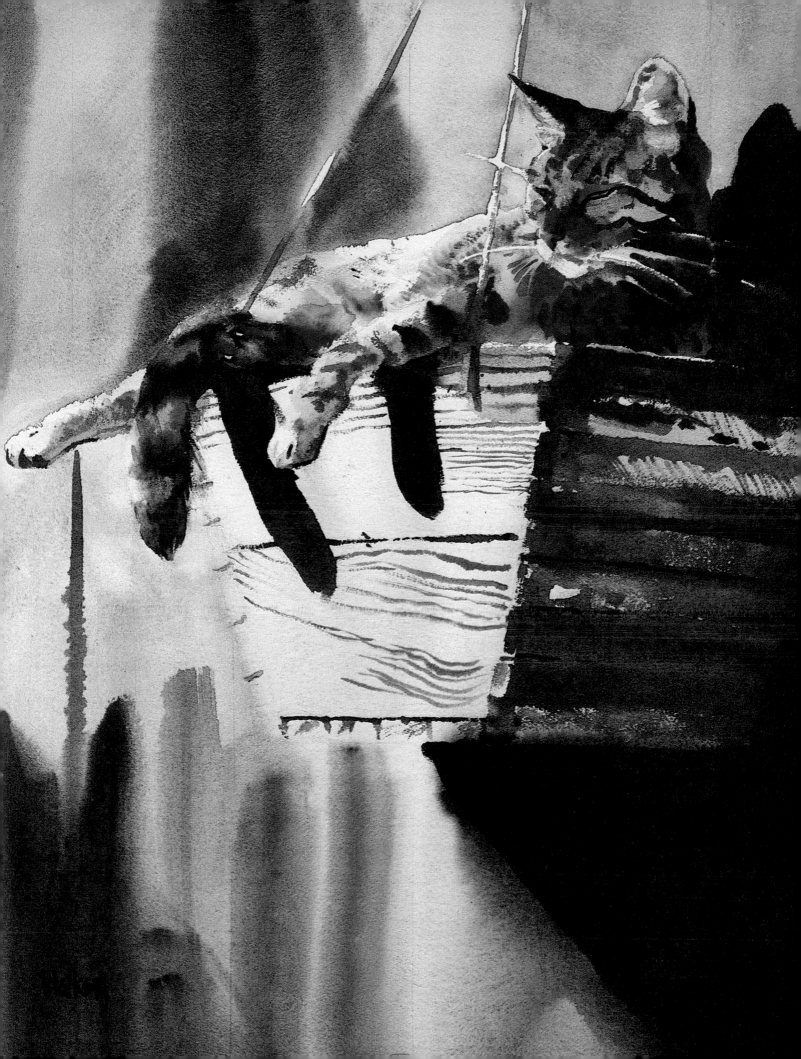

Rough brushing.

Graded wash.

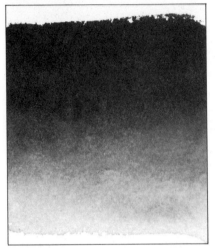

Drybrush.

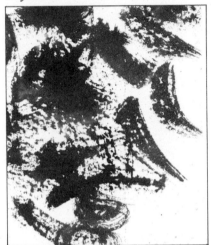

BRUSH TECHNIQUES

BRAVURA BRUSHSTROKES.
A term commonly used to describe bold and spirited brushstrokes, or otherwise expressive handling of paint on paper. Considering the spontaneous nature of the medium, such lively brushstrokes are particularly suited to watercolor painting. While these strokes may not appear to be careful or deliberate, they should, nevertheless, appear to be under control.

ROUGH BRUSHING. This is a method of creating textural effects by sweeping a rather dry brush (one with more pigment than water), back and forth over the paper surface. The brushstrokes can be made directly on the white paper, or over a wash that has dried. This is basically a drybrush procedure.
GRADED WASH. This is the gradual shading of a tone or color from dark to light, or light to dark. To apply a wash that blends from dark to light, start with a dark paint and brush it across the paper. Before returning the brush to the mixture on your palette, dip it lightly into clear water and add this to the mixture, lightening the tone slightly. Return to the bottom edge of the dark stroke and draw the brush down and across. Repeat this sequence of adding more water with each stroke until you achieve the gradation to white paper, ending with clear water. Pick up the excess water with a dried brush.

DRYBRUSH. To produce a drybrush stroke, moisten the brush with very little water; shake it out, drag the brush through the color mixture on your palette and then across dry paper. The pigment will pick up the rough texture of the paper, producing a drybrush effect.

Drybrush can be used throughout an entire watercolor in much the same way that a drawing medium would be utilized. It is more often used as a treatment of textural effects over washes or in conjunction with washes.

An imaginative underwash superimposed with drybrush can create limitless expressive effects for almost any subject you're likely to encounter.

1. Drawing the brush across a rough surface with the bristles spread.

2. Drybrush strokes on rough paper.

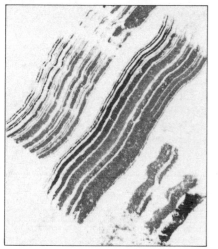

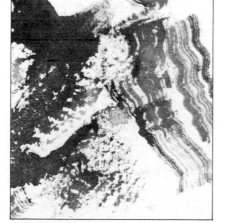

3. Dark areas are put in with a loaded brush and then the lighter areas are drybrushed in with the opaque mixture.

4. Drybrush over a dry wash.

When watercolorists "reserve" the white of the paper, they refer to leaving the white paper unpainted to provide the whites, thus allowing the paper to perform the role of white paint.

OPAQUE COLOR—DESIRABLE?

My own observations have shown that most watercolorists reject using opaque white in their watercolors. Their objections appear to be based on a number of charges with which, as a reformed objector, I am intimately acquainted:

The opacity of white dulls and intrudes upon the "purity" of transparent watercolor;
Opaque additions act as a "crutch" for those who cannot solve painting problems by using only transparent paint;
Opaque is used to reinforce a weak watercolor;
Using white paint is cheating.

OPAQUE COLOR—DEFENSES

Responding in reverse order: No, it is not cheating. Watercolor is not a performance art and so the means to the end is less important than the end result. This reminds me of my early college days when using a ruler in drawing class was considered cheating. The lesson I came away with at that time was: "You shouldn't use a ruler until you can draw a straight line without one." This brings me to the next two objections. Perhaps, if a watercolorist is using white paint to cover up unsolved problems in his transparent watercolor, he should realize that my ruler-axiom applies. One should attain sufficient control and mastery of the craft to solve all problems that may arise with the medium before using "short cut" aids to bridge the gap in performance.

No poorly painted watercolor was ever saved by adding opaque paint. Either the painting is good or it isn't! So, a "crutch" won't help a lame watercolor.

Finally, if opaque passages are as skillfully handled as the transparent passages, they will integrate favorably into the whole scheme. The combination of surface qualities of the two adds an exciting dimension to the transparent watercolor in some cases.

The last word on using opaque and transparent watercolor together might be from the example of such master painters as J. M. W. Turner and R. P. Bonington, who mixed transparent and opaque watercolor frequently. John Singer Sargent (1856-1925) also used opaque passages.

In recent times, acclaimed watercolorists Andrew Wyeth and Donald Teague (of the East and West Coasts, respectively) use opaque mixtures in their watercolors as their expression requires.

Although this book deals with transparent watercolor, I felt this observation might be interesting to those who are unclear on the role of opaque paint in watercolor. There are a few examples in this book that will specifically point out the use of opaque additions.

MIXED MEDIUMS

Contemporary watercolorists have made excellent contributions to the art world with their watercolors mixed with drawing mediums, e.g., pastel, crayon, or colored pencil added to their washes. Although a felt tip is also used, it is not permanent and most colored inks are considered fugitive color. Acrylic paint can be thinned and used like watercolor. Even tinted paper can be used with the addition of opaque white for highlights.

Able Hands that Tend the Hoofs *12x17 inches*

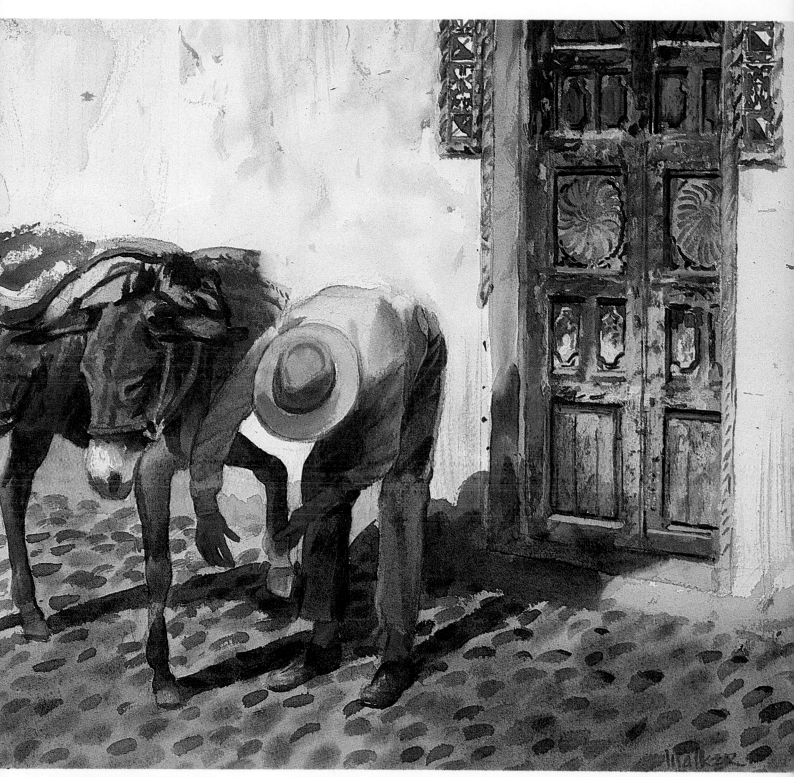

I used transparent watercolor to paint this entire picture. Then, feeling a need for additional enrichment of the ornate door and tiles, I decided to use opaque in the isolated area of the entryway. The decision was instantaneous and so the door was still damp. I added light gray highlights into this damp area. The gray was ultramarine blue, burnt sienna, and just a hint of Chinese white. Opaque additions over transparent passages often dry darker, so I mixed the opaque highlights a little lighter to compensate.

LIGHTENING A TOO-DARK WASH

SCRUBBING OUT. Use an oil or acrylic brush with stiff bristles to scrub out or lighten a passage. Be careful to scrub lightly. Also, work in stages to protect the textured surface of the paper. Float clear water onto the area and brush lightly in the same direction repeatedly (ten or so times); then, lift moisture and color with a dab of a paper towel. Repeat until the desired lightness is achieved.

SPONGING. A large natural sponge is useful for lightening or removing large areas of color. (Use small natural sponges for isolated areas that are difficult to reach.) Sponge the area with clear water and pick up excess water with a paper towel.

SCRAPING. Extreme care must be used in scraping off color. A scraped surface should not interfere with the character of the rest of the watercolor. Once you determine that you can proceed effectively, use a single-edged razor blade and scrape lightly and consistently in different directions. Entire areas of color can be scraped away to the white paper. However, you should not paint over the disturbed grain of the paper.

To achieve a sparkling effect, such as sun on water or various surface textures, drag the flat edge of a single-edged razor across a wash with one broad swipe. This will scrape away the uppermost portions of the paper's tooth to produce a sparkling effect. Special effects such as this are most successful when used sparingly.

CALLIGRAPHY (DRAWING WITH A BRUSH)

An accurate brushline need not be sharp or precise, but neither may

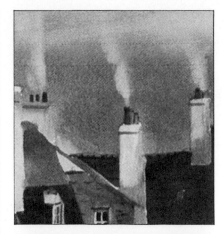

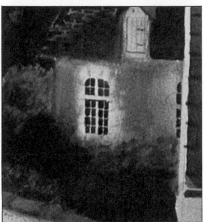

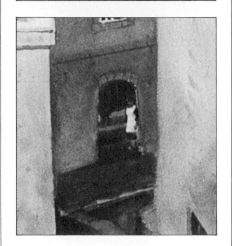

it be loose. The lines you put down with your brush should appear to be under control and consistent with the style and feeling of your painting.

Every brushline has weight and a degree of thickness. This quality can play a role in a painting.

FRESH AIR AND CHIMNEY SMOKE.

Close ups. The painting is shown on page 26.

I dampened the dry sky wash with a brush and lifted the pigment out with a paper towel to give the appearance of smoke.

The window area was sponged to give a brighter note to that spot. After the sponged area dried I painted in the dark window glass with a small brush (#4).

The lady was an afterthought, so the white of the apron had to be recovered from the dark wash of the doorway. I used a single-edged razor blade to gently scrape away this white shape.

Some watercolorists do a rough line drawing with the brush in a neutral color *before* painting (see *Trevi Fountain, Rome,* on the following page). This calligraphic line becomes part of the expressive flair of the watercolor. Other artists make a line drawing with pen-

cil. This drawing can vary from a rough sketch to a detailed rendering of even the smallest shapes in the picture. Whatever your preference, consider line work as a guide, as a point of reference, not an outline to be "filled in."

Once I begin painting over my penciled guidelines, my thinking switches to planes and three-dimensional form rather than to outlined shapes. I work wet-into-wet, slowly building and shaping forms with the brush. Any linear work is usually drawn with the brush over these semidamp washes, creating the illusion of depth and space.

EXERCISES. Drawing with the brush requires a fluid control of the instrument. To increase your dexterity with the brush, there are some simple exercises you can perform. Dip a No. 8 brush into black watercolor and draw ellipse after ellipse—hold the brush halfway down the handle. Old newspapers make a cheap, effective surface for this kind of practice. Draw the ellipse with one continuous movement of your arm in a counterclockwise direction. After an hour of this, change from ellipses to circles.

The circle should be drawn in two separate strokes. The first one starts at the top of the circle and sweeps counterclockwise to the bottom. The second stroke also starts at the top and sweeps clockwise to the bottom, completing the circle.

In addition to this loosening-up exercise, practice brush drawings, using either brown or black paint. Use inexpensive paper so that you don't feel inhibited in your motions.

Finally, practice painting a watercolor without using preliminary penciling.

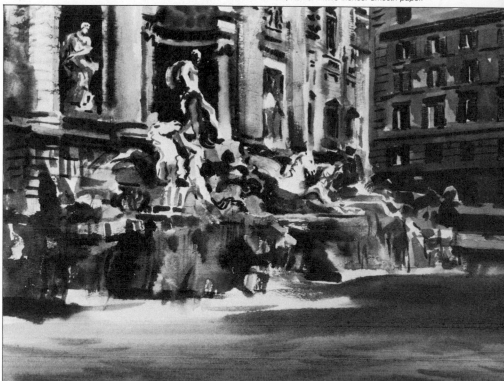

Trevi Fountain, Rome. *11x15 inches. Smooth paper.*

PROCEDURE FOR *TREVI FOUNTAIN.* *Hardly any preliminary penciling was used to draw this picture. Instead, I used a rough line drawing with the brush to block in the composition. Then I used a flat brush to brush in the broadest areas. The paper was still wet, so the brushwork results in a soft and fluid appearance. Why paint in this way? I have always felt that such a spontaneous and direct approach imparts a somewhat fresh, candid look to the watercolor.*
In my mind's eye I carefully planned the linework, then carried it out expressively. Here, there are several different procedures involved. I drew the brushline through a par-
tially damp wash that blurred the hard line. All the lines have widely varying weights. At the lower right, I painted the dark sea around the whites. Notice that the white lines change to dark lines when seen against the white tone of the boat deck. I also painted the dark sweater around the midline that runs between the top and bottom of the picture. This line itself is varied in color and value. I dashed in the lines at the left using the same principles.

This is a rather intuitive approach that works well for sketching, and in watercolors where spontaneity is of special value to the subject—in this case, a candid moment out on the bay.

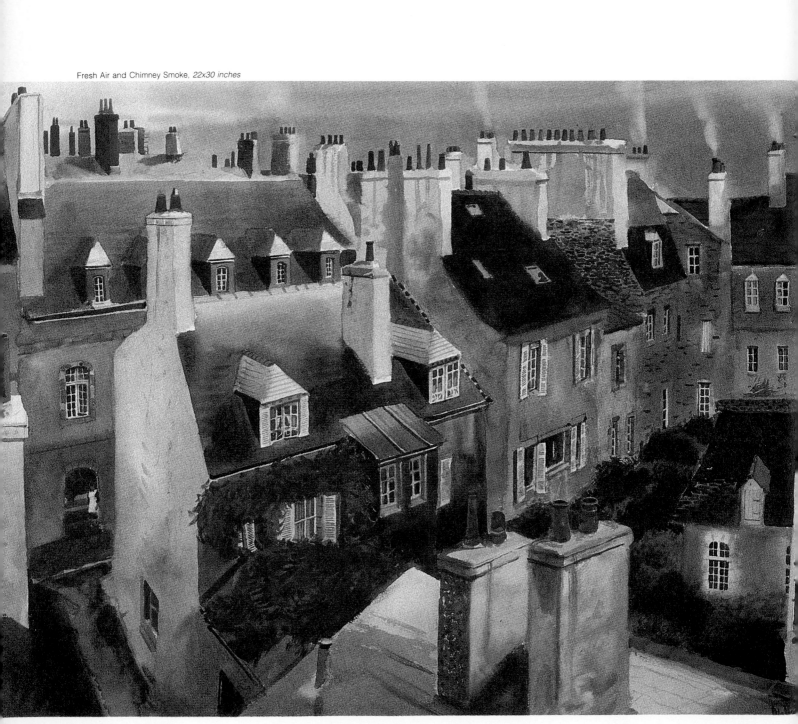

Fresh Air and Chimney Smoke, *22x30 inches*

PROCEDURE FOR *FRESH AIR AND CHIMNEY SMOKE.*

As I drew in my sketchbook, looking out the hotel window from this high vantage point, the chimneys were fascinating, but something was lacking in terms of a real statement. It was an overcast day, which added to the dullness of the scene; still, it was a scene that I liked and wanted to capture.

Later, as I completed the initial stages of the drawing in the studio, I lengthened the houses and extended the chimneys to give them a stately appearance. I decided to make any further adjustments as the watercolor developed during painting. I knew that I wanted a dramatic mood to accompany the unique architecture. I carried out the intended drama by lighting up the chimneys and darkening the clouds. In order to have a consistent light source, I imagined how the sun, breaking through from the right, would shine on the roofs after a rain. Rainfall will often darken various surfaces in tone and, at the same time, produce shiny, slick spots. So I graded the shiny areas from light to dark, and darkened all the rain-soaked foliage. I varied the degree of light and shade contrast in a continuum of light-dark-light pattern, to give dramatic clarity to each plane.

My usual procedure in portraying drifting smoke is to flood water into the smoke patterns at the time of the initial wash, and then pick up the excess water with paper towels. In this case, I was not sure of the direction of the smoke, (or even if I wanted to include it in the composition). Toward the end of the painting's development, I decided that a few vertical wisps of smoke would contribute to the continuing vertical theme that the chimneys created. So I dampened the dry sky in the areas where the smoke was to be seen, and gently scrubbed and patted the area with a paper towel.

At this final stage I had lengthened the structures, graded the values, darkened the sky, but still felt something more was needed. I considered putting a cat on the near roof, or a bird in flight. This might have worked. However, the already busy roofs could not take much more activity. I decided to put a young French maiden in the only visible doorway—she's getting a breath of fresh air after the rain. Thus the title, Fresh Air and Chimney Smoke.

5·STARTING A WATERCOLOR

Planning—The initial stage of a watercolor, as with any painting, is the idea. Then, having determined the subject and the general direction of a theme, some planning is necessary to transfer the initial mental image to the paper.

Composition, or the pictorial arrangement, is the next step. Consider any given theme as just an interrelated group of elements that can be moved about to suit the picture plan.

SKETCHING

Watercolor sketches have been my answer to preplanning a watercolor. Sketching from the start, in the medium you are using, requires you to think in watercolor terms from the beginning. These sketches fit loosely into the categories of thumbnail sketches, preliminary sketches, field sketches, working sketches, and studies.

THUMBNAIL SKETCHES. Tiny (3 to 4 in.) compositional sketches with light and shade indicated. These may be in color or value (black and grays, or sepia). Often it is necessary to do three or four with different light effects before your thoughts become organized. I use "thumbnails" when I am unsure of the placement of figures, light and shade, or composition.

PRELIMINARY SKETCH. This can vary in size from a half to a full sketchbook page. Frequently, it is the only stage I will use before the final painting. The "prelim" effectively allows a full-color representation, including all the elements of the final work, in a simplified version.

FIELD SKETCHES. These are "prelims" accomplished on location. As preliminaries they should be unlabored and spontaneous. With these, it is desirable to capture the *spirit* of the subject. The immediacy of watercolor is particularly suit-

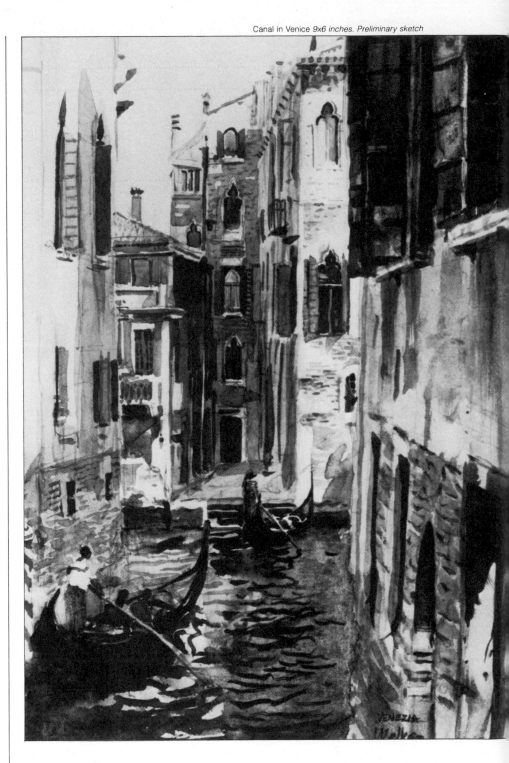

Canal in Venice *9x6 inches. Preliminary sketch*

In Canal in Venice, *the lighter values at the top and left balance the heavier, darker ones at the bottom and right, and diagonal elements of composition keep the picture from being just vertical and dull. Use such interesting contrasts in your sketches.*

ed to this method. Sometimes these small paintings can be successful pictures in themselves and may be considered as finished art separate from any larger, elaborate works that follow. The quality of art does not depend on size.

WORKING SKETCHES. For me a working sketch is a preliminary watercolor that is the same size as the finished painting. It is useful particularly in working out complicated subject matter. Sometimes awkward elements that are hidden in small sketches will show up at a larger scale.

For example, suppose I were to leave a large area of foreground with very little detail in a small sketch. It might show great promise in small scale, yet it might just lie there and look incomplete in the larger painting. A full-sized working sketch in watercolor would prevent this kind of unforeseen problem.

Now, let me ask you to consider another version of the working sketch: If a painting does not prove successful, don't think of it as a failure. Rather, view it as a "preliminary" from which to learn. Sometimes it is necessary to paint a subject several times before all the problems are solved. So don't be hard on yourself. The unsuccessful watercolor now becomes the working sketch along the road to the final statement.

STUDIES. When a small area or detail of a painting needs to be worked out, a study is helpful. This usually takes the form of a detailed rendering isolated from its background. The inherent beauty of a well-rendered watercolor surrounded by an elegant field of white paper or flat background, allows many a study to be framed and hung alongside the completed, final work.

WRITTEN NOTES

Make notations in your sketchbook or on a separate pad when time or conditions prevent producing an actual watercolor on location. This is particularly valuable when traveling. Some cultures discourage photographing or painting their images or ceremonies. For example, when traveling through Navajo, Hopi, or Pueblo Indian country, I frequently write descriptive notes on the native American ceremonial dances. However, during the Turtle Dance at the Santa Clara Pueblo in New Mexico, even note taking is not allowed. So I would run back and forth to my car to jot down such details as the direction and position of eagle feathers, turtle shells, etc.

Memory plays a major role in the painter's life, and keen observation is important. Many people *look*, but often they don't see. Make it a habit to observe closely the familiar things around you as well as the unusual things you see.

SKETCHES-SUMMARY

The watercolor sketch should be a spontaneous statement. Even careful, deliberate sketches should appear as uninhibited efforts. Try for that odd angle or unusual color combination that seems interesting. Often the sensitivity felt in a sketch is difficult to recapture on a larger scale. At their best, these are windows to the artist's personality. Try to preserve them!

Field sketch on smooth paper. A watercolor sketch such as this is like shorthand for the artist.

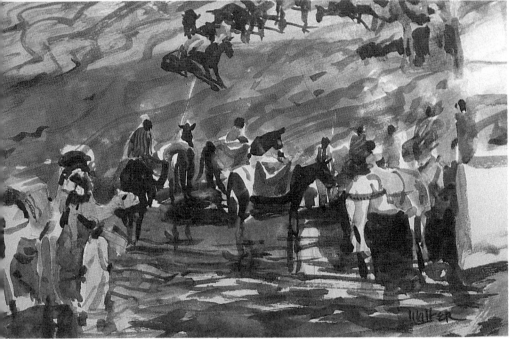

Moroccan Waterhole *Sketch*

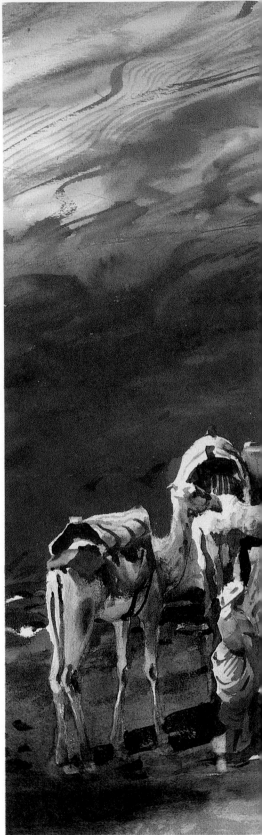

Moroccan Waterhole *22x30 inches*

The finished painting of Moroccan Waterhole *edits and refines the sketch, reducing the off-center circle of horses and camels and putting it wholly within the picture and emphasizing swirling beige dunes which contrast with the dark, strongly-colored water below. The painting is further discussed in the caption on p. 81.*

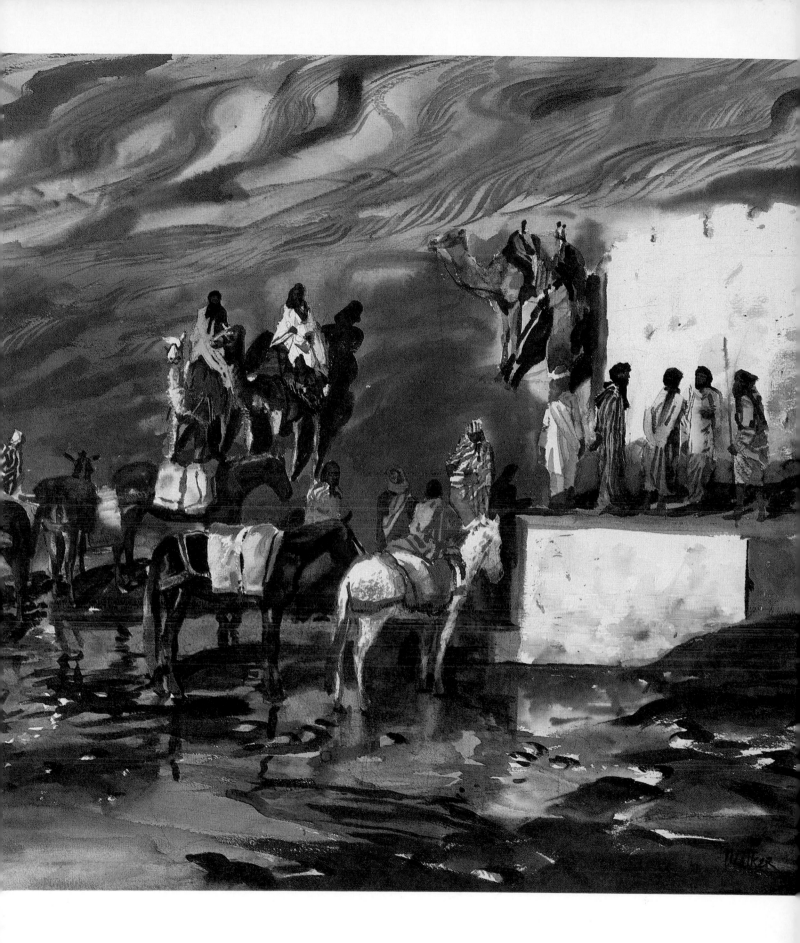

6·OUTDOORS

OUTDOOR PAINTING

Watercolor is an ideal medium for location work. You have no wet paint to contend with on the way home. For years, all my painting was accomplished on location. Since I painted all year 'round, I had to battle the weather at times.

Painting on location teaches you how to observe nature by going to the source. You can move around and actually experience three-dimensional forms—something you can't do when working from flat, two-dimensional photographs. Location work provides a visual understanding of things that can be drawn upon later in the studio.

One of the opportunities that on-the-spot painting provides is experiencing changing conditions of lighting, clouds, and other factors. Many times, in the course of doing a painting, birds, an animal, or people, will move into the scene, adding new possibilities, sometimes even providing the main theme of a work. Dramatic changes in lighting often occur on cloudy days, when shadows realign themselves into interesting patterns. Much of this

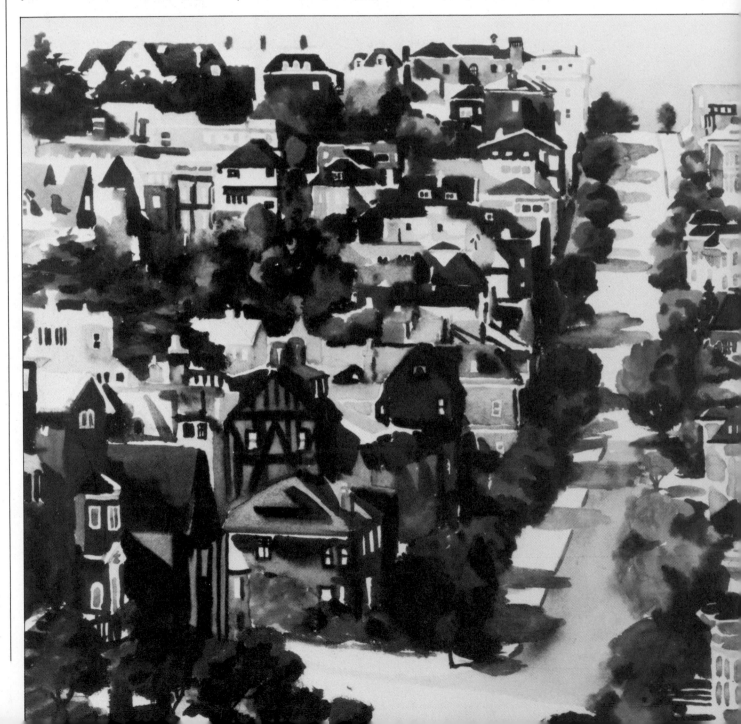

you will miss if you are on location only briefly, taking photographs.

STUDIO PAINTING

Some watercolors in this book were painted on location, others from sketches, memory, or composed from photos I took while traveling.

The visual aids you will need for reference in the studio will depend on what you want to accomplish in your work. If you want the direct simplicity of an impression, where detail is not important, you will need fewer reference aids than a realistic or detailed approach will require.

Working from field sketches can encourage you to stay loose and free in your interpretation. Working from photos offers additional access to visual facts and details that might be missing from your field sketches.

PHOTOGRAPHS. If you choose to work from photographs, be sure you use only those you take yourself. It is important to the integrity of your work that the entire concept and finished painting are *your own.*

Some watercolorists prefer to work from black and white photos, feeling that the values are clearer, and they also like to invent their own color schemes. There are advantages to this approach.

I will often take photos of a subject from all angles, especially when traveling. This is the next best thing to being there, and being able to walk around the actual subject. I rarely work from just one photo, feeling that a single photo tends to freeze the scene,

and lock out compositional development. Spreading out a series of photos will help remind you of the space and volume of things and will serve to widen your vision of the scene.

Possibly the biggest drawback to working from photos is the compulsion to *copy,* instead of *interpret,* as you might on location. Consider the differences: on location there is so much visual information that you must organize, condense, simplify, interpret—or simply be overwhelmed. The photograph abbreviates and condenses our vision. It appears to have solved some problems already by translating the borderless third dimension of reality into a flat-bordered picture surface.

Use the camera, but don't let it use you. The camera lens distorts, and there are adjustments you must make to correct such distortions. Perhaps most importantly, you should filter the photo's visual information through your own creative mind's eye. Art is an illusion and a poetic reflection of life, its sounds and scents as well as its sights. For this reason, observation of life is more important for your painting than observation of photographs.

When you begin with a photo, resist the impulse to render every detail. Make the picture yours, instead of the camera's. In Hillside: Pacific Heights, *what might have been a cluttered, crowded blur is unified by using a relatively limited palette and echoing the same hues again and again in different shapes—trees, walls, roofs, chimneys.*

Hillside: Pacific Heights *22x30 inches*

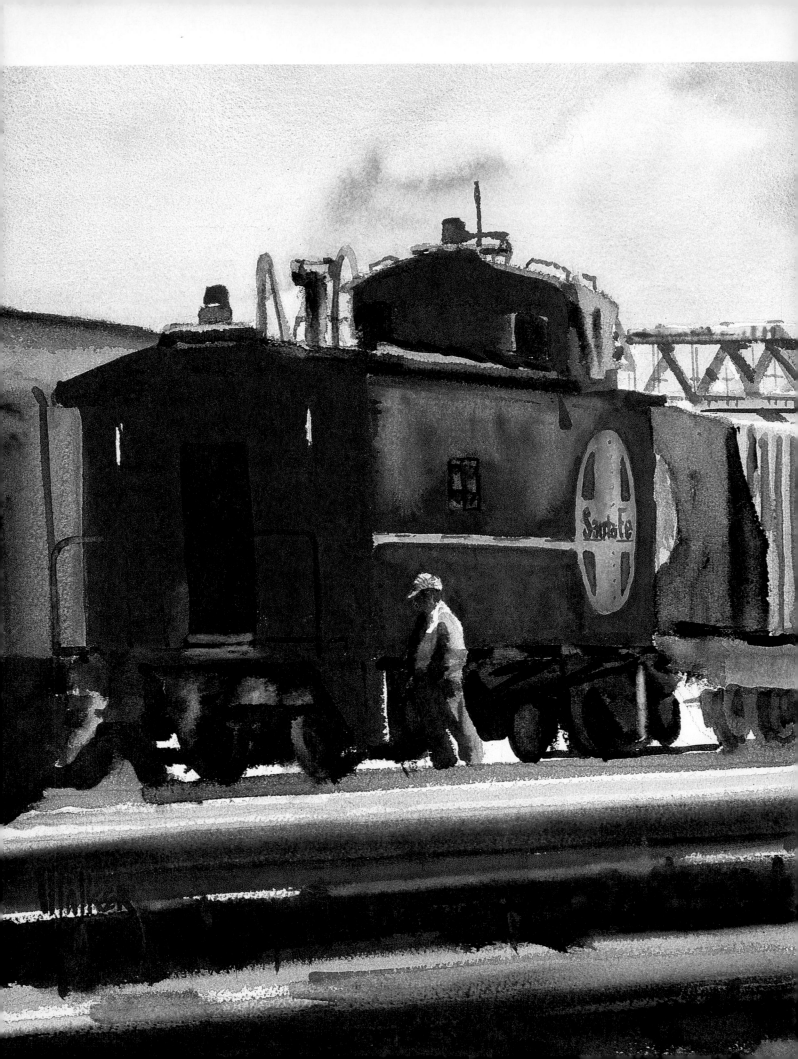

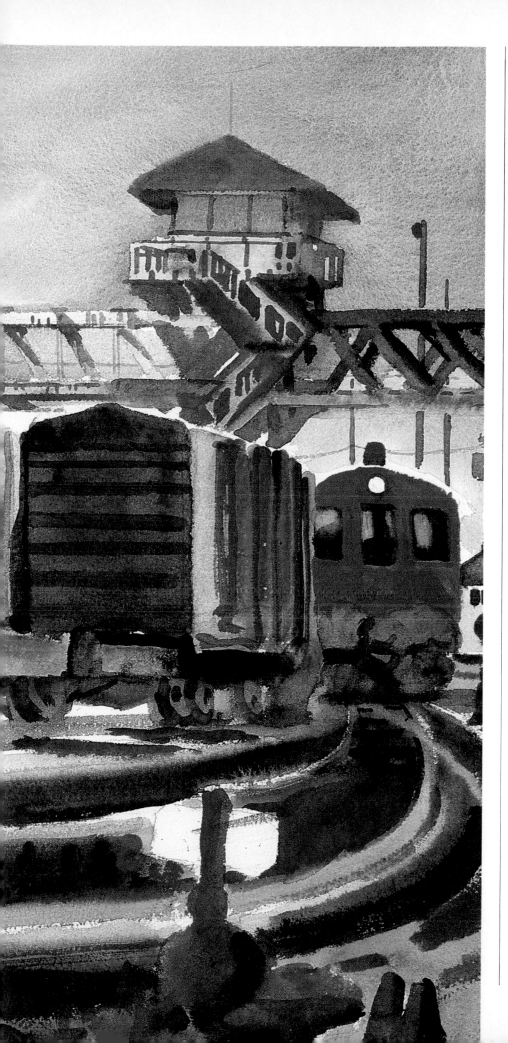

I obtained a permit to paint at the train yard and completed this entirely on location. The brakeman posed a minute for me and then went on with his work.

7·DRAWING

Draftsmanship, the ability to draw, is of primary importance to the watercolorist in establishing a linear structure on which to paint. I usually leave the pencil lines (without erasing) if they show after the painting is finished. I feel that this is part of the expression of the watercolor.

To achieve a high degree of accuracy in your pencil drawing, you will inevitably have to draw and redraw, so keep your penciling light. Don't be reluctant to change what you've put down.

DRAWING PROCEDURE

My system of drawing develops in stages:
1. Initial Rough-in, or Proportional Stage
2. Preliminary Refinement
3. Final Drawing
4. Details
5. Finishing Touches

INITIAL ROUGH-IN, OR PROPORTIONAL STAGE. Hold the pencil at the end—as you would a brush—and with sweeping movements of the arm (not just the hand) lightly rough-in the basic shapes. Pay attention to how the drawing fits onto the page. Note the shape of the objects *and* the shapes that are formed around the objects. This provides two frames of reference from which to check the drawing.

Work over the entire page, not just isolated areas. When the rough-in stage is complete, all of the areas will be developed to an equal degree of finish. The initial rough-in is called the proportional stage because proportions are measured visually against each other.

At the end of each stage, lightly erase the entire surface. You'll then have a ghost image to draw over as a guide in the next

stage. Remember: erase lightly so that you don't disturb the natural surface of the paper.

PRELIMINARY REFINEMENT. The preliminary drawing takes the rough-in stage further by rearranging, correcting, and refining areas that need these adjustments. Again, run the kneaded eraser over the drawing to remove excess graphite while leaving a ghost image.

FINAL DRAWING. By this stage, the forms should have been worked out enough to refine the drawing into the final stages. Before starting the watercolor, go over the pencil lines again with the kneaded eraser, so the washes will not pick up the excess graphite.

DETAILS can be indicated now; use a freshly sharpened pencil.

It is not the amount of detail that is put into a watercolor that finishes it. Sometimes an elegant simplicity used in one subject looks incomplete in another work.

I put in only as much detail as I feel is necessary to create a convincing illusion of the subject. There is such a thing as *over-detailing*. If details compete with, or detract attention from, the basic picture statement, they should be eliminated.

FINISHING TOUCHES. I suggest taking a five-minute break to get away from the constant image you are drawing. When you return, prop the work in an upright position across the room. Relax and observe what you've done. Usually you will see that additional changes need to be made. I make my alterations while the drawing is in this position. Then I sit down opposite the drawing, look at it again and consider whether any further adjustments need to be made. If you try to solve drawing problems with a brush later on, it tends to inhibit natural expression.

In this sketch for Sunshower, *the drawing is more sweeping than for* Queen's Horses at Royal Mews *or* Paisanos. *Detail in this particular painting is less important, but equal care must be taken in the subtle suggestions of the anatomy of the figure, the hands, and the facial features.*

I do more drawing here than might
be necessary, considering how much
of the detail is merely suggested in
the final watercolor. This additional
attention to the drawing allows me
to be well acquainted with the
shapes, forms, and anatomy, so that
I become more decisive and confi-
dent when the watercolor is brushed
in expressively in this involved com-
position. (Notice that the cat drawn
in at the base of the middle pillar
was later eliminated as I painted;
the base of the pillar thus becomes
less distracting.) The color repro-
duction of the finished picture ap-
pears on p. 126.

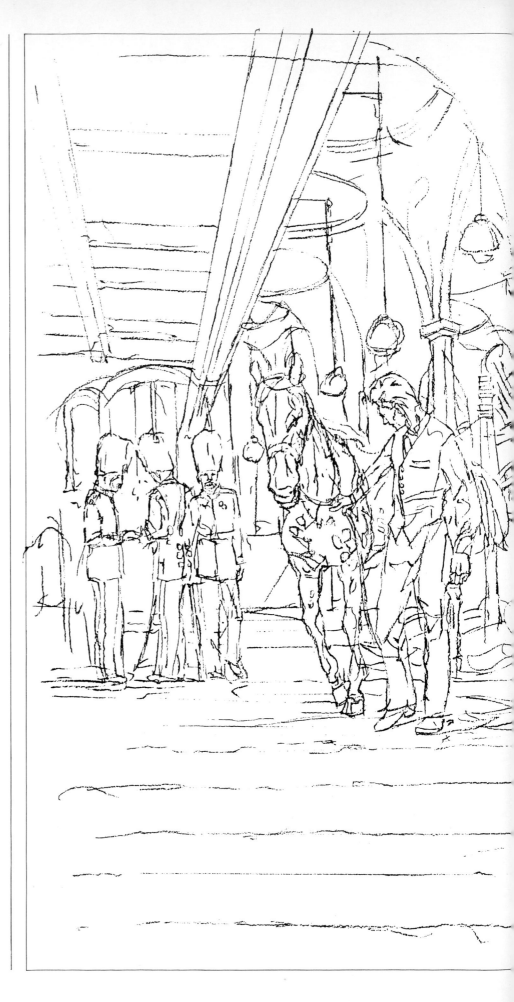

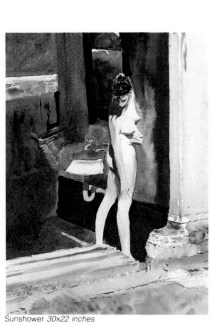

Sunshower *30x22 inches*

Queen's Horses at the Royal Mews *Sketch*

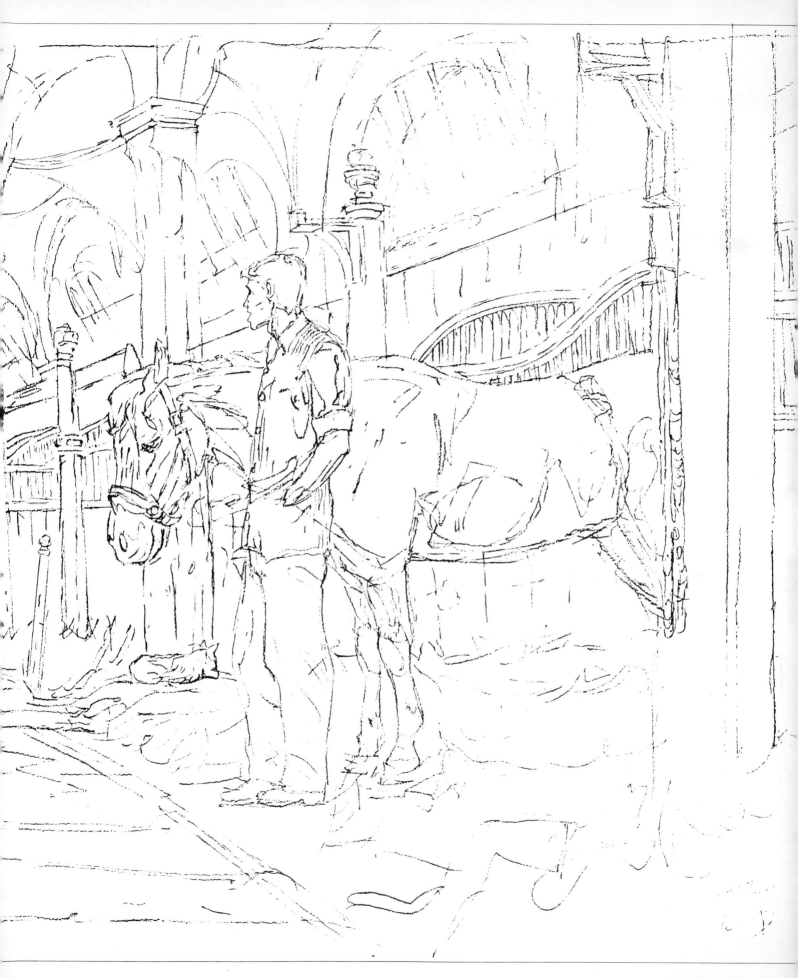

For Paisanos, *the figures and surrounding structures are broadly handled with mostly single sweeps of the pencil. The faces are more detailed, showing the various planes of the faces and establishing each individual character as a distinct personality. The hands are carefully drawn but not overworked. Compare this sketch with the color reproduction on p. 134.*

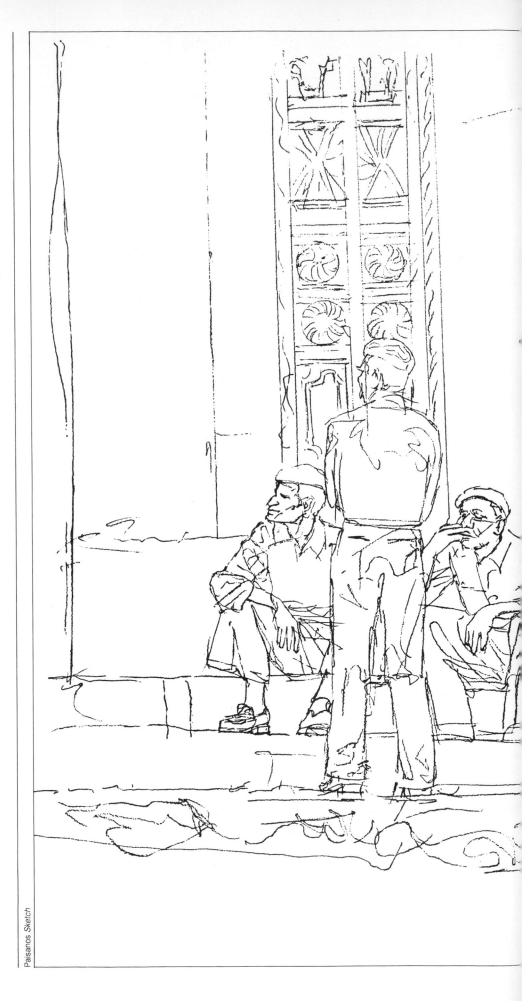

Paisanos Sketch

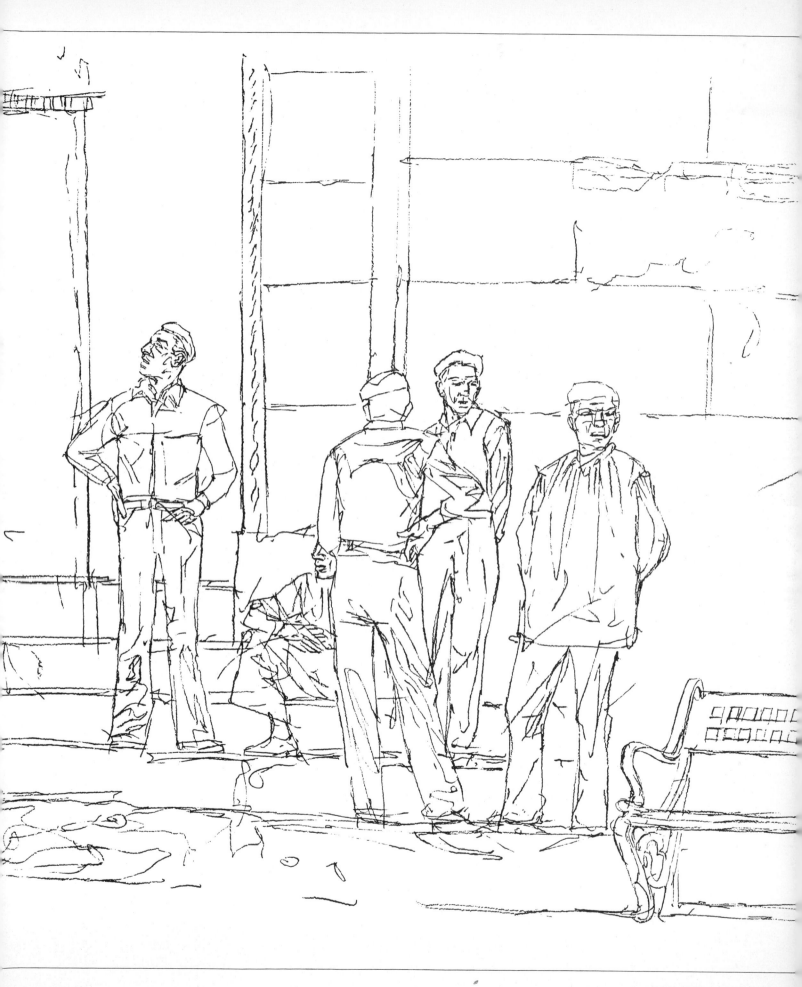

8·THE LANGUAGE OF COLOR

TERMINOLOGY

Color has three properties: *hue, value,* and *intensity.*

HUE. The name given to a color, such as, blue, red, green, etc.

VALUE. The degree of lightness or darkness of a color; also called *tone.*

INTENSITY. This refers to the degree of color saturation, the strength or relative weakness of a color. *Charged* color refers to the addition of extra pigment into a wash to heighten the color intensity or strengthen its value.

PRIMARY COLORS. Red, yellow, and blue. These colors cannot be produced by mixing other colors and so are considered primary colors. Primaries mix to produce secondaries.

SECONDARY COLORS. Orange (red mixed with yellow); green (yellow mixed with blue); and violet (red with blue). Together with the primaries, these produce the six *basic* colors.

TERTIARY COLORS. Mixtures of neighboring primary and secondary colors. See color wheel.

NEUTRAL COLORS. Grayed colors; subdued or "toned down" colors.

WARM COLORS. Hues from the yellow to red section of the color wheel as well as their neutral variations. Warm colors are said to "advance," or appear to come toward the viewer.

COOL COLORS. Hues from the green to violet section of the color wheel. Cool colors are said to "recede," or move back from the viewer.

COMPLEMENTARY COLORS. Hues opposite each other on the color wheel; for example, red and green, blue and orange, or yellow and violet. Placed side by side, they are dramatic complements to each other.

HARMONIOUS COLORS, also called analogous, are colors that are adjacent to each other on the color wheel. For example: yellow, orange, yellow ochre, and burnt sienna are considered harmonious. A complementary color accent stands out sharply within a picture with an overall harmonious color scheme.

MONOCHROME. A color scheme made up of different values of the same color; seen often in sepia or browns.

DISCORD. An inharmonious color. An example of colors that would clash to produce discord are a light violet set next to an orange that is darker in tone. If the colors are separated by black or white, or if they're neutralized, they can create vibrant effects.

Although discordant colors can be jarring, in certain color relationships, they can be used in very dramatic ways. (Consider the dark green leaf seen against a pale violet sky.) In small areas, they can produce a dynamic tension that can animate an otherwise dull area.

Discord can be effective. But use it as sparingly as a master chef uses a pungent spice.

THREE-COLOR PALETTE. Called a limited palette; usually using the three primaries. Watercolorists use this technique at times, feeling that the color scheme will be unified (considering that all secondary, tertiary, and neutralized colors are mixed from the primaries).

COLOR INFLUENCE. Sometimes called "keyed color." All color is influenced by neighboring colors. Suppose you have an area of orange that appears too red. If you place an even more intense red near it, the orange will appear more yellow. *Values* adjust according to the same rule. If you want a value to appear darker, place a lighter value near it.

Fox Hunt in Dorset *22x30 inches*

The sweeping landscape gives the sensation of boundless space for the figures and foxhounds to go about their adventure. Spirited animals appear to be attentive to activity beyond the borders of the scene and the rich colors suggest the joy of the morning.

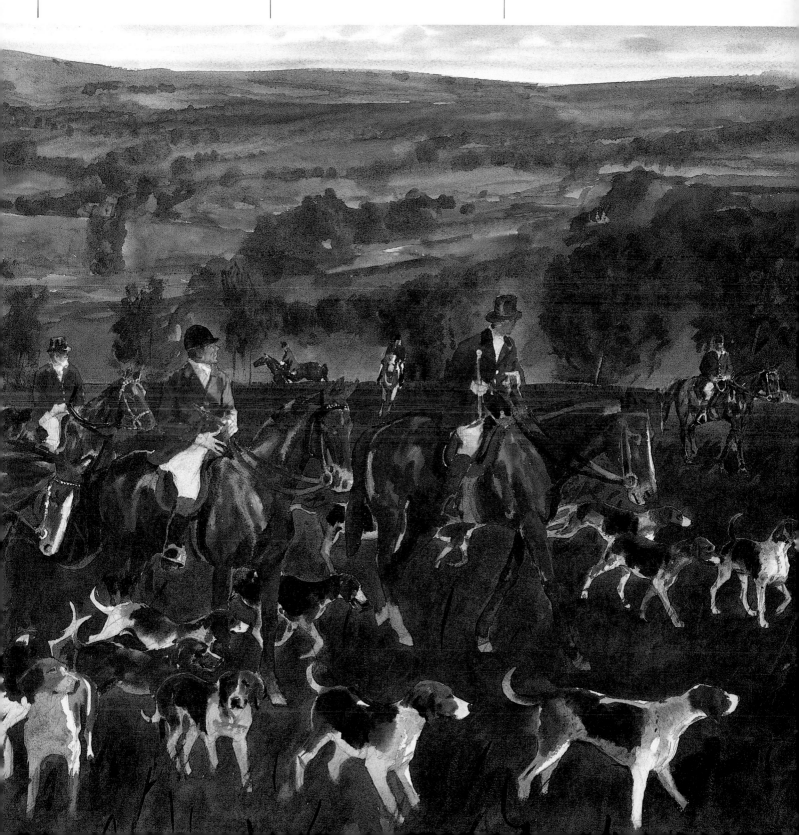

LOCAL COLOR. The color of an object as it would appear under a neutral light, such as a completely overcast day. A red object, for instance, that is struck by sunlight will appear *warm* in color, as if some orange had been added to the red. If the same red object is lighted by a window facing north (or a bluish fluorescent light) it will be slightly bluish and *cooler* in color.

CLEAN COLOR MIXING. The more colors you mix together, the more neutral or subdued the color becomes. The freshest, brightest colors are those that result from the least amount of mixing. Water should be relatively clean, although I must admit I put off changing the water for some time when I am engrossed in a painting.

Generally, I don't subscribe to limited palettes for normal painting. However, the beginner will benefit from practice in mixing from the three basic colors. Pure color, or color from the tube, can be neutralized most directly by mixing with its complement. Lampblack, burnt sienna, and yellow ochre are also excellent for neutralizing colors.

COLOR SWATCHES. In the course of a painting I test my color on a scrap sheet of paper before applying a wash to the painting surface. I use the same type of paper to test the color as that of the painting. These color swatches are useful in ways other than assessing the immediate tone or hue. They also can be cut out later and placed over unpainted shapes or areas in the watercolor to guide you in your choice of color and tone before you apply paint to the paper.

PINHOLES. The sizing, especially on unstretched watercolor paper, will sometimes produce a multitude of tiny dots called *pinholes*. Certain colors are more susceptible to this effect than others, for example, lampblack used as a gray, and Prussian blue. Charge a little more pigment into the problem areas before the wash dries. Predampening also will help prevent pinholing.

PALETTE

Your selection of colors is referred to as your palette. Squeeze out a generous amount of pigment at the start. A difficulty beginners often have is trying to get a full-bodied wash from a paltry amount of pigment, or, worse still, from a small dried lump of last week's pigment. Lay out fresh color each time—and be generous!

The basic palette should include:
warm and cool shades of yellow, red, blue, and green earth colors (like yellow ochre and burnt sienna)
black

COLOR WHEEL

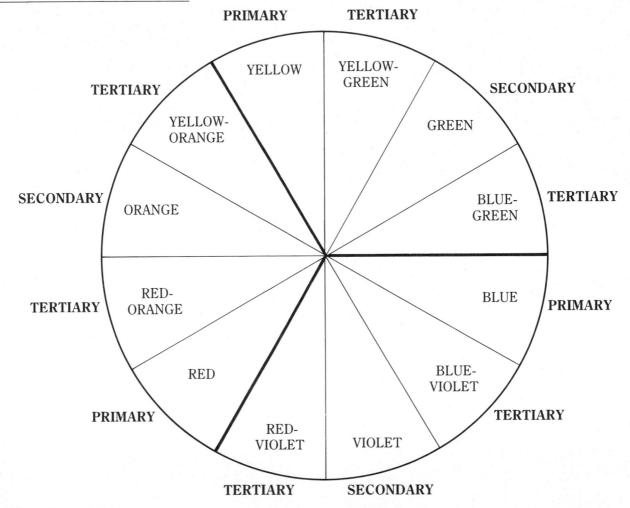

The palette you choose should be based on this basic palette and your own experimentation. Be flexible at first, and through the years you will develop a palette that best suits your needs.

This is my palette at the present time:

YELLOWS—*Winsor yellow*—a cool yellow
cadmium yellow, medium—a warm color. A good basic medium yellow
ORANGE—*cadmium orange*—an indispensable, clear orange; invaluable for bright notes
REDS—*cadmium red, medium*—for red-orange coloration and warm brown mixtures
scarlet lake—good all-purpose red; beautiful in its pure intensity as an accent
alizarin crimson—a cool red and indispensable for clear violet mixtures
permanent rose—creates a pink unattainable from any other pigment (I use this only occasionally.)
VIOLET—*thalo violet*—excellent, brilliant violet
BLUES—*ultramarine blue*—indispensable, basic blue; tends toward violet
thalo blue—excellent greenish blue from which *all* varieties of greens can be mixed; a staining and penetrating color
manganese blue—aqua, granular color
GREEN—*thalo green*—excellent, powerful base green
BROWN—*burnt sienna*—indispensable, base brown
BLACK—*lampblack*—a warm black; I use it as a base mixture with other colors for neutralizing and for grays.
CHINESE WHITE—Mix white on a separate palette.

ORDER OF THE PALETTE. I lay out fresh colors each time I begin painting. I always use the same sequence of pigments around the palette. I start from the yellow side of the color spectrum, through to the orange - brown - red - violet and end up with blue and green. I use a muffin tin so I have middle areas left, on which I place lampblack and yellow ochre.

Use a logical order and stick to it so that, even in fading light of sunset, you'll instinctively dab the right colors. A colleague of mine has so adjusted to the order of his palette that he can paint in moonlight.

THE PERMANENCE OF WATERCOLORS

There are many other popular colors besides those listed in the first chapter, but a number of them are not generally recognized as permanent (speaking in terms of significant fading in fifty years). Ask yourself, "Am I willing to spend my time and effort to paint the best work I can at this time, then not have my work last?" The permanency of your picture may not be important to you in your beginning efforts, but as you grow and improve as an artist you will want to buy high quality paper, brushes, and permanent pigments.

Watercolors are as permanent as any other medium so long as care is taken to systematically construct permanency into a painting from start to finish.

If permanent pigments are used on a neutral pH, 100% rag paper, the surface will remain white and will not yellow in time.

When your painting is framed, it should be backed with acid-free rag board so that the watercolor's back surface is not in contact with any cardboard. This will prevent *foxing,* or *brownspotting,* of the painting through the years. If the watercolor is matted with a high-rag-content matboard that is also acid-free, unsightly brown rings will not be able to develop around the painting.

Secure the watercolor to its mat at the top by two hinges of self-adhesive *cloth tape* (not gummed tape, masking tape, paper tape, Scotch tape, etc., all of which contain glue and brown dyes that would discolor the work in time). Professional framers will tell you that two hinges are used instead of three or more, so that if a stiff jolt were accidentally applied to the framed watercolor, the tape—not the painting—would tear. Then, seal it from dust and dirt in its frame, with glass or Plexiglas. (Plexiglas will not break, but can be scratched. I use Plexiglas for large work because glass tends to be quite heavy on 30- by 40-inch watercolors.)

If you take these precautions, your watercolor will outlast many an oil or pastel and remain faithful, in color and tone, to the day it was completed.

It is the responsibility of the professional who wishes to sell the watercolor to protect himself, the buyer, the dealer, and the framer from liability by protecting the watercolor from impermanence.

PROPERTIES OF PAINT

OPACITY. Some pigments have opaque characteristics. These include: cadmium orange; cadmium yellow (medium, deep); cadmium scarlet; cadmium reds; cobalt blue and violet; cerulean blue; manganese blue (when used thickly); terre verte; yellow ochre; raw umber; Davy's gray.
SEDIMENTARY. Some pigments have a granular quality:
Slightly granular: cadmium scarlet; ultramarine, cobalt, cerulean blue; viridian, Hooker's green; raw sienna; burnt sienna; raw umber; Payne's gray.
Very granular: manganese; terre verte; yellow ochre; Davy's gray.
TRANSPARENT. Pigments displaying a translucent quality are: Winsor yellow, lemon yellow; gamboge; scarlet lake. thalo red, violet; permanent rose; alizarin crimson; ultramarine blue; manganese blue; thalo blue, green; viridian; Hooker's green; raw sienna, burnt

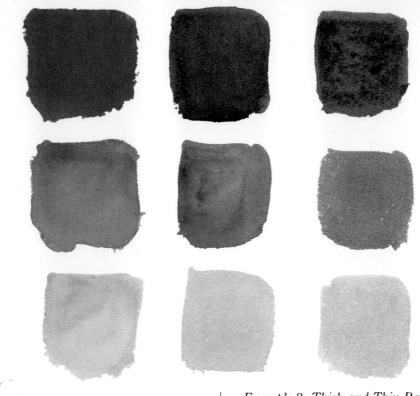

◀ *Example 1: Simple Color Values.*
Colors in watercolor are lightened in tone or value by adding water. In these three colors, the darker hues are applied with more pigment and less water. The middle tone has a little water added to thin the pigment, and the lightest tone is applied with more water than pigment. (Examples used are cadmium orange, thalo violet, and thalo green.)

Example 2: Thick and Thin Paint.
1. Burnt sienna and yellow ochre
2. Cadmium orange and cadmium red
3. Ultramarine blue and thalo violet
4. Manganese blue and cadmium yellow light
The dark sides of these swatches represent pigment applied with virtually no water and then each is thinned, *moving toward the center with increasing amounts of water. The natural opacity of the cadmiums and the manganese blue is apparent in the thick pigment at the ends of the swatches. I use pure pigment on dry or damp paper for its dazzling effects. It is a nice contrast of tone, purity of color, and texture to the thinner transparent washes in the middle area of this example.*

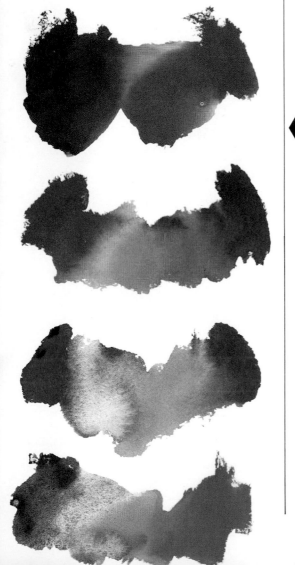

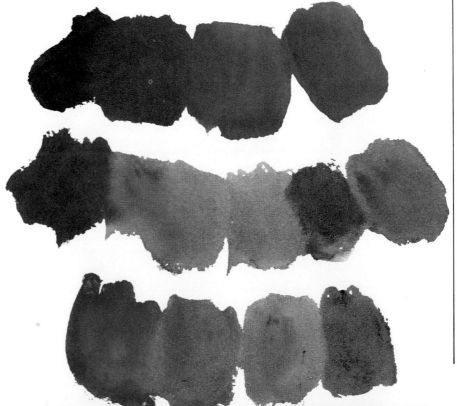

Examples 4 and 5: Mixing Grays and Neutral Browns. ▶

No mixing is necessary for grays if you add water to black, but colorful grays and interesting neutral hues can enrich a watercolor immensely.

Many different color combinations can be mixed together to produce grays and browns. The examples here are typical of my procedure:

Example 4
(1) Ultramarine blue
(2) Violet
(3) Yellow ochre
(4) Cadmium red
(5) Neutral brown

All are brushed separately onto the paper then dragged to the center with the brush. The ochre and red are allowed to predominate in Example 4 so an interesting neutral brown results. In Example 5, the same hues are mixed, but a grayish hue (5a) is produced because the blues predominate.

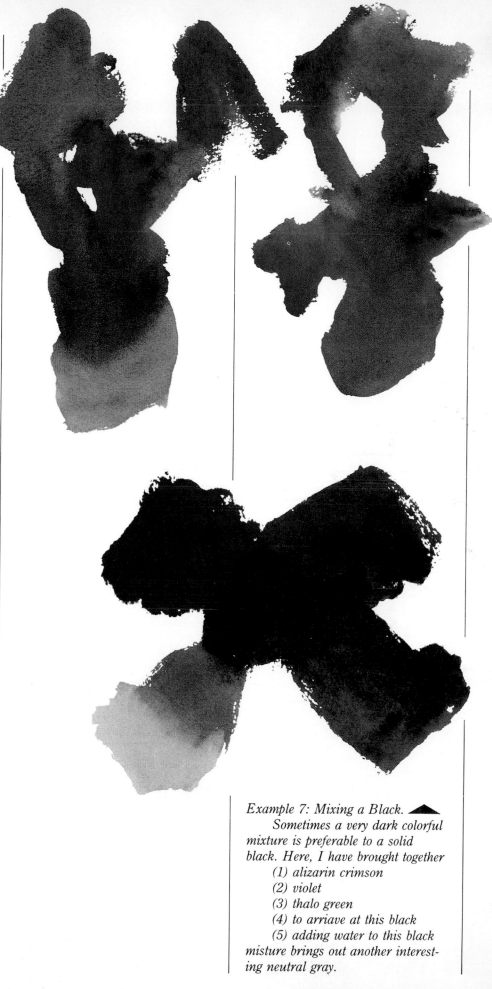

◀ *Example 3: Mixing Color Variations.*

1. Burnt sienna mixed with yellow ochre. On the left side the sienna color predominates, and on the right, the yellow ochre is the predominant color.

2. Cadmium red mixed with ultramarine blue. On the left side, the red mixture is the predominant hue; on the right, the blues predominate.

3. Cadmium orange mixed with thalo green. The left side shows a predominantly orange tendency. On the right, the green is the predominant color.

Example 7: Mixing a Black. ▲

Sometimes a very dark colorful mixture is preferable to a solid black. Here, I have brought together
(1) alizarin crimson
(2) violet
(3) thalo green
(4) to arriave at this black
(5) adding water to this black misture brings out another interesting neutral gray.

sienna; Payne's Gray, and black.
STAINING. Pigments that have a staining quality are: cadmium orange, reds; scarlet lake; all thalo colors; permanent rose.

THE TONALITY OF COLOR

Every color has the quality of lightness or darkness. We call this quality tone. Differences of tone are quite easy to see when the colors are not very strong or intense. For example, looking at tones made of burnt umber, or of sienna, it is quite clear which ones are the darkest, lightest, middle tones, and so on. However, if you place washes of bright red and green or blue and orange next to each other, the brilliance or intensity of the colors interferes with your ability to isolate, then focus on only the *lightness* or *darkness* of the color.

Squinting, or half closing your eyes as you compare one with the other, will help you see the proper tone. As you move your eye across the border between a bright red and a bright green, look *only* for the difference in lightness or darkness.

Another helpful device in judging tones is a black and white value scale. Place the bright red tone against the gray tone that seems to match it (for lightness or darkness) on the value scale. Squint *very hard* and look only for tone (lightness and darkness). Try to ignore the *hue,* that is, the redness or greenness of the wash. It's as if you were looking at the full *color* picture of *Sunshower* on page 38, and seeing it as if it were the *black and white* on page 49. Notice the intense red at the shins of the model, compared with the same area in the black and white reproduction.

With practice, you'll soon be able to recognize the tones or values of all the colors in the scene before you, and control them in your painting.

Watercolor dries slightly lighter than it first appears when applied. Many pale or washed-out watercolors can be attributed to

this subtle variance. If you find that you are not achieving strong values, try charging a little more pigment into your washes to counteract this tendency.

DENSITY AND TRANSLUCENCE. Using the natural opaque characteristics of colors such as yellow ochre and cadmium orange, mixed generously into *dark* washes, will give a certain density to the wash that adds solidity to the things you paint. Conversely, yellow ochre and cadmium orange, thinned out to a light wash, produce highly translucent effects that give a light, airy quality to things. When the two, density and translucence, are used in the same watercolor, they can create a strong three-dimensional effect. The pots in the immediate foreground in *Moroccan Pots,* (page 50), appear to be surrounded with light and air, while the pots in the

background seem to form a solid, weighty mass. Undoubtedly, the strong light and dark contrast contributes to the distinction of forms, but the luminous quality owes a debt to this difference of dense and translucent pigments.

Sunshower—see color reproduction on p. 38.

1. *Opacity—cadmium orange and red is thickly charged here into a damp base wash of burnt sienna/ lampblack.*
2. *Sedimentary—manganese and viridian/burnt sienna.*
3. *Transparent—pale washes of crimson, ochre, and violet.*
4. *Staining—winsor, or thalo blue/ greens.*
5. *Variegated wash—p. 51*
6. *Discord—this was explained on p. 42.*

Sunshower Sketch

Sunshower 30x22 inches

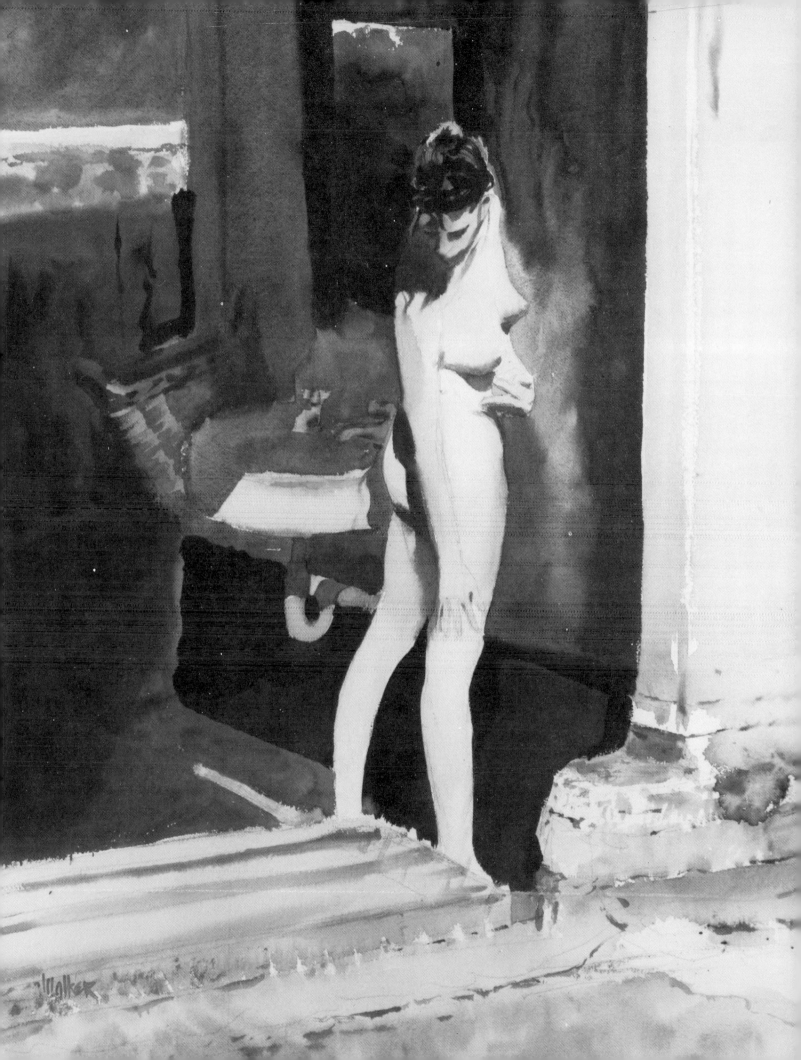

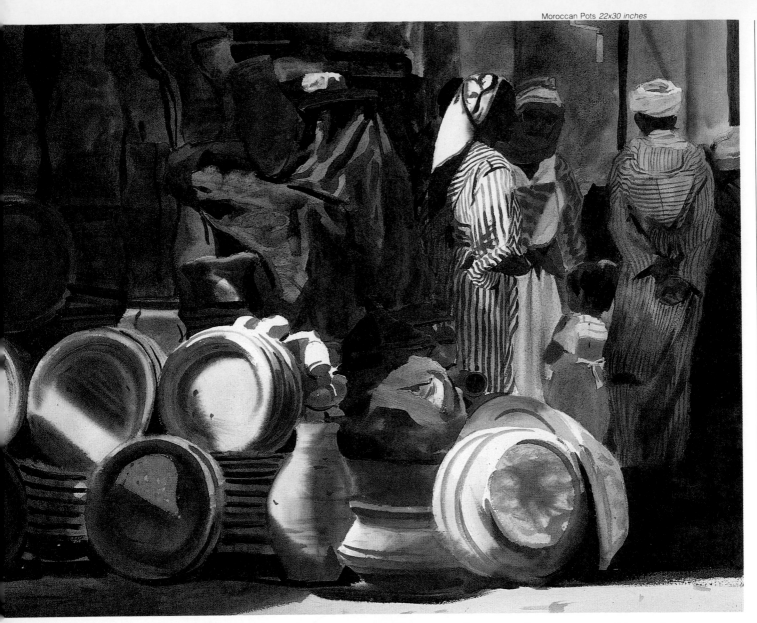

This watercolor is typical of my direct approach, where I complete each part as I go along, with no overlaid washes. I started the watercolor at the top right and, finishing as I went along, worked counterclockwise around the figures. Then, having established the background, I could more clearly determine what lights, darks, and color relationships I needed within the figures that are so important to the final statement.

Do you agree that adding the little girl makes a rather unfamiliar culture seem universal?

PROCEDURE FOR *MOROCCAN POTS*. Two full days were spent on the drawing to assure a workable composition. The second day was particularly helpful because I could look at my work with a fresh eye and refine every area to a higher level. The actual painting took less time than one might think, compared with the amount of preliminary work. Working carefully and intently on the drawing makes me familiar and confident with the subject when it is time to paint.

I mention this because by now you must realize that watercolor is a bold, demanding medium. At times it's unpredictable, so your mental preparation is always important to carry the painting through

to a successful completion.

I started by prewetting the upper right background and blended varied amounts of burnt sienna, lampblack, yellow ochre, and blues and violets into the damp area surrounding the figures. This mixing was more or less intuitive—I can't give you the exact mixture proportions I used. Such information is to be uncovered by studying each section of the painting.

I completed the pots within the shaded area before laying in the darks around them. I mixed yellow ochre into the brown-violet pots to give more opaque body to the dark wash. Burnt sienna, cadmium orange, and violet provided the base pot color. I worked from top to bottom on dry paper. After

laying in the highlights in areas of these dark pots, I mixed the same pigments darker, by using less water, and overlaid a middle tone into the damp washes. At this time I added some red and red-browns into some of the pots to brighten the color scheme.

Next I painted the drapery in the center. It became apparent that the pure blue area appeared isolated and discordant. To overcome this I introduced brown into the still damp, light areas of the cloth. This united the blue tarpaulin with the rest of the picture.

I then prewet the light-struck pots in the foreground and worked wet-in-wet to create a soft, light, translucent effect that contrasts with the dark, dense background. Into the damp foreground I brushed a series of colors (consisting of more water than pigment). First yellow ochre, then cadmium orange, and then pale violet were each placed side by side and allowed to mingle freely. All these were of the same tone and constituted the lightest areas of the foreground, over which the halftone mixtures were added. The halftone mixtures consisted of burnt sienna, thalo violet, and yellow ochre. The lighter areas are predominantly yellow ochre, the darker areas have larger portions of burnt sienna and thalo violet. Then, using a No. 8 brush, I delineated the contours and deeper shadows between the pots with a thick burnt sienna, violet, and lampblack mixture (equal parts sienna and violet with just a small touch of lampblack).

I used the brightest colors and the strongest contrast of light and dark in the figures; they are the focal point of the painting. I predampened the garments and whisked cast shadows into this area. While this was drying, I indicated folds by superimposing strokes of a darker tone. I then drew the lines and designs of the *djellabas* (the long robe-like garments) over all this, allowing some of the lines to merge and fuse into their base wash, and others to remain crisp and hard-edged.

I used a rich crimson and burnt sienna mixture for the lightest fleshtones—adding violet to the mixture for the darker shadows of the face, arms, and hands.

At this point there were many areas between the major objects of interest that were unpainted white paper. This provided an opportunity to use these sections to modify the existing color and tone. For example, if a painting appears to be too dark, I might choose to keep bits and pieces of unpainted areas on the light side as a balance. In this case, the light areas created by the pots and figures seem to provide a good balance of light and dark within the picture. Textural effects, further delineation of form, and reinforcement of shapes made up the final stage of the painting.

Variegated Wash. This is a term I coined to describe the effect resulting from a succession of different pools of color placed side by side and allowed to merge and blend. The effect is that of a mottled variance of color and tone.
To paint a variegated wash:

1. *Place pools of the primary colors—red, blue, and yellow—on dry paper. The colors should touch each other so they can blend.*

2. *With the brush, push these colors into each other, neutralizing them somewhat. Use the complement of one color to subdue another. Mix these until the desired intensity or grayness is reached.*

3. *Continued mixing will neutralize, or gray, the colors still further. If the mixture becomes too red, push a little yellow and blue into the red areas. The final result of the variegated wash depends on the effect you want. If you wish to leave bright notes of color as I have in* Sunshower, *then less mixing is needed; a more neutralized version would require more mixing.*

Color plate Variegated Wash

9·COMPOSITION

TERMINOLOGY

PICTURE SPACE. The area within the four borders of the picture.

PICTURE PLANE. The pictorial surface on which you draw or paint. It is on this plane or surface that you create the *illusion* of three-dimensional objects or of three-dimensional space by the use of light and shade, changes in color and tone, perspective, etc.

OBSERVER. The viewer of the scene or painting.

HORIZON. In realistic or representational painting, an imaginary or actual horizontal line across the picture space at the eye level of the artist.

PERSPECTIVE. The illusion that objects and spaces appear to diminish in size with distance. All objects within the picture plane are subject to the rules of perspective; however, in art there is some leeway. Perspective rules do not have to be followed strictly as long as the picture retains visual integrity. For example, one of the charms of *Primitive* painting might be a lack of proper perspective. Artistic license allows us some discretion in changing things around to suit the design and pictorial emphasis.

DESIGN AND COMPOSITION. The arrangement of the elements within the picture space to produce an interesting, unified whole. Seldom is a real life scene so perfect that it cannot be made more interesting by moving things around, changing sizes, tones, color, etc. Seeking the maximum visual effect is the job of the artist. Whether you choose to paint an orderly composition or the extreme instance of a spontaneous assemblage of objects, the arrangement of elements in your picture should always appear to have a purpose and be under control.

CENTER-OF-INTEREST EXCEPTIONS

The center of interest is the principal object or objects of importance within the picture. The observer's eye, after traveling over the whole picture, comes to rest or focuses on the center of interest. *Spanish Window in Winter Light* is one exception to the rule.

An object or objects placed close to the edges of a painting can be unsettling and appear unbalanced. The theory is that such a placement pulls the eye *out* of the picture rather than guiding it inward. However, what is true in most cases can be untrue in others. In this painting, half the statement is the white wall that supports and gives relief to the window grille. This arrangement is an exception to the usual rule and should serve to remind you than an unusual angle or placement, if not overly used, can add intriguing character to your paintings.

Essentially, this composition works because the *path of vision* is redirected towards the center by virtue of the crossbars that move left and downward, and the protrusion of the lower part of the grille, which points inward. (The path of vision is the direction the eye of the observer travels within the composition. The path of vision is guided by linear and tonal rhythms throughout a painting, or by color. The dark, concentric window adds another daring aspect to this composition. There are enough surrounding darks to justify its presence.

My exceptions to rules of composition should not be confused with objections to the rules. Rules for composition should be understood and used as guides for organizing elements effectively within the picture plane.

DESIGN BY ADDING OR ELIMINATING ELEMENTS

It is generally understood that a long, vertical line or lines near the center of the painting will appear to "cut" the painting in half and separate it into two disconcerting parts. This is certainly true in most cases. There are, however, ways of remedying such a condition.

The sense of three-dimensional depth or distance is created by overlapping the smaller figures of the market people with the larger forms of the nearby horses and riders.

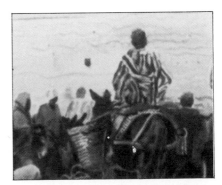

The recession into the picture plane is enhanced by the overlapping forms of the near riders over the distant line of the market people.

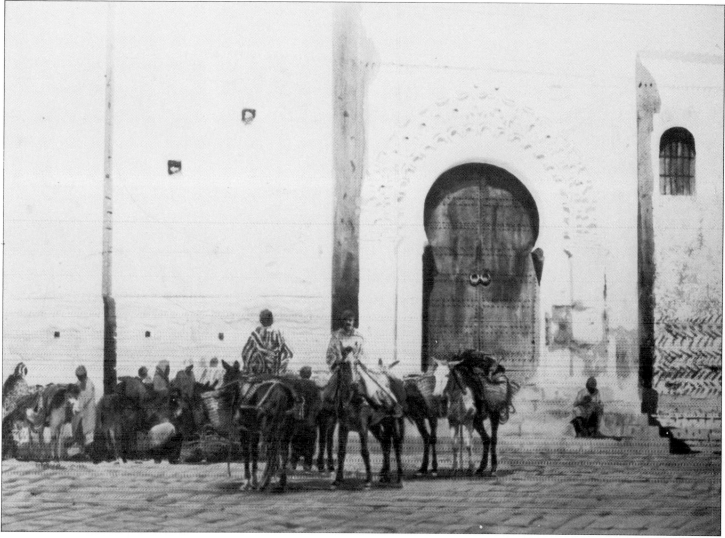

There were two vertical wall recessions (center and right), casting two vertical lines of shadow through the right half of the scene. I painted it the way I saw it but realized almost immediately that the activity was unbalanced—thrown to the right of the picture.

I added the vertical jog in the wall at the left to balance the picture and solve the problem.

The shallow depth of the architectural undercutting and resultant shadows of the arched frieze provide a delicate relief to the flat, massive wall. The bricks add textural interest to the ground plane and add to the illusion of depth as they diminish in size toward the wall. Although carefully planned, the bricks are applied with quick, spontaneous strokes into a damp base wash. This softens the lines used to describe them and offers an interesting contrast to the crisp, sharp details in the frieze and doorway.

In Spanish Window, *simplicity, stillness, and light are the keynotes, emphasized by the slightly mottled, almost monochromatic plane of the facing wall, enlivened by and contrasted with the busy flanking details of the window grille, the grille's shadow, the roof tiles, and the small round window. Flowers add subtle color.*

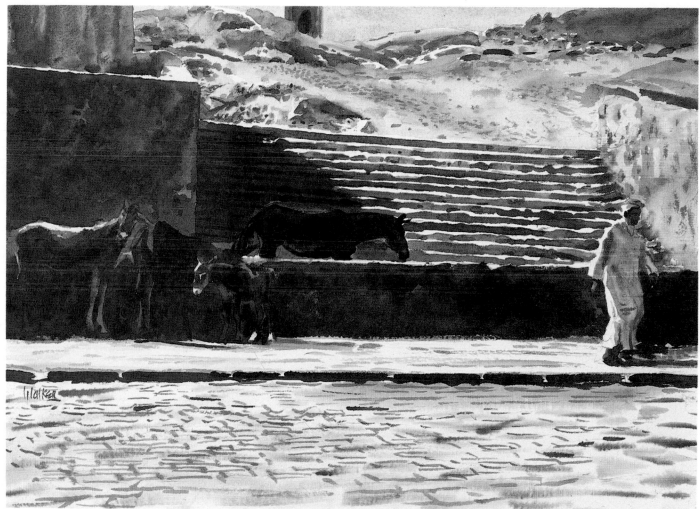

Steps in Morocco *14x22 inches*

Flanking points of interest are unusual in composition. The illuminated steps are the primary center of interest in this picture. In this rare instance, the animals and figures provide secondary interest on the edges of the picture space.

I preserved the white of the steps to infuse the glare of a desert brilliance into the watercolor. The play of yellows on the dampened white paper insured soft variance of tone. Together with the strong shadows they pitch the watercolor into a high, sunlit key.

French Market *22x30 inches*

The dark shapes of the shuttered windows lead down into the picture, while the striped awning ties together the basically light upper half of the painting with the dark lower half.

The scene that inspired this watercolor required many additions for the sake of interest and continuity, as well as some elimination of distracting elements.

There was a confusion of labels on the crates which I omitted in order to bring out the simple elegance of the light and shadow pattern of the boxes. I also subtracted intruding wires that complicated the scene. There was an uninteresting horizontal slab above the awning, so I added bas-relief cats playing with a ball. (I actually saw this motif elsewhere in Paris, but it fit well here.) And I added wooden shutters to replace the stark windowpanes in the real facade.

The rows of bottles were also my addition to the composition, replacing an otherwise dark, dull window. They provide a balance to the lettering on the left by adding a series of light notes. The rhythmic repetition of the bottles also ties in with the horizontal and vertical lines repeated throughout the painting. By adding venetian blinds, I continued the theme.

There is a modified symmetry in this facade that could have been too static. To provide the necessary variety, I added the triangular sign. Irregular shapes, such as the wrought-iron tracery in the balcony, the bas-relief, and the flowers, can also be a welcome variation in a composition dominated by horizontal and vertical lines like this.

I chose a diagonal light source to increase the depth and contours of the facade, not by outline, but by changes in tone.

Contributing to the organized structure of values in this watercolor is the "positive" (or light) upper half and "negative" (or dark) tonality of the lower half. This division of the composition could have caused a split of the top and bottom were it not for the awning, which forms a transition between the halves.

PROCEDURE FOR *FRENCH MARKET*. I used 140-pound cold-pressed paper and painted on the dry paper. The light tones were placed in first; form and shape were built up by overlaying washes into the damp undertone. I used only one or two layers of tone for the overlays to keep the effect clear and simple. There is surprisingly little detail in this seemingly complicated painting.

Because the subject required a considerable amount of careful drawing, I became better acquainted with all the forms than if I had started painting with only a loose drawing. This allowed me to use the brush with a sure hand which contributes to the unlabored look of the final rendering.

The dark shapes of the shuttered windows lead the viewer's eye down into the picture, while the striped awning ties together the basically light upper half of the painting with the dark lower half.

Bridge scenes often suggest a vertical picture format. Here I have repeated the vertical theme in the cedar trees, and filled the picture space with landscape by using a high horizon. There is an interlacing of diagonals in the running wall, the road on the hill, and the bridge walkway, that provides a re-lief from the dominant vertical shapes in the composition. The rays of the sun striking the bridge create light shapes that contrast strongly against the dark shadows.

The small figures on the bridge reveal the warmth of living things amidst the architectural framework. They also provide a sense of scale.

PROCEDURE FOR *TWO BROTHERS*. I sponged the sky lightly and brushed an ochre and ultramarine blue mixture (approximately two parts blue to one ochre) into the damp area with wide sweeps of the brush. The distant hills of darker mixtures of the same colors were brushed in with a No. 8 brush. I then darkened the tones and sharpened detail as I moved downward, indicating various green, olive, and yellowish flat planes of color for the fields. When these areas were almost dry, I modulated deep greens into tree shapes. I varied the sizes of the trees, but kept the same tree type throughout. Only two basic tones were needed to indicate tree forms, a midtone and a dark.

During the drying time for these fields and trees, I skipped to the stone and brick surfaces. I broadly washed in warm and cool versions of brownish-gray in a very light base color across each house. The cool areas of the stone surfaces consisted of two parts blue to about one part ochre and one part sienna. The warm areas were predominantly sienna, with small amounts of ochre and blue. The white houses were dampened with clear water; then this entire band of washes was brought down into the cobblestone street area. Working quickly but carefully, I drew the bricks and stone in with a No. 4 brush.

A dryish mixture of red-brown was used for the cottage brickwork, and ultramarine blue was added, along with more water, to create the cobblestones.

I worked quickly in order to catch the damp washes and blur the edges. This is a *controlled* wet-in-wet technique.

As the street wash dried, I realized I needed more interest in the foreground. After drawing the figures, I decided to cast a foreground shadow over the street and make the English lads appear as dark shadow shapes against the light structures. To do this, I re-wet the street and brushed in new stone patterns. As I brought the wash down, I added lampblack and burnt sienna in dryish dark strokes to grade the wash. After this dried, I put in the detailed texture of the stones with a No. 7 brush. Then, using the brush, I carefully drew the window panes, shutters, and doors, picking values that served to bring out each particular house.

I felt that the chimneys and the two boys were features of the painting, as well as the roofs. I painted them in last so I could use values and colors in the rest of the picture to see just how much tonal contrast or color strength I needed to make them stand out. I took extreme care to lay a unique base color for each roof, and I varied the brushstrokes and color to capture the individual character of each roof.

The roof mixtures are varied in tone as well as in color. For instance, in the roof to the far left I placed cadmium red (neutralized with just a touch of ultramarine blue) in patches the size of the shingles that I wanted to stand out. Next to these I placed a blue-gray of the same tone (quickly, so as to catch the damp edges and allow a soft blended effect). The blue was grayed with a slight touch of cadmium red. More water than pigment was used in the mixing of these tones, bringing the naturally dark blue to a tone similar to that of the red.

A more random difference in tone was used in the other roofs. The darker areas were mixed (two parts to one) with a predominance of burnt sienna with some ultramarine, or a predominance of ultramarine with some burnt sienna.

The second door from the left was painted blue as an accent. The chimneys were carefully indicated with enough detail to preserve their distinguishing characteristics. Strong light and shade separated them from the background.

This Shaftesbury, England, hillside required an attention to detail because of its uniqueness. The adjustments I made in designing this were mostly exaggerations of what was there, plus the addition of the two children.

I elongated the houses, raised the already steep pitch of the roofs, and extended the tall chimneys to an even higher level. By thinning all the structures very slightly, I was able to fit in another unique-looking house at the bottom of the hill. The vertical extensions provided a counter direction to the horizontal contours of the rolling hills.

The road is also the foreground; it pulls our eye strongly into the picture. The foreground shadow increases the intensity of light on the main subjects. (Half close your eyes, and a stagelight effect is more noticeable.)

I added two figures walking away to lead your eye into the scene, and subdued their detail by casting them in shadow. I accentuated the differences in surface textures of the tile, slate, shingle, and thatched roofs, as well as the weathered plaster, brick, and stone of the houses. The illusion of depth was enhanced by these warm colors contrasted with the distant hills fading out into cool "receding" colors of green and blue.

Rhythm, or the sense of movement, is created here by a strong diagonal pull from the top to the bottom of the hill, and the zigzagging trees in the distance. The exaggerated swagger of the two lads also provides movement, as well as human interest.

I sponged the sky lightly and brushed an ochre and ultramarine blue mixture (approximately two parts blue to one ochre) into the damp area with wide sweeps of the brush. The distant hills of darker mixtures of the same colors were brushed in with a No. 8 brush.

I then darkened the tones and sharpened detail as I moved downward, indicating various green, olive, and yellowish flat planes of color for the fields.

Only two basic tones were needed to indicate tree forms, a midtone and a dark.

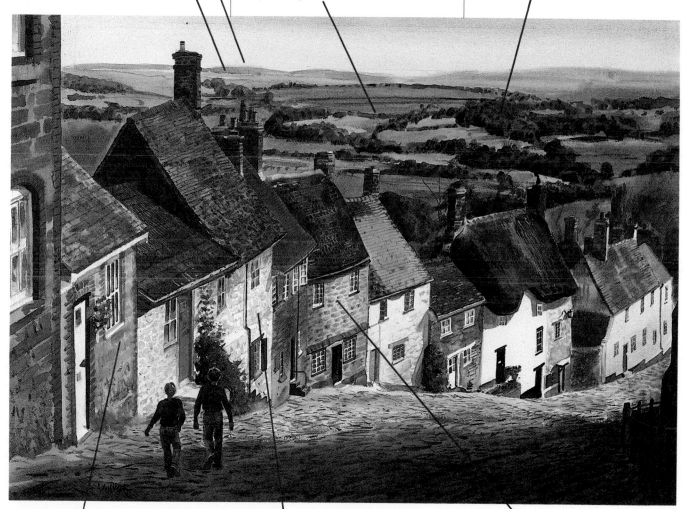

I broadly washed in warm and cool versions of brownish-gray in a very light base color across each house.

The cool areas of the stone surfaces consisted of two parts blue to about one part ochre and one part sienna.

The warm areas were predominantly sienna, with small amounts of ochre and blue.

Two Brothers 22x30 inches

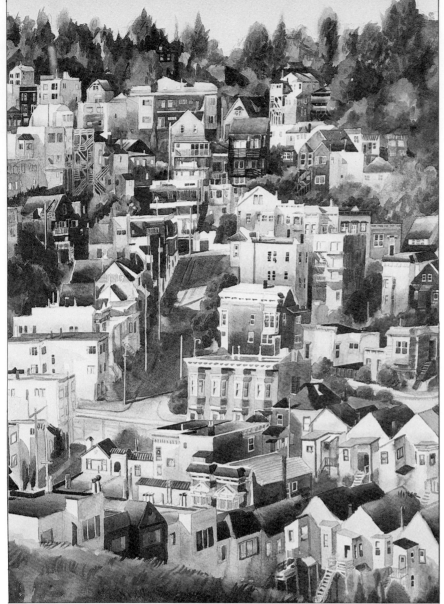

Upper Market: San Francisco *30x22 inches*

HILLSIDE SERIES

All the hillside series were painted entirely on location. They took a few days to complete. I would go back each day to the same spot, at the same time of day, to catch similar light. At times, if the weather changed, I would alter those areas that were favorably affected. For instance, an overcast day might deepen the tone of the trees and so I might use that lighting, but use a bright, clear morning light on the houses.

These pictures have an all-over pattern formed by the many buildings that fill the hillside.

The white streets and roofs create a path of vision through the colorful network of buildings. The crisp, hard edges of the houses contrast effectively with the softer edges of the wet-in-wet trees and foliage. I usually leave cars out of hillside watercolors because they add another element of confusion to an already busy design.

DEVELOPING A SERIES

DIFFERENT VERSIONS OF THE SAME THEME. Often an artist will explore one theme or subject at length by painting different versions of it. A subject that excites you is worth developing by seeing and painting a single theme from different viewpoints. It is part of an artist's creative process to develop those themes in different ways.

If you feel you still have something to express about a given subject, then you should continue to develop it. Having said this, I hasten to add that there is a time to move on. Change is also essential to artistic growth.

I extended the hill vertically to emphasize or exaggerate its height. Consequently, it fills almost all of the picture space with colorful shapes and planes. The simple sky provides relief from the contrasting complexity of the hill.

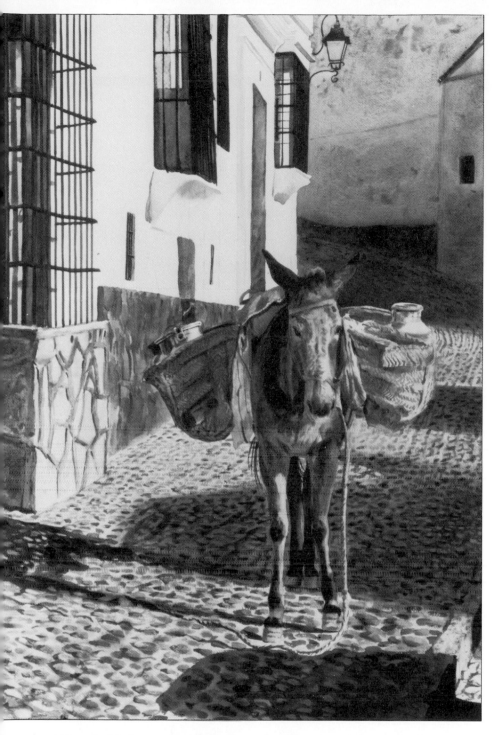

UNCONVENTIONAL COMPOSITION TO ENLIVEN THE THEME. *Milk Delivery:* Consider the unusual composition of this watercolor. The vertical design relies on strong light effects, and the attention to surface differences emphasizes the detail.

Small but clear and decisive preliminary sketches are very useful in solving cases such as this. They show you whether the placement of elements within the picture will be interesting and effective.

Without the *counter movement* of the figure, the placement of the burro might not have worked. Although the burro looks down and left, (guiding our eye out of the picture), this movement is canceled by the standing figure, which looks back toward the right and guides the observer's eye back into the painting.

Notice that everything is centered. The details occurring along the four sides of the painting are balanced by the large, solidly dark shape of the doorway. The sign, window grille, and lantern are similar in weight and volume to maintain balance within the picture.

The large dark square in the center would not have worked if the shirt sleeve was not a brilliant white. I experimented by cutting out different colors painted on separate sheets of paper in the shape of the sleeve and placed them over the figure to assess the possible effects. It soon became apparent that the deep recess of the door needed a brilliant light to serve as an effective foil against the dark background.

Although this burro takes up half the foreground, the bold elements of the background hold their own with the main character. This is a painting as much about the morning light and textures as it is about the delivery of milk in Spain.

Morning's Work to be Done *30x22 inches*

PROCEDURE FOR *MORNING'S WORK TO BE DONE* AND *MILK DELIVERY*. In each of these milk delivery watercolors, I painted the background first, and I worked light to dark. The burros were painted last to fit more effectively into the scheme. (After the background darks and lights are completed, then the main subject may be brought out by contrasting tones against this background.)

I reserved the white of the paper by simply painting around it. I mixed warm and cool colors on the paper—not on the palette—to produce blended and mingled striations in the stone and stucco areas. The colors were allowed to neutralize in some areas and retain their purity in other areas. Mixtures included variants of ultramarine blue, manganese blue, burnt sienna, ochre, and pale versions of thalo violet and crimson.

I painted the base color for the baskets wet-in-wet, then used careful, descriptive brushwork to bring out the form and texture.

I used yellow ochre and burnt sienna with touches of cadmium orange, crimson, violet, and lampblack to paint the burro. The shadows were generally equal parts of burnt sienna and violet (and just a touch of lampblack), with mostly pigment and only a quick dip into the water before applying.

The lighter areas were accomplished by prewetting the area and brushing different colors into this. I usually start with yellow ochre, neutralizing it with touches of violet, adding touches of cadmium red here for a warm, beautiful effect, and cadmium orange there for a bright, glowing effect. Proportions of these colors are hard to gauge because you simply add touches into the damp wash and let them mingle, adding more where you

Using the same strategies of composition, contrast, hue and intensity can relate different views of similar subjects and make them a series.

visually decide there is a need. Just before all this has dried, I stroked in burnt sienna (more pigment than water), for textural effects.

The cobblestone pavement was painted in two stages: First, I used an undercoat of a neutral color indicating a half tone and a shadow tone. Then, while the area was still wet, I painted in stone textures. I reinforced the form of these stones by allowing them to cast subtle shadows in some cases. Note the change in the *Milk Delivery* cobblestones. On the left, the stones are dark on light. On the right, I have reversed the shading to light stones on a dark ground. This type of subtle variation in tone can enliven a dark passage of watercolor.

Overlapping forms does two things: it creates a sense of depth and unifies the elements in the painting. Here the burro overlaps the doorway and the figure (which is between them). Unusual placement of elements, such as this, helps create provocative design.

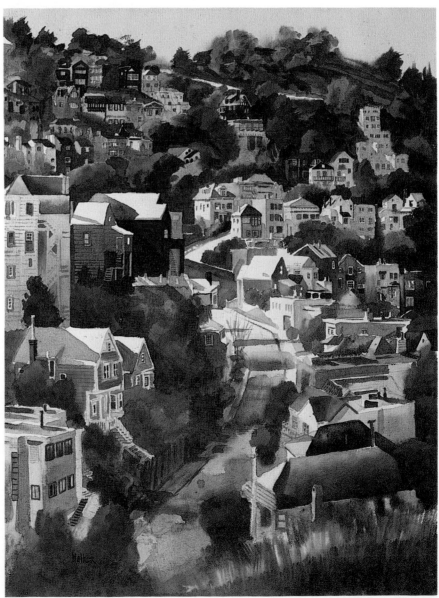

After the Rain *30x22 inches*

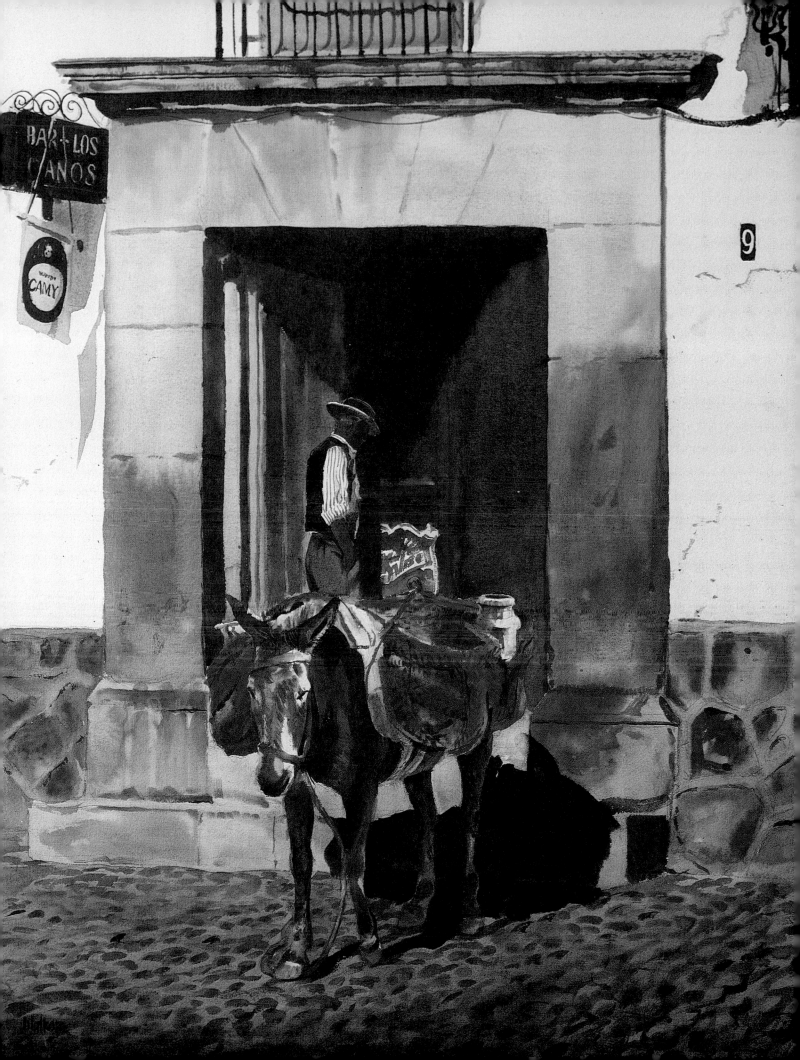

10·SPACE AND VOLUME

Scale, space, and volume are elements of proportion, depth, and weight within the picture plane. Giving attention to these factors insures the sense of solidity about elements within a watercolor.

TERMINOLOGY

SCALE. The relative proportion of the various things within the pictures.
SPACE. The sense of distance or three-dimensional space within a painting.
VOLUME. The illusion of bulk or three-dimensional form.

EMPHASIZING DESIGN ELEMENTS

Scale can be manipulated by exaggerating the shape or size of things within the picture plane. Enlarging one element may make another appear smaller. In the same way, forcing or exaggerating the perspective can increase the illusion of size difference as well as depth and volume.

The density of the color—controlled by thinning out washes, heavily pigmented color, or granular washes—can play a part in suggesting the bulk and the weight of a form. Granular passages give an extra presence—a more substantial look—than a pale wash. The light quality of pale, thin washes, contrasted with heavy pigmentation, can affect the apparent weight of objects. Observe how this factor works in *Low Tide,* where the pale pools of water and granulation contrast with the dark, heavily pigmented seawall.

Conversely, lessening the perspective by bringing things in the background forward will decrease the depth and volume. For example, where things in the foreground (such as the great harbor wall of *Low Tide*) are sufficiently massive,

the background can be brought forward or enlarged.

As I looked across the harbor while painting *Low Tide,* it was difficult to see and appreciate the fascinating architectural details on the distant buildings. I decided to enlarge them to nearly twice the size that the structures appeared in reality. The huge wall in the foreground permitted the feeling of distance to remain intact. The addition of figures helped in allowing the logical perspective to prevail. Introducing familiar objects into a scene gives the viewer something by which to relate the size of things. By placing the figures in the foreground, midground, and background, and diminishing their sizes accordingly, the viewer is given the feeling that the scene is in proper proportion.

Another benefit of moving the background closer is that it fills the picture space to a greater extent (where this is desirable). Often I have been faced with too much sky and too little interest across a landscape. Bringing in the background often has solved this problem. The use of cool background colors will help to keep the sense of proper distance while still allowing the benefits of bringing the background closer.

Several things can help to establish space and volume in a picture. For example, the broad handling of background washes will push things back into the distance. In contrast, things close at hand and rendered in detail will move forward and increase the illusion of depth or distance between the foreground and background.

This is the case in *South Rim, Grand Canyon,* (p. 66), where the foreground and middle ground are more defined, with darker and more complex shadows than are apparent in the distant forms. In

this canyon, where the look of monumental proportions was necessary, the prominent cliffs to the right, and extending pinnacles on the left vertically overlap the horizontal sweep of the canyon to accentuate the spatial vastness. I used a high horizon to allow a steep descent and lightened the foreground slightly to further increase the depth and volume. I painted the tiny riders slightly smaller than they would be in reality, to help exaggerate the immensity of the cliff.

Although there is a high degree of detail throughout, I have followed the principle of defining less as things go back to the horizon. I have cooled the colors around the distant rim, although the predominant colors in the rest of the canyon are warm.

In *Roman Forum,* the high vantage point and the vertical format emphasize the tall elegance of the ruins. The appearance of bulk and mass was achieved by the density of the ground and the shadow tones behind the pillars. I used extra pigment in the ground washes, which gives a look of solidity that thinner washes may not have; in turn, I lightened the pillars to a translucent, pale wash indicative of white marble in the sun.

Close observation will reveal tiny figures that I included at the center, and another group (top left) at the bottom of the steps, along a balustrade. As insignificant as these barely visible figures might be, they add scale to the unfamiliar sights.

The verticals are thematically important for this watercolor, so I emphasized them where possible, even to the point of the extended trunks of the trees in the upper left-hand corner.

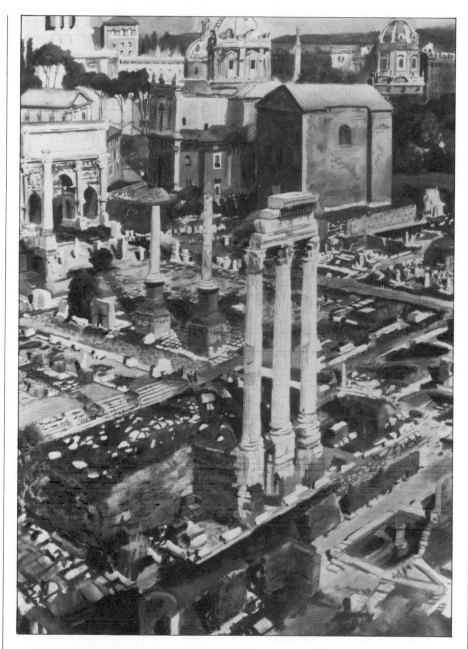

Roman Forum *30x22 inches*

Vertical format, strong contrasts, and the introduction of small figures make the ruins seem large and massive. A full discussion is on page 64.

The light, sedimentary wash that creates the shiny pools of blue water surrounded by slick mud contrasts sharply with the massive, dark harbor wall.

Low Tide *22x30 inches*

South Rim, Grand Canyon *22x30 inches*

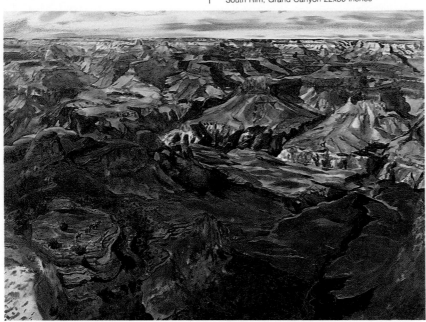

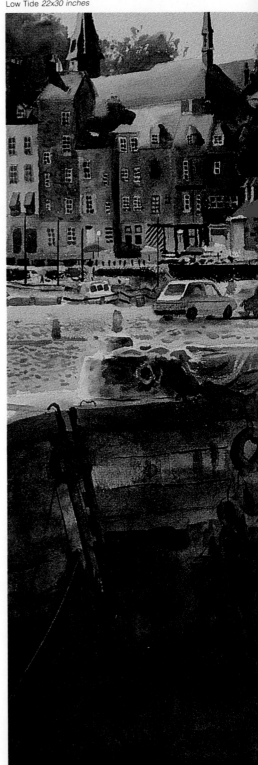

Monumental depth is emphasized here by the transition of foreground warmth to the cool distance, detail in the near ground, and fading out of the middle ground, with only suggestions of detail at the horizon. Such a panoramic painting suggests a continuance of the canyon beyond the margins of the picture space. (Panoramics are discussed on page 113.)

Diagram A. The buildings in the background actually formed a rather thin strip across the rear of the scene.

Diagram B. Because the buildings had interesting features, I enlarged them. This created the illusion that they were closer. However, they still hold their place in the picture, well behind the massive sea wall.

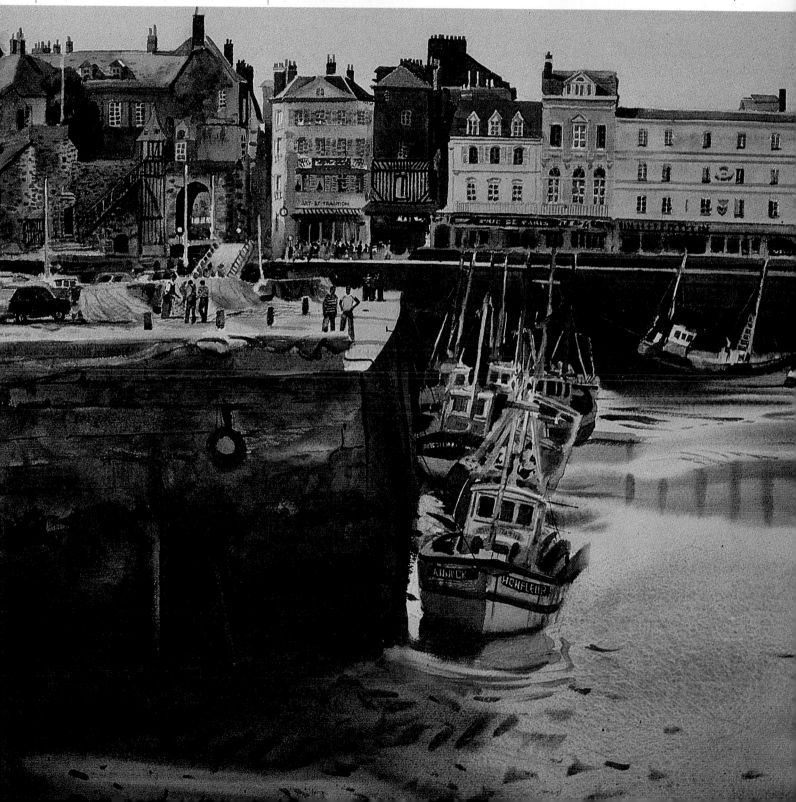

Rhythm is the pattern of movement throughout a painting. Often there will be a natural rhythmic movement through a scene, such as rolling hills, winding rivers, cloud formations, etc. Such naturally occurring rhythms may provide sufficient activity to give an active *flow* to the watercolor. Look for these rhythms even before drawing the image on paper, and use them to infuse a sense of life into your watercolors.

An easy way to establish further rhythmic passages in a painting is to emphasize similar rhythmic patterns that occur in the scene.

REPETITION

Repeating distinct elements in a composition can create rhythm in a painting: a row of fence posts, trees, telephone poles, and so on. The arches in *Moor in the Mosque at Cordoba,* opposite, were aesthetically built by the Moors to convey opulent rhythms. My contribution to these rhythms was simply the light-to-dark, top-to-bottom tonal gradation. Any repetition in painting, including the tone and color, can produce a rhythmic progression. *Steps in Morocco* relies on the progressive intervals of light and dark tone of the steps to fill the picture plane with a rhythmic sequence. The vertical buttresses in *Basket Carriers Behind the Cathedral* create a similar rhythm.

LINEAR MOVEMENT

Movement can be in the form of curving lines, coils, wavy lines, zigzags, and other such regular flowing designs. In *Cat on a Marble Pillar,* the rhythmic arc of the cat and pillar adds movement and vitality to a peaceful scene. Such rhythmic contours occurring in cityscapes and landscapes along a row of roofs or roads that cut across the hills will likewise endow a composition with a sense of life, movement, and energy. *Sugar Ray Leonard vs Tommy Hearns* is a composition built on counterdirectional movements. The arms and legs of the boxers are in the same direction; the torso and right leg of the near boxer form a *counterpoint* by slanting in the opposite direction. In portraying action, these linear dynamics of design help to organize a sturdy, balanced composition.

COUNTERPOINT

The addition of a related but independent element to a basic series of elements is counterpoint. Used in its proper place, repetition can be a stabilizing force in a composition, but at times a repeated motif needs a counterforce to control the visual movement, as shown in the diagram of *Mending Nets.* In the painting, I coordinated the figures into this rhythmic scheme to act as a counterpoint to the boats as well as to provide the main theme. The colorful boats give a natural orchestration of color and tone.

Two stabilizing controls on the upward- and sideward-sweeping boats are the straight, horizontal headlands and the counter direction of the figures. The foreground prows of the boats make an effective counterpoint to the lateral direction of the background boats.

The upright figures overlap the vertical buttresses, producing an unusual composition and rhythmic interval in an otherwise common scene (San Miguel De Allende, Mexico).

Moor in the Mosque at Cordoba 30x22 inches

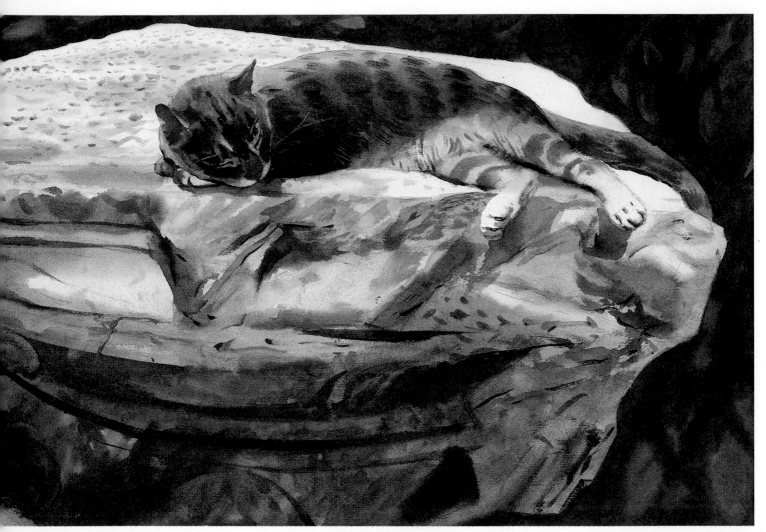

In Cat on a Marble Pillar, *a careful control of color intensity makes hard stone look as soft as a pillow and contributes to the mood of ease and restfulness. A full discussion is on page 68.*

Cat on a Marble Pillar *16x24 inches*

There is an overlapping counter-movement to the two boxers. The ropes provide stabilizing elements that also serve to connect the referee to the main characters. The ropes are left white to accentuate this connection.

Sugar Ray Leonard vs Tommy Hearns *22x30 inches.*
Collection of Sugar Ray Leonard.

In contrast to the broad wash procedure, as used in *Downieville,* opposite page, where simplified planes are sufficient to describe form, a textural watercolor can make use of descriptive or decorative texture to enliven these shapes and forms. Combinations of the two can also be successful, if they are consistent throughout the painting.

Descriptive texture clarifies the subject's surface to develop a sense of realism.

Decorative texture is shown in symbolic patterns, calligraphy, and designs apart from realism, such as expressive squiggles, swirls, loops, waves, crosshatches, various dots, stabs, and darting strokes of the brush that are designed for their lyrical or abstract qualities. They are poetic representational devices rather than renderings allied to realism.

In the area of textural work, you can really loosen up and become inventive by experimenting with crosshatching, staccato effects, dotting, or swirling movements, into a damp watercolor sheet to explore possibilities with the brush and other implements.

In Cool Drink from a Red Cup, *strong rectangular planes are enhanced by devices of texturing (see diagram next page). Discussion of the techniques used in this painting appears on page 76.*

Cool Drink from a Red Cup *15x16 inches*

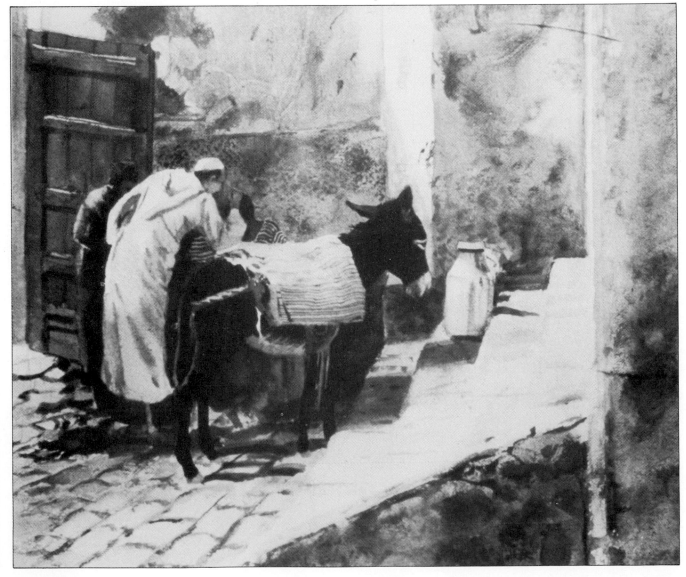

Downieville *22x30 inches*

There is a fine line between a well-worked area of texture and an overworked area. Contributing to this tendency to overstate is the rather hypnotic effect that repetitious dabs of the brush may have on us. In other words, we get lost in our own activity, forgetting to watch for the effects the accumulation of dabs has en masse.

When things start looking good, there is a tendency to try to make them look even better by continuing beyond what is necessary for the effect. Considering the spontaneous character of water-color, it is often safer to simplify, to proceed slowly, checking the work as you go and, when in doubt, to pull back from your rendering and reassess where you are going.

DESCRIPTIVE TEXTURE

BRUSHWORK. Use an old brush so that vigorous strokes can be rendered without ruining your best brushes. On a dampened surface, a brisk dotting and dashing with a small brush, with just a little pigment of the correct tone, can describe everything from pavement to sand to leaves. I've used this technique with appropriate variations of color and tone to describe flowers and leaves in *Window in England.*

BRUSHTIP. The handle end of the brush can be used to pick up pigment, leaving a reverse, or light line in dark pigment, where paint is scratched.

The pinstripes in the blue sweater shown in *Market in Portugal* were dragged out with a brush tip. In the baskets, a light wash was allowed to dry as a base color. A second, darker wash was then applied over this first one. With the wooden tip of the brush handle, I wiped off the second wash in the pattern of a basket weave,

wiping the end of the brush with a paper towel after each stroke. The grain sacks were texturally developed by drybrush over an initial wash.

DRYBRUSH. Use an old brush with more pigment than water; test by wiping across a scrap of watercolor paper. The pigment picked up by the grain of the paper will produce an uneven, grainy texture.

STIPPLE. This refers to the deliberate dotting of the brush on the paper. An irregular stippling can be achieved by dipping or pressing corkboard, crumpled paper or tissue, textured cardboard, corrugated surfaces, foil, flat rocks, and other surfaces, into a pool of watercolor and simply stamping onto the paper.

These effects can be used to represent textures of actual surfaces in the interest of realism, or can be arbitrarily used to enrich areas of the watercolor that need more textural interest. These devices can appear gimmicky if not consistent with the general appearance of the work. An isolated area of stipple may look contrived if not balanced with other textures in the picture.

WATER SPOTS AND SPLATTER. Sprinkling water with an atomizer into a damp wash produces soft water spots. Holding a loaded brush over the surface (dry or damp) and hitting the brush with the index finger for irregular dotting is called "splatter." I cut a piece of paper out and place it over areas where splatter is not needed.

WAX CRAYON. Rubbed across paper before a wash is applied, the wax will resist the watercolor and yield a regular stippled effect. Candle wax will provide a similar result.

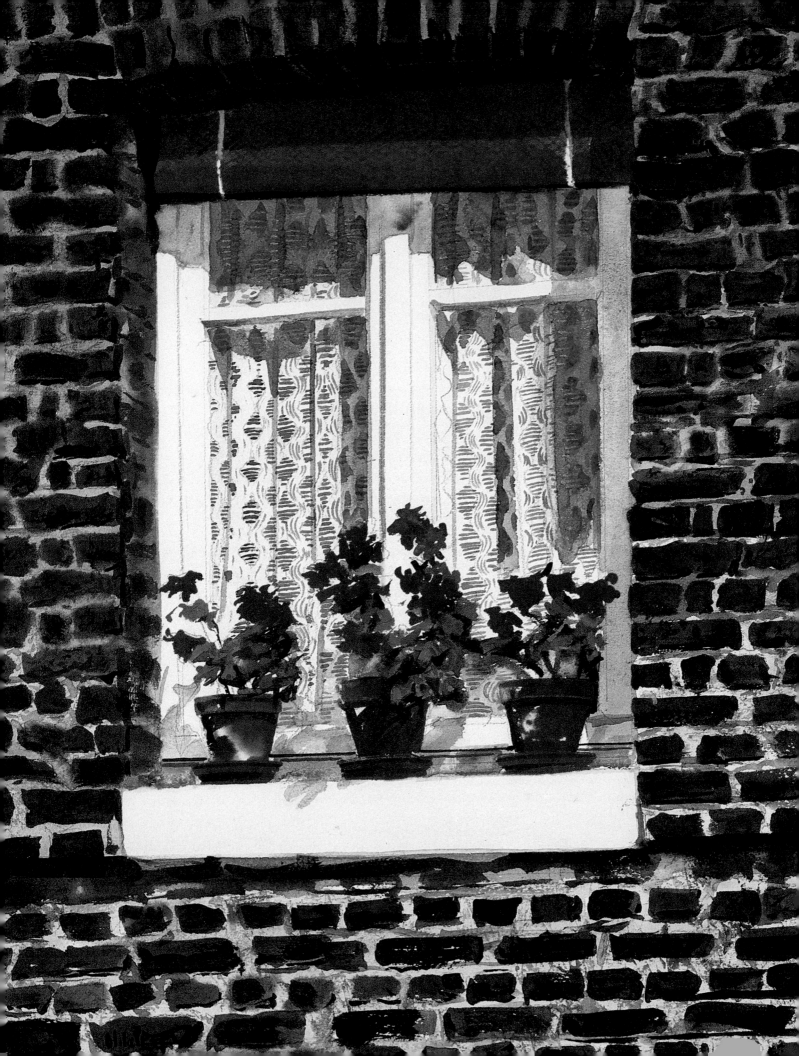

Bold texturing of the bricks in Window in England *was done with old and slightly stiff brushes.*

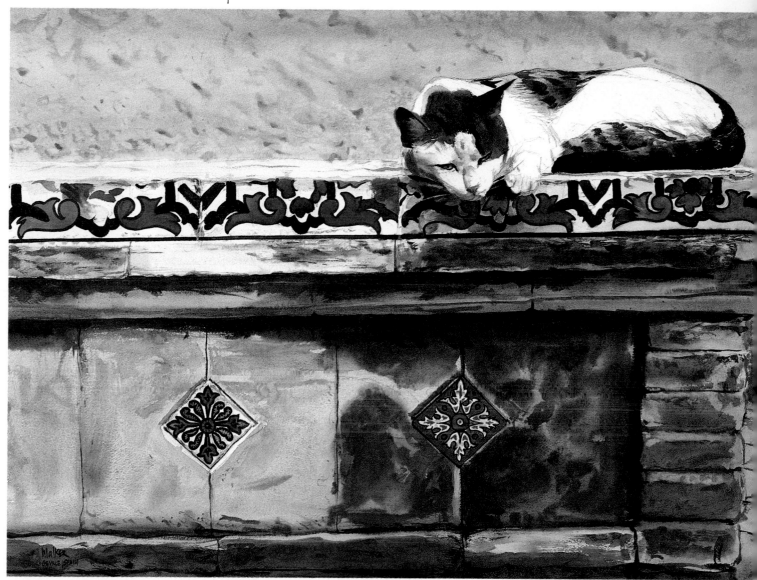

Cat on a Tile Bench *displays several painterly effects in the rendering of the bench and the cat's fur.*

Cat on a Tile Bench *22x30 inches*

PAINTERLY EFFECTS. Compare the chipped marble and stone surface of the bench in *Cat on a Tile Bench,* pg. 75, with the wall in *Cool Drink.* The bench was textured entirely by a medium-sized round brush without use of the random textural devices of the *Cool Drink* surfaces. This gave a painterly quality to the surface of the tile bench; the brushstrokes are evident in the surface effect and become an integral part of the expression.

Fur can be rendered effectively, as in *Cat on a Tile Bench,* by the use of small, fluid brushstrokes over a damp wash. The cat was entirely dampened before I dropped in a half tone of undercoat in the area of the patches of color in the cat's coat. Over this undercoat I brushed descriptive wisps with a pointed brush. One must use restraint in the depiction of fur; like the depiction of waves, leaves, and other repetitive motifs, a suggestion is usually all that is needed.

In *The Lantern,* hard and soft edges, together with bright highlights and deep darks, convey the effect of clear, heavy glass. Note that the darks have reflected color and flecks of light; these are related to surface tone behind the glass and direct light facing the glass, as well as reflected light.

It is difficult to write rules for effective use of texture, but following are some concepts that are worth considering:

CONSISTENCY

An overall consistent handling of texture will show control better than a series of seemingly unrelated treatments. You can mix various treatments, of course, but they should have a unity of purpose that allows the general appearance to mingle as a cohesive whole. If the variety of lines, scratches, splatter, and blotches looks like the wooden door you are depicting, there is probably a unified consistency, but if the lines, scratches, splatter, and blotches jump out at you, then what you have is a scattered assemblage of unrelated textural events that need to be unified. This is often remedied by simply merging the disparate treatments, patiently overlapping them, mixing them, and bringing them closer in tone.

COMBINING TEXTURES

The watercolor *Cool Drink From a Red Cup* serves to illustrate a few of the textural methods employed in the same work. I used a number of materials to produce the effects.

A graded wash was applied over the wall area. I stamped a *cork* that I had smeared with pigment and a little water into the damp wash. Then I wiped darker passages with an *old bristle brush* and scraped a *single-edged razor blade* carefully across the flat washes to achieve highlights. I then dabbed a *sponge* into the areas I wished to lighten further or keep moist, and used my clean, dry *thumb* to smear and soften drying edges. I dropped *salt* into the lower right passage of wet pigment, producing tiny white flecks. (Light-toned droplets form around *salt* and *sand,* producing dotted effects.)

After the entire surface was dry, I *splattered* small sections with pigment from a *toothbrush,* then *stippled* the wall with small *dots* of a pointed brush, to even out the overall tonal "color."

I used more texture-achieving methods here than would normally be necessary because I felt that the more varied the appearance, the more realistic the surfaces would appear.

COMPATIBILITY

It is possible to mix styles, but in a wet-in-wet painting, if you add dry-brush to the watercolor, remember the difference will stand out. It is the exception that commands the

Splatter with brush and toothbrush.

Brushing over candle wax.

Stipple.

attention, so be aware that if you change to a different style in mid-painting, it is that change that will be noticed. This might be the effect you want, as with the mixture of wet-in-wet and drybrush in *The Lantern*. But if you are not featuring this contrast in treatments, then you might have an *incompatible mixture* of styles. The opposite is also true. For a predominantly drybrush picture, any singular addition of a wet-in-wet, free treatment will pop out. So, for realistic and convincing textural work, consider the treatment you use in relation to the rest of the painting.

DECORATIVE TEXTURE

This expressive, poetic version of texture is related to design. Symbols, called motifs, are brushlines, calligraphy, geometric shapes, lin-

ear patterns, symbolic shapes, or a series of lines that all suggest objects in nature. The motif is an integral part of the expression. Such symbolic imagery as wavy lines can depict kinetic forces such as smoke, water, wind, even smell. Extend your pictorial language by inventing new symbols for your own interpretation. This, of course, is the point of departure for abstract painting which is non-representational by definition.

This still life represents several handling procedures, such as fluid brushline, wet-blended passages, and drybrush.

The Lantern *30x22 inches*

In Lady in Mexico, *the Pepsi Cola bottle resting in the midst of a scene that could otherwise be centuries old gives an anachronistic touch to the theme.*

I used candle wax across the white wall area to form beads in the initial wash, creating the appearance of porous textures. Then I used a clean rag to dab and shape the whites out of this wash. The door molding was painted in a series of procedures. First, the initial graded wash (the base wash) was applied. I rough-brushed a darker tone into this base wash, and while it was drying I splattered a still-darker pig-ment into the area. Finally, I made vertical marks with a white crayon to add to the richness of the surface markings. (It is easy to overdo this mixed-medium marking, so I use it sparingly.)

For the door, I applied a base wash that grades light to dark in patches, and into this wash I dragged various brush handles to carve random notches, scratches, and unpredictable scribbles. In the end, these must appear to be the wear and tear from the vagaries of life, and not the calculated markings of the artist's hand.

Lady in Mexico *22x30 inches*

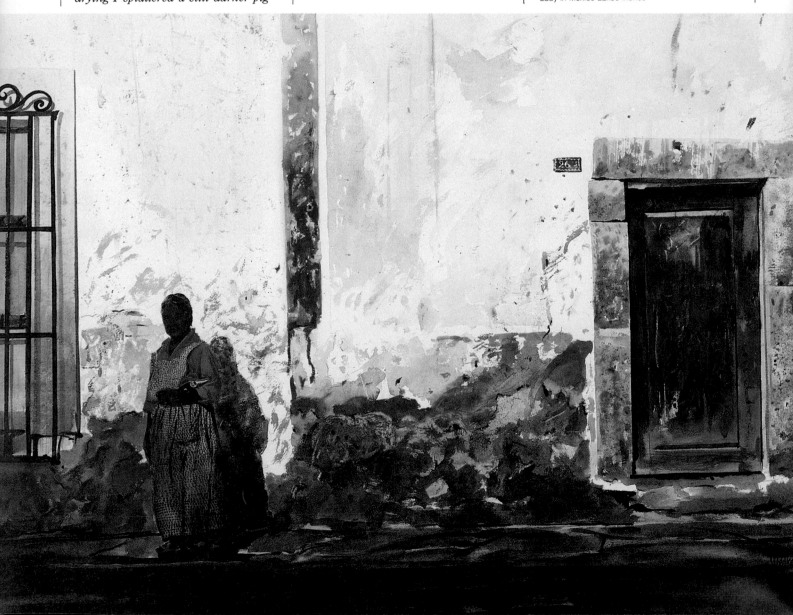

The impression of water, here, is conveyed by nondescript dashes of light and tone. Such vague and less deliberate representations are sometimes more effective than a motif that is too well worked out or too obvious. Block out the figure, and what is left is an abstract pattern. Wet-blended dashes and free gestures of the brush are sufficient to portray the spray of water when used in transparent glazes.

Morning Shower *5x6 inches*

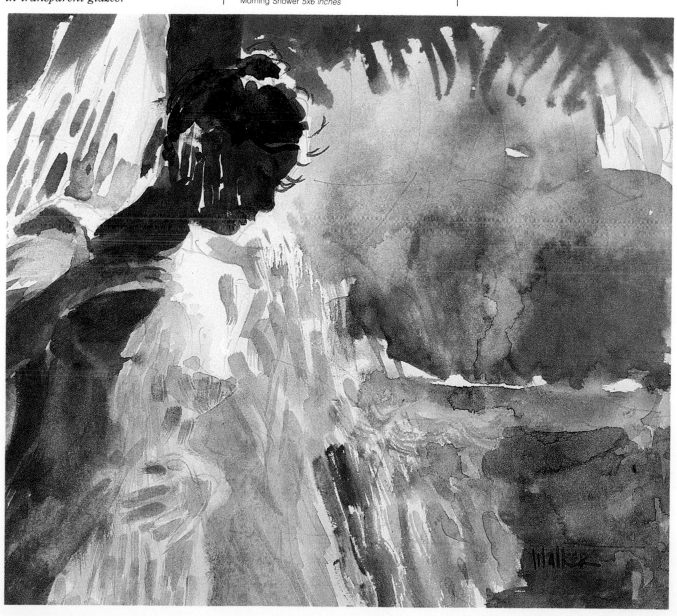

13·LIGHT AND SHADE

DIRECTION OF LIGHT. Shadows must be consistent with the direction of the light source. Normally, this is not a problem with obvious daylight or other direct-source lighting. However, with invented light, where the artist changes the lighting or imagines or creates a light source, consistency must be specifically designed into the painting.

The sun's arc on location shifts and can reverse the light direction during the course of a painting. Be aware of this and pick a light direction and stick to it.

The direction of light can be emphasized by darkening the shadows and lengthening them.

WARM, REFLECTED LIGHTS. The white of the paper can convey the brilliant light of sun on light surfaces in watercolor; the corresponding shadows will often need to be enlivened by a sense of warmth. Adding a cadmium yellow pale to these will warm up the cool blue shadows on white walls and light surfaces. The warm colors of the spectrum, such as yellow, orange, red, and violet, can create warm reflected lights within the generally cool shadows. *Sun and Shade* exemplifies this addition of warm reflected lights to the shadows. I've added rich color into these potentially forgotten areas in deep shade.

SUNNY HIGHLIGHTS. Aside from the white of the paper, sunny illumination can be depicted by a light glaze of lemon yellow, cadmium yellow pale, or yellow ochre over sunlight areas. Another method is to lighten the details to a mere suggestion in the illuminated passages. In the watercolor example *Spider Rock*, I used the white paper for highlights and blanched out the detail within the light to half tone areas.

SIDE-LIGHT, also called *crosslighting* by location painters, reveals the three-dimensional aspects of objects by casting light and shade across the form in such a way as to catch the contours and accentuate the real shape. In addition, the shadows that extend to the side are useful in the composition and reinforce the presence of the object. As this shadow extends from the object and traces its way along the ground, sidelit objects appear anchored to the ground in a stable way.

As shadows modify their shape to the contours on which they fall, they can provide greater possibilities for patterns that add interest to an otherwise dull area.

The compositional power of this watercolor is due to the vantage point and to the natural forms that nature has provided. The design is emphasized, however, by careful planning. The light pinnacle stands out in brilliant sharpness against the dark, cool shadow behind it. The river's emphatic blue sheen winds through shade and breaks up the dark masses on the canyon floor. The dramatic light effect of this canyonscape is created by the warm, high-key colors of the sunstruck rock contrasting with the cool dark blue, blue-green, and violet shadow areas.

PROCEDURE FOR *SPIDER ROCK, CANYON DE CHELLY.* I worked top to bottom. The sky area was dampened, and as it dried I broadly mixed yellow ochre with slight touches of cadmium red and burnt sienna, allowing them to mix and blend on the paper itself rather than the palette. I kept the mixtures very light and blended them to a neutral that has traces of the original colors applied in small amounts from the tubes.

The narrow strip of treeline that spreads across the rim of the canyon was gradated dark to light, left to right, to convey the illusion of distance. The gradation makes use of warm browns and greens (umber and Hooker's green) for near foliage and cool blues for the far distance.

As I worked light to dark on dry paper across the canyon planes, I emphasized the illumination of the cliffs by using a strong side lighting. I deepened the shadows and lightened the half tones to strengthen contrast.

Reflecting the sandstone, limestone, and various other earth colors in the canyon walls, I used a damp brush with small touches of permanent rose, then another with burnt sienna, another with yellow ochre, then violet, then crimson brushed into the moistened light areas. I moved these mixtures about with a dry brush to draw and chisel out minute striations in the rock forms. I accomplished this with vigorous, free brush strokes, showing more control and pulling the forms together with the later additions of shadow shapes.

I was consistent with this method throughout the rest of the canyon walls and slopes; indicating light areas first, then defining the middle tones, and finally carving out forms with shadow.

During the drying time of the light areas of the distant hills, I would work forward and, concurrently, indicate light areas in the other sections of the watercolor. As I modulated the half tones and left them to dry, I would define half tones in other areas. The dark passages represented the last stage of this sequence of development. (I work this way in order to develop as wide an area of the watercolor as possible in order to compare values and detail as well as to make color comparisons.)

I let the pigments merge wet-in-wet, using many colors instead

The Elements *illustrates a backlit, silhouetted watercolor, with a definitive use of contrast and negative space. I was painting on location in San Francisco one day and crossed paths with George Post, who was also painting on location. Since I had no camera with me I sketched him, catching his likeness in pencil.*

 Later, in the studio, I saw that *I didn't have enough detail to make a studied representation. So, I decided to use deep shadows of the stark city light to cast strong diagonal patterns, and obscured the detail in the shadow's path. (George paints in full sunlight, which is unusual, and he is left handed.) The post in the left hand corner was a good-humored reference to Mr. Post.*

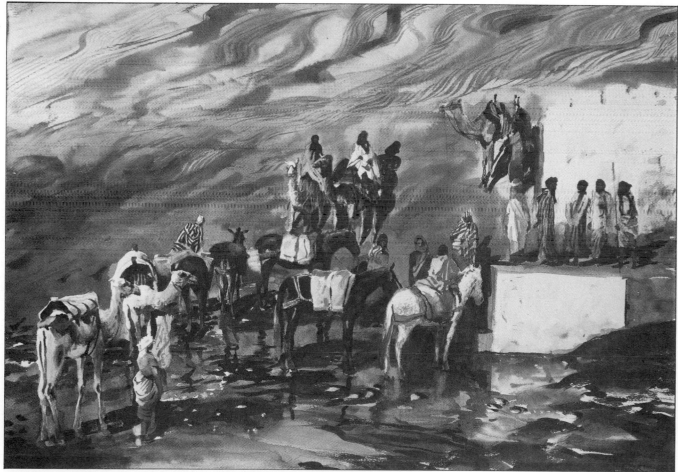

Moroccan Waterhole *22x30 inches*

I encountered this waterhole on my last trip and took care to develop an impression that would not be far from the sense of high drama that such a sight generates in the western observer.

 The desert sand dunes rise away to a vast and boundless expanse. Sun floods the scene, allowing the special clarity of color that frontlighting can provide. Form and depth are accentuated by the cast shadows immediately behind these characters of the North African desert.

Emphasis on reflected light can accentuate contours that would otherwise be lost in shadow. Reflected light gives a three-dimensional shape and roundness to all surfaces here. In the shoulders, underbellies, and legs from hock to fetlock, reflected light is evident in these burros' extremities.

Warm colors are charged into the white wall shadows. In the direct method, these warm yellows should be distributed into and around the damp blue washes at the initial application. Otherwise any unnecessary overlapping after the washes are dry may lead to unwanted greenish tints instead of the desired clean, mottled color variance.

The surface color, or local color, of the wall in shade appeared to be a gray blue. Observing at length, I noticed that there was reflected coloration within the obvious blue or blue-violet base color. I looked for these colors and added them in the initial wash in a mottled way to merge and blend. I took care to keep these varieties of reflected color notes the same approximate tone. The overall effect observed at a distance is that of a shadowed white wall with an interplay of reflected colors.

Shadows in summer light will produce blue to blue-green shadows on white surfaces, whereas winter light produces a shadow tendency toward blue-gray to blue-violet.

Sun and Shade *22x30 inches*

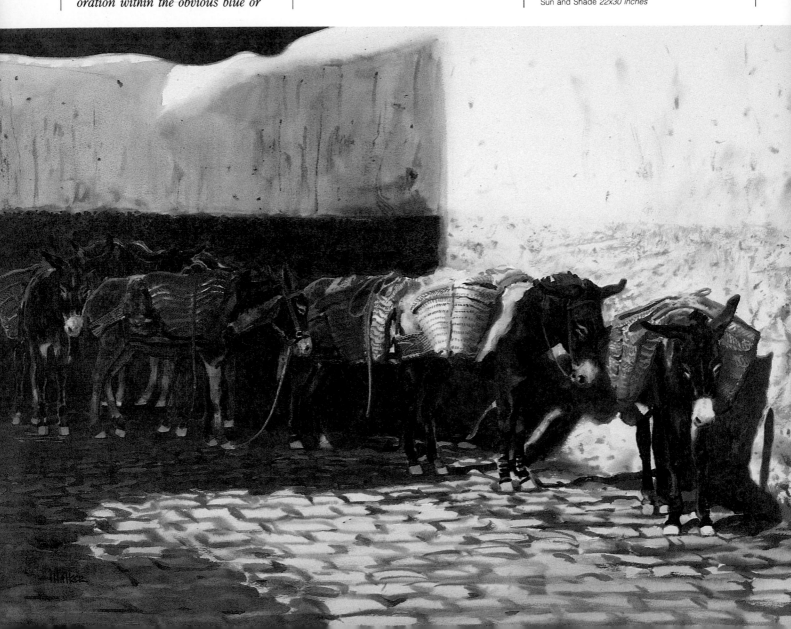

The compositional power of this watercolor comes from the vantage point of the viewer and the natural forms that nature has provided. The design is emphasized, however, by careful planning. The river's emphatic blue sheen winds through shade and breaks up the dark masses on the canyon floor. The dramatic light effect of this canyonscape is created by the warm "high key" colors of the sunstruck rock contrasting with the cool dark blue, blue green, and violet shadow area.

Spider Rock, Canyon de Chelly *22x30 inches*

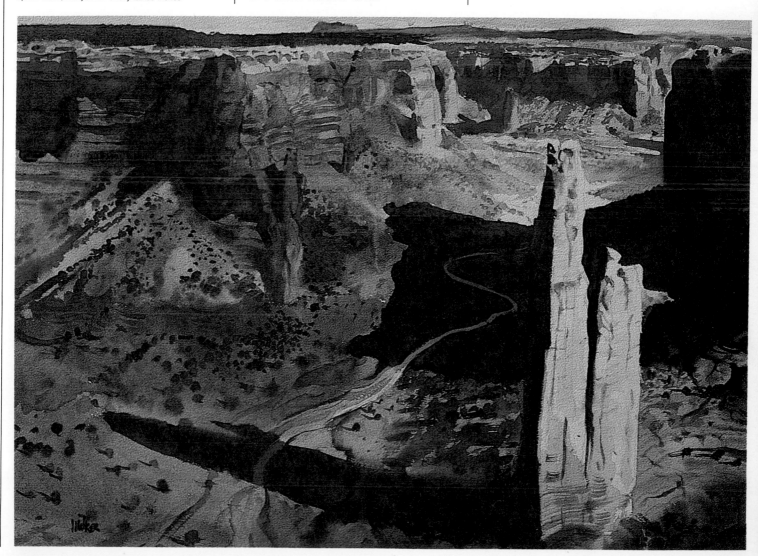

of just one for the shadows. I combined cobalt blue, ultramarine blue, cadmium orange additions, ochres, siennas and Alizarin crimson, in various strengths, essentially drawing with the brush to shape and define the shaded forms.

The foreground was sponged lightly and moisture evened out with a paper towel. Pinks and grays and ochres and blue-grays were the four basic colors I chose to interplay in the immediate foreground wash.

All colorful washes were laid in side by side in what I have described earlier as the variegated wash. I used four brushes alternately, each loaded with different pigments.

I introduced a brilliant red reflected light running up the *Spider Rock*. All the hues were charged deeper in chroma than they actually appeared to me as I looked at the scene.

In this predominantly warm color scheme, the small additions of olive green and pale green in the near right corner, and pale greenblues throughout, complete the orchestration of color. Bravura brushstrokes assist in keeping this watercolor free—adding an uncontrived, natural expression.

LIGHT VARIATIONS

FOGGED LIGHTS. Fog diffuses sunlight to create the familiar veil that elicits a sense of mystery in a painting. A yellow glow can sometimes accompany the foggy effect. On such days I use a yellow ochre mixed with a slight addition of ultramarine blue.

To achieve the cool, misty color of harbor fog, I mix two parts ultramarine blue with one part lampblack and one part violet, mixing thoroughly with plenty of water. Blue-gray, or my favorite, a light brownish gray, are the colors I use for city fog, such as you might find in San Francisco or London. For this I add a little burnt sienna to the above mixture.

DIFFUSED LIGHT. Overcast light is an almost shadowless light where color is neutralized. *A Long Drink on a Slow Day* and *White Cat on a Wet Street* illustrate such diffused light.

TONALIST APPROACH. *White Cat on a Wet Street, Snow Bunnies,* and *The Elements* are all essentially tonalist in approach. It is a type of painting in which color is neutralized in favor of the grays, sepias, and light and shade which carry most of the impact and subtleties.

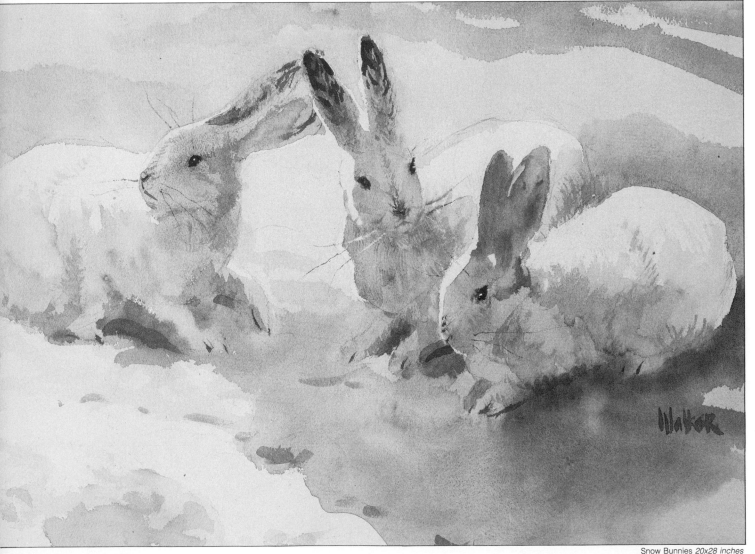

Snow Bunnies *20x28 inches*

In the context of this book, the tonalist method is presented as a manner of painting that allows the maximum benefit of the interplay of values, i.e., chiaroscuro.

In such a scheme, small notes of color *can* be introduced to produce accents. In tonalist work, a small amount of color becomes an important feature and draws attention, and so must be used with restraint.

I used only four basic values in this rather simple and spontaneous watercolor. Eliminating one or more of the middle tones will tend to increase the contrast and bring more importance to the remaining tones. Such contrast, with even a high key watercolor, sharpens the design and heightens the sense of drama.

In a predominantly high-key scene, darks in any area create tonal accents and draw attention to that area. This can be distracting in the wrong place but will work if used in the right placement. In *Snow Bunnies* I used this effect in the ears and eyes to draw attention to these important points.

PROCEDURE FOR *SNOW BUNNIES*. I wet the paper with a large round brush, bringing clear water around the contour of the rabbits. The entire paper was then damp with the exception of the shapes of the rabbits. I then brought a cool wash of manganese blue and raw sienna down and around the rabbits. Then, continuing the background wash downward, I changed the colors gradually to warmer pink-grays. (See full-color reproduction in the Introduction.)

About halfway into the drying time of the background, I damp-

ened the rabbit coats to achieve soft edges as I whisked a variation of blues and violets (neutralized by yellow ochre and siennas) into the lower halves of the rabbits' bodies, and throughout the ears and faces. (Just one-fourth part of yellow ochre or burnt sienna will neutralize a blue or violet.) I preserved the white of the backs and, using great restraint, brought descriptive brushstrokes from this area down into the body of washes in subtly crosshatching movements to resemble fur.

I then laid a mixture of the same color varieties together, establishing a solid half-tone shadow in the faces and the foreground shadow. This reinforced the halo effect that strong backlighting sometimes produces.

I charged slight notes of yellow ochre into some of the colder areas to relieve them of their chilli-

ness. I also used a small amount of permanent rose and cadmium orange in the ears of the right-hand rabbit.

To anchor the rabbits to the snow-laden surface, I darkened the areas where fur meets snow. I then picked out the highlights of the eyes, using a single-edged razor, and scratched in the white whiskers with strokes of the blade.

Finally, I recovered a small white triangular shape between the ears of the rabbit at the right. This was accomplished using my method of cutting and peeling off the top surface of the paper with a razor (see page 14). On top-quality watercolor paper, this method allows the paper to still generate the effect, where white paint would appear out of place. In a high-key, transparent watercolor such as this, opaque additions would stand out as intrusions.

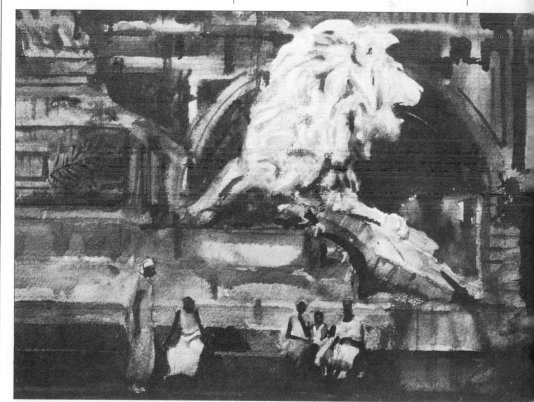

African Women in Milano *9x11½ inches*

In this highly translucent watercolor, the values are simplified to a white, a few half tones, and a dark. Wispy strokes indicate a suggestion of fur. Infusions of ochre, manganese blue, cadmium orange and permanent rose enliven this almost monochromatic scheme.

Although a low-key watercolor, this account is still heavily charged with deep color. The background consists of improvizations on architectural forms, some of the earlier discussed bravura brushwork. I found the lion here to be a symbolic reference to the central theme. The inventive

light *I have chosen to use allows subtleties, such as pure notes of cadmium orange and Winsor yellow to be arbitrarily illuminated. Likewise, the marble African lion is lighter to emphasize its profile.*

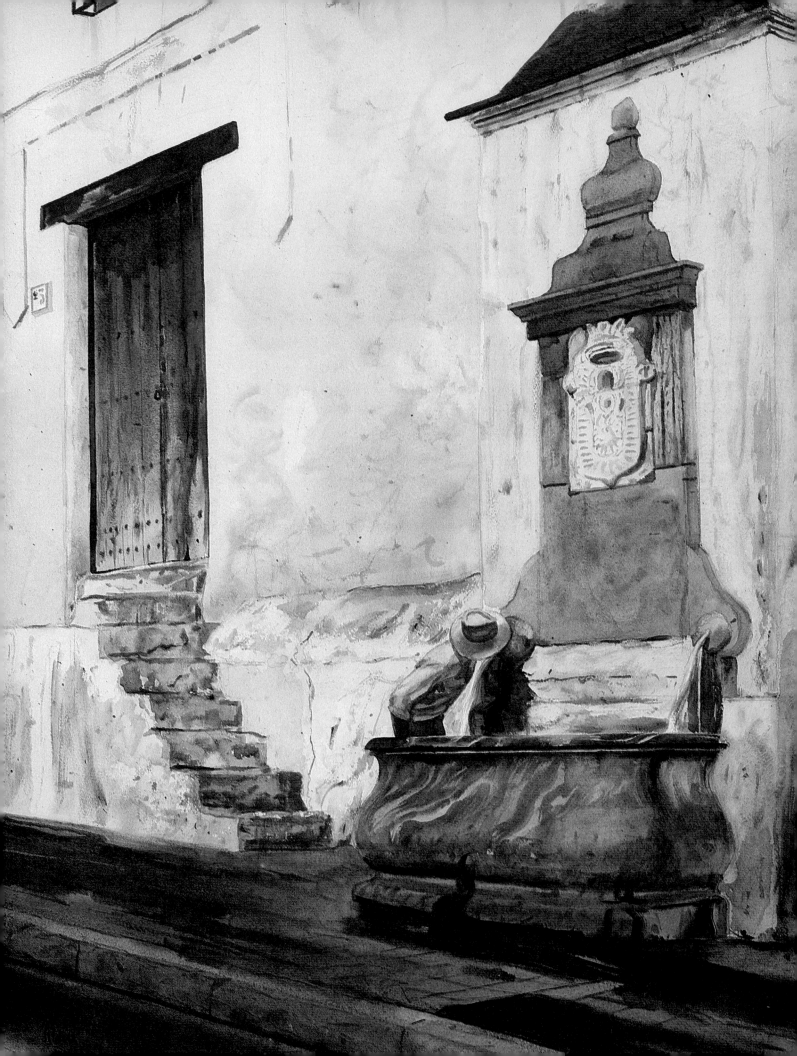

White Cat on a Wet Street *22x30 inches*

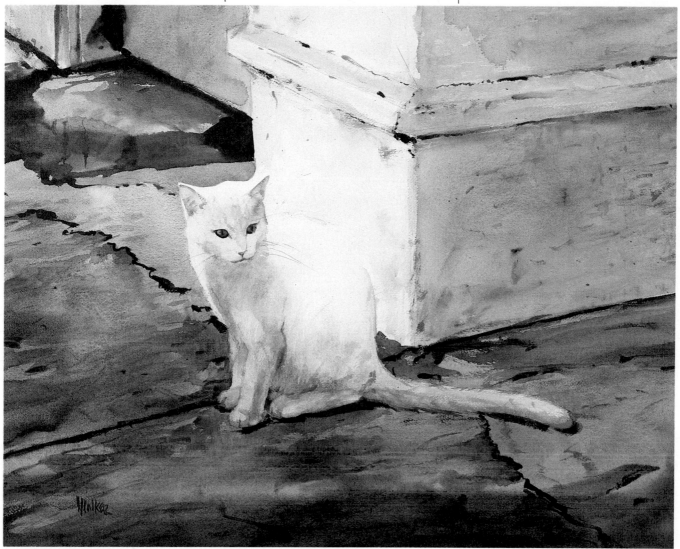

Although both the cat and the wall appear white, the only true white is the cat's crown. This is a tonalist approach in which the tones or values, rather than the hues, dominate the picture.

I placed accents of pale red within the ears and blue-green in the eyes. In a tonal work, even a single note of color draws attention.

14·MOOD

The quality of atmosphere or feeling throughout a painting is referred to as the *mood*. The ability to generate a preeminent mood in this medium is one of the hallmarks of the skilled watercolorist. A watercolor without any mood becomes simply a wall decoration, without the depth of human spirit and contemplative involvement that serious art evokes.

Usually, a subtle combination of the following factors can assist in establishing a mood, but only when combined with a proficiency with the medium itself. Let these suggestions encourage you to be resourceful in establishing a mood.

TIME OF DAY OR NIGHT

The classic dramas of dawn, dusk, and the afterglow of sundown, radiant sunsets and sunrises are, of course, clichés for the setting of a mood. Even so, as my old painting professor told me, "There's nothing new under the sun," and therefore we should be encouraged to attempt our own personal and unique statement around the time-worn themes and not let *it's been done before* discourage us.

WEATHER

The seasons, and weather-related possibilities such as cloud forma-tions, wind, rain, fog, mist, dust storms, snow, ice, etc., can be effective accompaniments to a main theme. (See *Clouds Breaking Up: Honfleur,* below). The list that follows suggests potential resources for supporting efforts to establish atmosphere. For example, *Sea Wall* (page 92), and *Windmills of La Mancha* (opposite page), both rely heavily on weather to set the mood.

Clouds Breaking Up: Honfleur *30x40 inches*

PORTRAYING WIND

In *Windmills of La Mancha,* I made an attempt to portray the sense of wind. In selecting a low vantage point, I revealed more of the sky and made use of this space to design nimbus clouds that spearhead across it.

The curvature of these sturdy windmills then leans with the wind, and the gleam of the rocks that have a similar, although subtle lean with the wind, evokes the look of a gale blowing across the land.

After the watercolor was finished, I noticed that many of the spired clouds echoed the spires of the windmills and I wonder if I subconsciously chose the cloud shapes for that reason.

PROCEDURE FOR *WINDMILLS OF LA MANCHA.* I pre-wet the paper around the edges of the windmills, which were left dry. I mixed warm, neutral grays on the paper (instead of the palette), to acquire a variety of color nuances in these gray tones. I designed the shapes as I went along. The blues were added into the dampness to further define the cloud forms and to add some optimism to the possibility that the sun will break through these clouds. I used the white of the paper as an illuminated lining around the clouds.

Within the shadows of these windmills are reflected light and reflected colors. I chose to heighten this effect with pure colors such as ultramarine blue, cadmium red, yellow ochre, and smaller touches of burnt sienna, brushed in random areas. Then, with a brush full of water, these colors were pushed around, merging and blending with each other. This neutralized each pure color. I watched the effects as these colors were pushed into each other; I tried to keep a similarity of tone throughout by adding

Windmills of La Mancha *22x30 inches*

The changes I made in the transposition of the existing sky to the final painting are evident in this highly active composition, in which a calm, cloudless day has been replaced by a tempest.

more water here and there, using a dry brush to take water away from areas with too much water. If an area became muddy I quickly dabbed it with a paper towel, flooded a little water into the area, and added some more pure color that was again mingled with its neighbor until a neutral half tone was achieved. Mixing a half tone in this way leaves traces of pure color showing through the grays and gray-browns, and, to me, breathes life into these tonal masses.

Next, I applied a thick mixture of burnt sienna and ultramarine blue (equal amounts, with a touch of lampblack) for the darkest tones (roofs and rocks). These were mixed and graded around the spires from dark to white by gradually adding water. The rocks were

also worked dark to light and while they were still damp, I added the neighboring midtones of bright orange and yellow-green grasses. All these tones were allowed to blend softly at the edges. I filled in any gaps between the watercolor passages that were unintentionally missed while all these washes were still damp.

I drew the windmill vanes on dry paper with singular, deliberate strokes of a No. 5 pointed brush loaded with lampblack and burnt sienna; then I added clear water to soften the edges.

I added the figures as a last-minute decision, composing them standing and sitting to slope with the angle of the twisted stick. The scale of the figures emphasizes the towering height of the windmills.

COLOR EMPHASIS

Color is an enormous help in creating the mood of a painting. Rich, dramatic reds can incite a theatrical effect, such as in *Candlelit Flamenco* (page 142) or we may be reminded of a stormy harbor scene with somber grays, blues, and blacks.

Remember that color should be thematically consistent. *Goat Herder* is a modified monochromatic scheme that is consistent with the antiquity of the fourteenth century Roman bridge. A painting dominated by neutral browns tends to have an antiquated look.

The emotional connection registered with colors, such as green, which conjures up thoughts of spring, foliage, etc., is helpful in achieving a desired effect.

SUBJECT MATTER

Figures and their attitudes or activities can evoke emotions such as nostalgia, sentiment, mystery, storytelling. Subjects and events that exude strong feelings, apart from the way they are painted, can provide strong foundations for a painting.

Such sentimental themes as mother and child—or beloved animals—are universal in their appeal. Still, these and other emotionally charged themes sometimes encounter negative reviews from the art community. However, I learned at an early age not to try to ingratiate your art with anyone, least of all, the critics.

Go ahead. Indulge yourself in the themes that mean something to you. Forget what the critics say.

You'll paint best what you're involved with the most.

Goat Herder *22x30 inches*

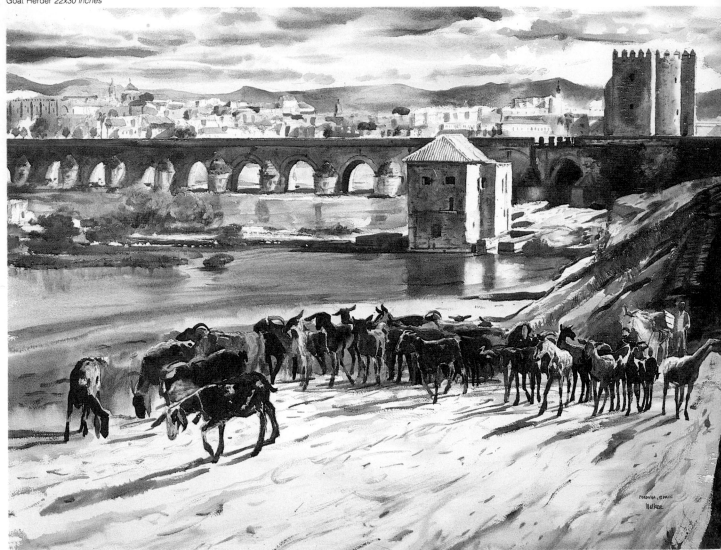

Bright light from the sun can be effectively portrayed by preserving the white of the paper as the brightest light, and softly grading this with clear water to a cadmium yellow light, with wet-blended touches of cadmium red or scarlet red. The shadows glow from reflected light and the sun casts variations of the abundantly warm hues across the sky and the trodden path.

The Flower Arrangement *22x30 inches*

PROCEDURE FOR *THE FLOWER ARRANGEMENT.*

Flowers can bring an aesthetic atmosphere into the context of a theme. In watercolor, flowers are easily overworked. They should appear delicate and varied in color. I prefer to depict blossoms in a highly transparent manner with a rather full-bodied wash in the background. Color of the interior in *The Flower Arrangement,* is applied with washes of thick, rich pigment. Deep reds, a mixture of alizarin crimson, Winsor red, burnt sienna and Winsor violet lend somewhat opaque characteristics to the wall. Lampblack is added to these hues for the aged wood of the door. Broken light from the right floods across the central theme of the picture.

The flower area was pre-dampened and into this the various hues of the flowers were placed,

In The Flower Arrangement, *the dark-hued background might create a somber mood except for the areas*

allowing some to form soft edges, others to remain crisp against the background. When the flat, but individually varied flower colors were almost dry, I dropped in the darker shadows of the petals. Then, the dark, leafy patterns were brought in around these blossoms. Soft and hard edges were used for variety.

An off-center composition such as this may lend a candid feeling to the scene. The figure is almost directly centered, but is offset by the position of the massive door placed left center. The figure looks to the left. The flower arrangement shares equal emphasis with the figure. This, together with the contrasting table and chairs, sets up a left-to-center grouping that is unorthodox, considering the lack of activity to the right. There is, however, sufficient detailing of the palms along the right border to provide a vertical distribution

of white in the foreground and center. The varied colors of the flowers stand out more strongly by contrast.

shapes and lively design to balance this side of the composition. Such compositional informality breathes life into a scene. Views of events as they occur in reality are seldom so organized as a perfectly composed painting. Thus, we have the appeal of the odd-angle, the imbalanced aspect of a composition, the blank wall or negative space, etc. There is a place for a well-ordered composition and a place for the apparently less ordered arrangement. Certainly, as much thought may go into creating an unusual composition as might be used for a more conventional arrangement. Artists with an innate sense of design might have a better grasp than most of this intangible thing called *composition.* Certainly, those who are sure of what they want to express about a subject will know when a composition distracts or detracts from the message.

SEA WALL. The chapel at Camaret-Sur-Mer in France is visited frequently by fishermen's wives who go there to pray for the safe return of their men from the sea. Knowing this tradition presets the painting's mood. The dominant neutral colors and the dramatic contrasts of tones are meant to suggest the brooding tenor of the place.

Some small notes of color were added to the denser areas to overcome the possibility of making the picture too somber. The white of the paper, preserved in small scattered areas, helps to enliven the dull surfaces. These highlights increase the drama and give the spotlight effect of the sun's rays casting illuminated patches throughout the scene.

On the shore, to the left of the wall, is a sand and pebble beach that I wanted to include. However, I was strongly attracted to the idea of the sea wall emanating from the bottom border and leading your eye forcefully back into the picture. This is a risky compositional maneuver that intrigued me. It had the potential of dominating the entire scene. I resolved that problem by casting the lower section of the wall in shadow, thereby reducing its importance. In the end, it worked as a strong link from foreground to background, offering a change from the predictable horizontal emphasis frequently encountered in seascapes and landscapes.

Contributing in small part to the sense of space and depth is the flock of seagulls rising in the distance. Their wavering V-formation provides possibilities for finding those important rhythmic lines that can give a feeling of movement against a static sky.

PROCEDURE FOR *SEA WALL.* I predampened the sky area with a large flat brush; then, with No. 8 and No. 10 rounds, I swirled neutral gray into this area to suggest cloud formations. Essential to the sense of depth and variety of interest is a wide tonal variation. I tested the various tones on a scrap of paper before applying the mixtures to the sky.

Nimbus, or moisture-laden clouds, have a slight gray-brownish

Sea Wall *22x30 inches*

The wall itself, like a directional arrow, leads back into the depth of the picture, toward the church and other buildings and boats in the distance.

In contrast to this direct continuous lead-in, the nearby boats are placed in a staggered arrangement to add interest to the foreground area.

cast compared with the faded gray of stratus clouds, which are low and more diffused. Here the sky contains both, and I kept these factors in mind as I worked the dark areas at the top, down to the light, distant horizon.

Next, I predampened the embankment and dike, and into these areas I added a pale, neutral mixture of sienna, lampblack, ochre, ultramarine blue, and reds. These colors were mixed on the paper while the wash was damp. Equal parts ochre and ultramarine blue provided the basic neutral color, enlivened by small strokes of sienna and cadmium red. If it retained too much color in places, I added a slight touch of lampblack with a damp brush.

While the area was drying, I stippled and dashed in with the point of a small brush some dark brown and gray-brown for textural effects. The darkest shadow areas were mixed with thalo green (one part), burnt sienna (two parts), and crimson (one part), and allowed to blend with the surrounding half tones to achieve a soft edge.

I then painted the ochre-browns of the chapel, the red-brown of the brick building, and throughout the watercolor, in small areas, blended bright oranges, reds, and burnt siennas with rich darks (darks that have color—crimson or green casts—but are close to black). These patches of color, along with the reserved whites, allowed a moody atmosphere to prevail without being overly dull or gloomy.

I painted the boats last, after all the supporting stage had been set. In this way, I could better judge the correct tones and color relationships. I worked dark to light on the boats. I accentuated the rust on the large crafts by streaking red-burnt sienna through cobalt blue.

At this point, I left the watercolor for a few hours. On returning, I looked at it with a fresh eye and saw where I could gently connect the remaining unpainted areas and unify the entire painting.

Mood should never be forced or look contrived. Often the most successful paintings are made when the mood of the work is coming through without calling attention to the underlying devices for achieving it. Light and shade can help to control the mood of a picture. A high-key painting is bright, and is associated with an optimistic, even cheery mood. A low-key painting is more serious, somber, even brooding. A contrasting tonal scheme can combine elements of both, as in *Mariachis,* which contains both low-key grays and contrasting garments.

Dramatic shadow patterns can enhance the mood already established, as in *Sun and Shade,* page 82. The burros' positions against the wall and their similarity of attitude have been stated thematically, and the light effects support the theme.

In *Venetian Windows,* page 98, the strong light effects are as important as the subject matter in setting the atmospheric tenor of the watercolor. In some cases, the light and shade can be the primary picture theme as is seen in *Sunrise* on page 131.

LIGHT SOURCES

Consider the variety of effects that different light sources can provide. One of the most appealing qualities available in a painting is that of natural light seen through a window or door, as it falls across the subject. *Mariachis: San Miguel,* page 94 and *Sunshower,* page 38, make use of this natural light source, using indirect light and direct light, respectively.

Specific patterns, such as that of light shining through an arched window, louvered shades, or venetian blinds, offer some of the many possibilities that shadow distribution can provide through a window. Certainly, the light from a fire, a fireplace (see *Crepes,* p. 123), candlelight, campfire light, etc., are highly effective in setting a mood. I mention these as encouragement to observe your surroundings. *Art is where you find it.*

The contrasting tonal scheme of Ma-riachis: San Miguel combines strong, lively darks with muted lighter values for an overall effect of elegance.

Mariachis: San Miguel *22x30 inches*

By placing light planes against dark backgrounds and dark planes against light backgrounds, you create the maximum impact and visibility.

This principle was used in placing this building against its background of shadowed mountains on the right and lighted areas on the left.

After the Deer Dance *22x30 inches*

The Taos Pueblo provides a sun-drenched interface to the cool mountains above and blanket of snow below. Note the contrast on the right between the shadowed chaparral and the adobe; then, to the far left, the dark, adobe shadows were contrasted against the tone of light cottonwoods behind the structure. This allowed the true shape of the building not to be lost in shadow against the mountain. This unique shape then became a feature of the painting.

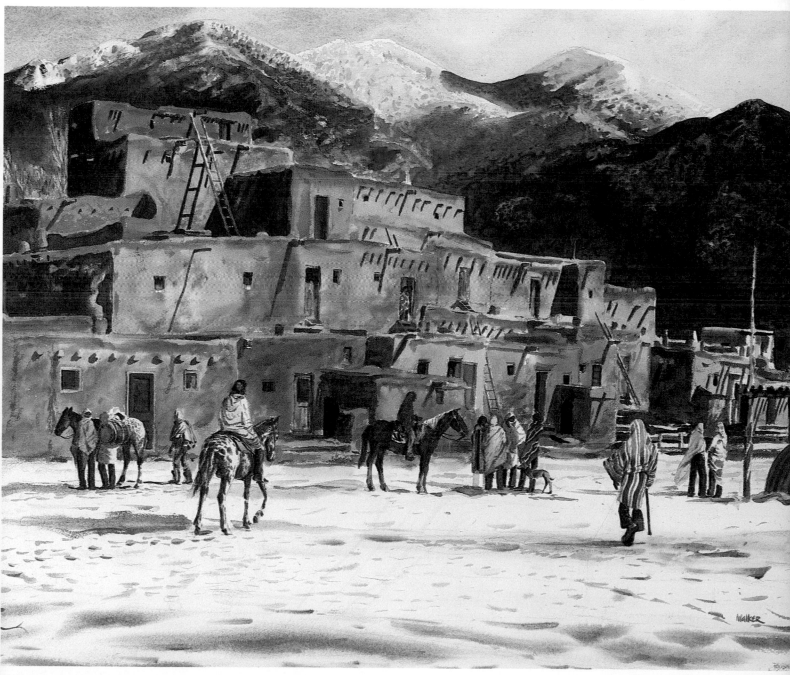

15·ARCHITECTURE

A basic understanding of perspective is essential for drawing buildings. This, along with reasonably acute powers of observation, will afford a good start in the understanding of how to create convincing drawings of architectural subjects. In addition, it can be helpful to do a brief amount of research on architecture, at the library. In this way, you can become familiar with basic styles and know what is typical and consistent within an architectural type.

I find sketching on location, from the source, to be an excellent way to learn this subject. A few months of watercolor sketches, of many different subjects from many different angles, are invaluable.

Expression is the usual concern in creating an artistic statement. Mechanical and technical facility are less important in a *fine art* representation of architectural themes than is your ability to observe and *get it down* with expres-

sion. In other words, we are replacing the calculated, flat tones and ruled lines appropriate for the architect's rendering with the softer, flowing lines and sensitive touch of the fine artist's painting. A building should appear to have a solid foundation and a convincing sense of mass, consistency, etc., yet you should not lose sight of uninhibited expression. Try to approach an architectural watercolor as you would a less structured subject, such as a landscape or a seascape. However, in architecture you also need to know what to look for, and know what are the essential characteristics necessary for an effective representation of a structure. In fine art, you need not be an expert in every specialized subject, but you should use keen observation and be able to document the essential elements of the subject and the scene.

An artist expressing architectural forms need not tighten up and

become intimidated by structures. Buildings, from barns to the *Basilica*, can be treated with a simple and direct dignity.

Don't be sidetracked when painting architectural subjects and become absorbed in meticulously rendering such details as the wood grain, when it was the light effect on the structure that was the initial feature to stir your imagination. (At times, intricate subjects can be painted with considerable brevity.)

Consider what it is you want to say with your picture, then let that be your guideline as you proceed. Take care not to lose sight of it! In our efforts to make a simple, direct, spontaneous statement, we need to be sure we have stated enough, yet not overworked our statement.

It is often difficult to loosen up when faced with the geometric shapes of buildings. It is useful, in this event, to try to think of the architectural forms as simply light and shadow shapes. Going even further, we might merely *suggest* these shapes in the course of the watercolor and go back later to define them clearly, if necessary.

I have used a loose treatment in the sky, wet-in-wet, and simplified the distant shapes into light and shade patterns. This was carried out quickly and intuitively in an attempt to get down an impression rather than a replica or copy of all the architectural elements. As I moved down the page I became more careful and exacting, still working in my usual direct manner while bringing the middle distance and foreground into progressively sharper focus.

In the immediate foreground I had carefully drawn the spires and so I was able to paint around them, leaving the white of the paper as the highlights.

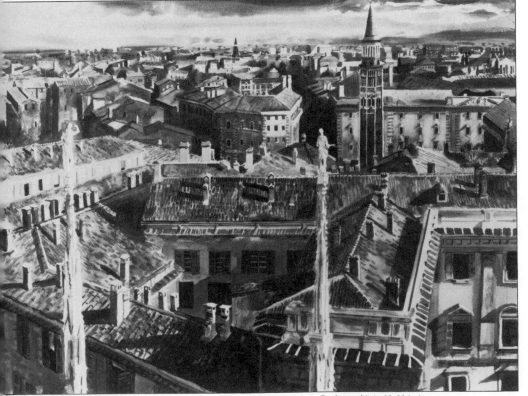

Rooftops of Italy *22x30 inches*

DETAIL IN ARCHITECTURAL THEMES

Consider what detail is essential to the composition and what is expendable. *Primary* detail is that which will be featured, and *supporting* detail is *secondary* but equally important.

PROCEDURE FOR *VENETIAN WINDOWS*. If the wrought iron balcony, shutters, rug, figure, and shadows make up the primary details, then all the rest of the scene is secondary and should support the main features.

On location there was an assortment of boxes and things, which I left out of my painting, on the upper level. The removal of the clutter and simplification of the upper tier, along with a simplification of the wall detail, allows the primary detail to stand out with no confusing distractions. Simple, flat areas play a vital role in compositions where ornamental intricacies need some visual relief. I used a flat, even, light tone that balances against these details and becomes as important as the primary detail in the final statement.

The three-dimensional aspects of the windows are due to the shadows that I darkened and extended in length. When back in the studio, I noticed I needed an interesting shadow cast from the wrought iron, so I fashioned one by bending a coathanger into the shape of a railing and shone my desk lamp on it to create an approximate shadow configuration.

The shadow from the right is secondary detailing, as is the shutter on the left, but both serve to give the sense of forms outside the picture space. My final point about detail in architecture is that even if "it" is there, you need not put "it" in the painting; if you choose to include a detail, you should have a reason for doing so.

ORGANIZATION

PARIS ROOFTOPS. At first glance, the actual scene was a confusing cluster of dissimilar structures. In order to capture the essence of the scene, I had to determine *what* was to be featured, and *how* it was to be shown.

From my point of view, the white chimneys and red smokestacks were the most important features. So, I elongated them. I also removed several unsightly structures and confusing roofs. These were replaced by more typical chimneys and roofs that were in the area to the left or right of my position. I simply moved them into the picture.

I then organized the tonal structure, shaping light against dark, and dark against light, to bring out and clarify the shapes. I used a relatively limited palette of pinks, browns, black and white, reds, blues, and neutral grays.

Part of the organization of a crowded scene rests on the ability of the viewer to pick out interesting bits of detail, such as the two windows with their curved roofs in the immediate foreground. The emphasis on light and shade calls attention to key areas in this geometrically ordered cityscape.

MONT ST. MICHEL. Rising steeply from granite rock, above the sands is the Gothic Abbey of Mont St. Michel. The village is connected with the mainland by a raised causeway that, during high tides, is submerged. Truly, this historic structure calls out to be rendered with architectural and historical accuracy.

The topmost tower culminates in a spire suggesting a shadow cast from a cloud. I used frontal lighting to reveal more clearly the shallow buttresses. A side lighting would cast longer shadows and throw the planes in deeper relief.

The summit holds the Benedictine Abbey, and the lower sections the thirteenth century monastery. The houses at the foot of the hill make up a medieval town and all is surrounded by beach fortifications. Each of these clusters has a character that should be painted like a portrait. Such details as the lofty, gabled windows and the subtle changes in surface tone are as important as the more obvious spires and towers.

I darkened the foliage to create a forceful contrast of tone for the sun-flooded structures. Without the dark pattern the impact would be reduced.

ANGLE

The *front view* in a painting has a confronting presence. It can take on a formal look, as in the *Basilica,* page 102, or, as in the *Venetian Windows,* page 98, present a more forceful and insistent image before the viewer. Depth is restored in both instances by the use of deep shadows that accentuate the depth.

The *three quarter* view generally suggests more of the form of a structure. In *Puento Nuevo,* the view emphasizes the massiveness of the bridge. The lofty vantage point is broken, or checked, by the addition of a walkway, visible at the right.

CAPTURING THE CHARACTER

Analyze the structure for its distinguishing characteristics to determine what approach to use. *Puento Nuevo* was inspired by the imposing form of the stone structure.

Surface texture reveals a lot about the character of structures. Weathered wood, time-worn sur-

The addition of an incidental *figure* may change the entire nature of the painting. Imagine this seemingly insignificant figure removed from the window. There would be a shift from the perception of the recession into the room to a more shallow relief of the building's facade. The figure adds a new dimension as well as a thematic opportunity.

When I observed this sight in Venice, the shuttered windows and balconies appeared to me to be a worthy subject. Later I considered a number of things that had to be changed to produce the compelling facade that I saw in my mind's eye. I think it was the potential for expression, rather than the actuality that brought me to this subject inasmuch as there were no interesting light effects in reality, and no figure was present.

My first thoughts were to change in some way the confusion existing on the upper terrace. This top level was cluttered with distracting objects; it also had a rather harsh geometric wrought-iron railing. I replaced this with intertwining wrought-iron, typical to the area, and removed the clutter. I left the wall and windows simple and in shadow.

I then lightened the horizontal marble entablature and deepened the shadows around the supporting brackets. These supports, or corbels, are also marble, with the characteristic time-darkened markings. I attempted to bring out the light reflected in them in order to indicate variances in tone otherwise too dark to see. I took care to texture the surface of the wood shutters so as to distinguish their surfaces from the marble and plaster textures.

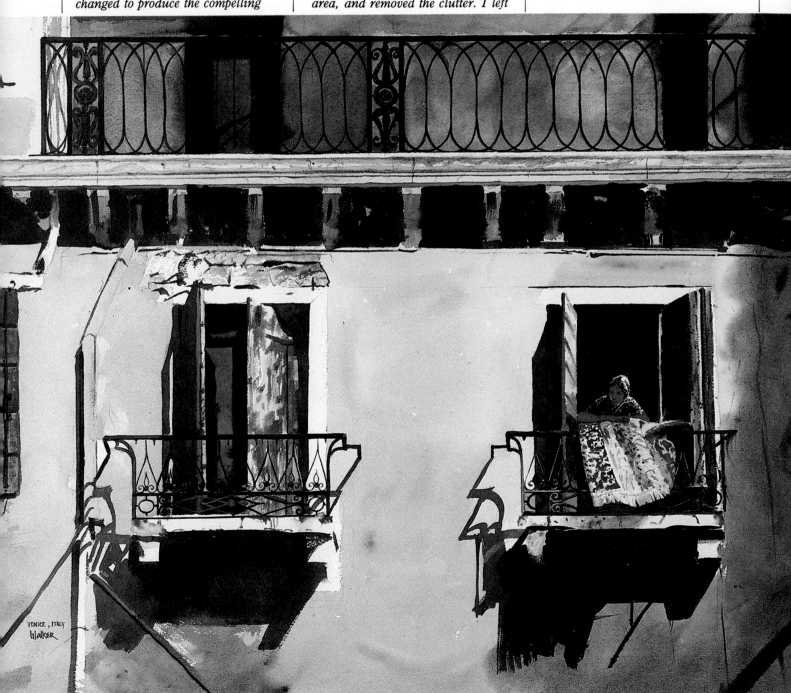

Venetian Windows *15x24 inches*

Mont St. Michel *22x30 inches*

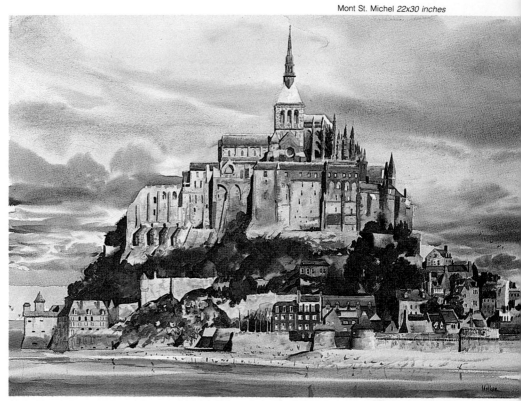

The choice of frontal lighting for Mont St. Michel *brings out select- ed architectural details which light from other angles would have ob- scured.*

Elimination of confusing detail, ex- aggeration of the most important features, and careful selection of color and tonal effects give Paris Rooftops *unity and drama.*

Paris Rooftops *22x30 inches*

Notice how the walking figure on the bridge gives scale to this massive structure. There are also figures on the balcony above the central portal.

faces, etc., contribute to their character and also suggest their comparative ages. In the hillside series, I frequently encounter modern structures that appear quite uninteresting and lack character. In the watercolor *Upper Market: San Francisco,* there are several large blocky looking buildings that fit this description. I solved the problem of "character" here by translating all the shapes into simplified block-like patterns. In the proper environment, any structure can be made to relate well to any other. Here the rectangularity is assimilated by emphasizing these rather formal shapes. I've graded the washes over the fronts of the houses to give a similarity of tone over the dissimilar structures. In this way, the character of the buildings can be retained without losing the sense of overall unity.

PROCEDURE FOR THE HILL-SIDE PAINTINGS. I first draw the scene in lightly and accurately on 140-pound, cold pressed paper that has been taped down to anchor it from the wind. Then, generally I work top to bottom, in a direct manner, blending one wash into another on dry paper. I finish each section as I go along. There is minimal overpainting (stairways, house slats, etc.) in most of these hillsides, and to get an animated effect I intensify the color and the tonality.

The sky was laid in first with a mixture of yellow ochre with a little ultramarine blue. I worked the lightest tones of the treeline and cliffs into the damp sky to blur the edges. I mixed touches of cadmium yellow and equal parts of Hooker's green and burnt umber for the tree color highlights, with a slight touch of lampblack mixed with equal parts of burnt sienna and blue to indicate the shadows.

I wanted to vary the tree clusters subtly throughout the composition, so I painted most of the trees in at this time, slightly changing color, tone, and shapes. I carefully avoided the houses without the use of block-outs.

Working quickly to catch the wet edges of the trees, I placed the shadowed planes of the houses alongside the tree forms. These two stages of shadow development were painted in sections from top to bottom.

The house half tones and the tree darks gave me, along with the white of the paper, a good value range from which to further judge the tonal pattern. The whites of the windows and roofs give a sparkling effect, so I carried out the washes around the window areas. I used no block-out solutions, because often I do not know where I will need touches of white.

I dropped in accents of orange and red late in the painting, as needed. I vary each red and orange, and don't simply use a color in different areas because it is on my brush. It is important to take the time to observe subtleties in order to include them in the painting.

There is a decorative quality to these hillsides that I wanted to capture in my watercolor. By pulling the background forward, the slant of the hills is increased. Also, I used the same color balance in the background as in the foreground. This increases the decorative effect. By contrast, if I had used more cool, receding colors in the background, I would have conveyed a more traditional feeling of recession into the picture plane. This would have been a valid statement, and it does illustrate a point. The difference in the statement you wish to make can often hinge on a few changes in procedure, color, or value.

AN APPROACH TO ELABORATE ORNAMENTATION

Architectural ornamentation can be found in subjects worldwide. Consider the opportunities offered in such diverse subjects as London's Houses of Parliament; temples in Burma, India, and China; American Victorian houses; missions of the southwestern United States and Mexico; and the cathedrals of Europe. Profuse ornamentation of interior subjects, such as beautifully carved altars, and so on, are also available to the artist, usually without need of traveling great distances.

PROCEDURE FOR *BASILICA.*

My procedure for painting the Basilica in Venice is typical of my thought processes and methods of painting such elaborate forms.

The Basilica, first of all, has great historical significance, so a realistic version holds an additional sense of reward by making a statement that, beyond the depth of the art, might hold a worthy record of the appearance of the structure at the time of the painting.

To me, a loose treatment seemed pointless because the character of the structure is designed to be majestic. Even so, I felt an interpretation of the lavish sculptural decoration, statuary, mosaics, and bas-relief, could be *suggested,* without the use of minute detail.

I analyzed the structure and the essential detail: The facade rises in two sections. The lower section is supported by an abundance of marble pillars. A terrace separates the two levels. Rising above this are three prominent domes, or lead-covered cupolas. Adorning all this solid structure are the ornamental elements. I generally worked on dry paper to keep a maximum of control, starting first with a careful but unlabored drawing that stressed proportional accuracy rather than detail.

I worked from top to bottom on the structure. The sky was left until later, when I decided a simple graded, gray sky would complement the predominantly brighter colors of the Basilica, not compete with them. The pinnacle ornaments were painted in cadmium orange over the sky wash.

I brought a graded wash down over the Eastern-style lanterns that surmount the domes, and graded a gray-brown mixture (equal parts burnt sienna and ultramarine blue with a touch of lampblack) across these domed cupolas. Before these were dry, I streaked the descriptive lines across them, letting edges blur and lines fade as they moved toward the lighted side.

I painted around any statuary at the base of the domes, then with the same mixture, tending this time more to brown, I painted the roofs of the spired canopies that encase the statues. These statues I simply suggested in cool steely grays with sepia shadows. Throughout the painting, I roughed in sections and later came back to add touches here and there.

The center winged lion (the symbol of Venice) and the angelic statuary were painted *gold* by using cadmium orange and Winsor yellow, against a Winsor blue background. I painted *around* each of the dots. (*Patience is a virtue!*) I later filled them in with gold color mixtures. This work in watercolor began to feel reminiscent of illuminated manuscripts.

I then used the same neutral-mixtures with which I started in varying combinations to indicate the semicircular bas-relief borders of the mosaics. I intensified the color in the mosaics to closer approximate the vitality of the general appearance in real life. Any use of such pure color becomes an accent when used in a surrounding field of grays.

Mixing up and applying a thick blue-black for the central window, I avoided the grid pattern, which I later painted burnt sienna.

The marble surfaces across the terrace, balustrade, and supporting arches were wet-blended with variations of burnt umber, lampblack, ultramarine blue, cobalt blue, and touches of yellow ochre, all allowed to touch and mingle. As this wash dried, I lightened the ornamental niches by picking out pigment with a paper towel, and then, using the brush, I drew the shadows of the statuettes in a warm brown. Then I went back and further defined suggestions of detail here and there.

I charged the color again, to indicate the lower lunette mosaics. In the center arch I suggested arabesque bas-relief patterns around the borders, with abbreviated brushstrokes holding a mixture of neutral sepia color.

Along the bottom section of the structure there are five portals set in deep niches. The entrances are obscured in shadow, so, in the watercolor, I lightened each one and illuminated certain details as if from a reflected light source. I worked a controlled wet-in-wet within these, to keep the look of soft shadowed edges.

During the painting of the facade, I avoided putting any paint into the flag areas, the outline of which had been carefully drawn. After the structure was finished, I placed in the flag colors. The overall vertical sensation of this watercolor is due in part to these flags, along with the standing figures that line up like a continuum of pillars at the base of the composition. This vertical repetition of elements is often very effective in a horizontal format.

I used a device here that I would avoid using with any regularity, that is, cutting the figures' feet off at the bottom of the picture. Normally, this would appear awkward. In this composition it appears to work by virtue of the layered effect that takes place. The standing figures provide a first layer overlapping the pillars as the second layer of a series of surmounted layers of the structure.

The figures represent the many nationalities that visit the Basilica. Each was painted on dry paper with close attention to their relationship in tone to the surrounding figures and to their color relationship to both other figures and the structure.

These statues I simply suggested in cool steely grays with sepia shadows.

The center winged lion (the symbol of Venice) and the angelic statuary were painted gold by using cadmium orange and Winsor yellow, against a Winsor blue background. I painted around *each* of the dots. (Patience is a virtue!) *I later filled them in with gold color mixtures.*

Upper Market: San Francisco, *part of my hillside series, shows how the repetition of a few basic shapes can make coherence out of clutter.*

Rendering of the elaborate architectural ornamentation in Basilica depends more on suggestion than on a photographic accuracy.

Along the bottom section of the structure there are five portals set in deep niches. The entrances are obscured in shadow, so, in the watercolor, I lightened each one and illuminated certain details as if from a reflected light source. I worked a controlled wet-in-wet within these, to keep the look of soft shadowed edges.

The marble surfaces across the terrace, balustrade, and supporting arches were wet-blended with variations of burnt umber, lampblack, ultramarine blue, cobalt blue, and touches of yellow ochre, all allowed to touch and mingle.

As this wash dried, I lightened the ornamental niches by picking out pigment with a paper towel, and then, using the brush, I drew the shadows of the statuettes in a warm brown. Then I went back and further defined suggestions of detail here and there.

Upper Market: San Francisco 30x22 inches

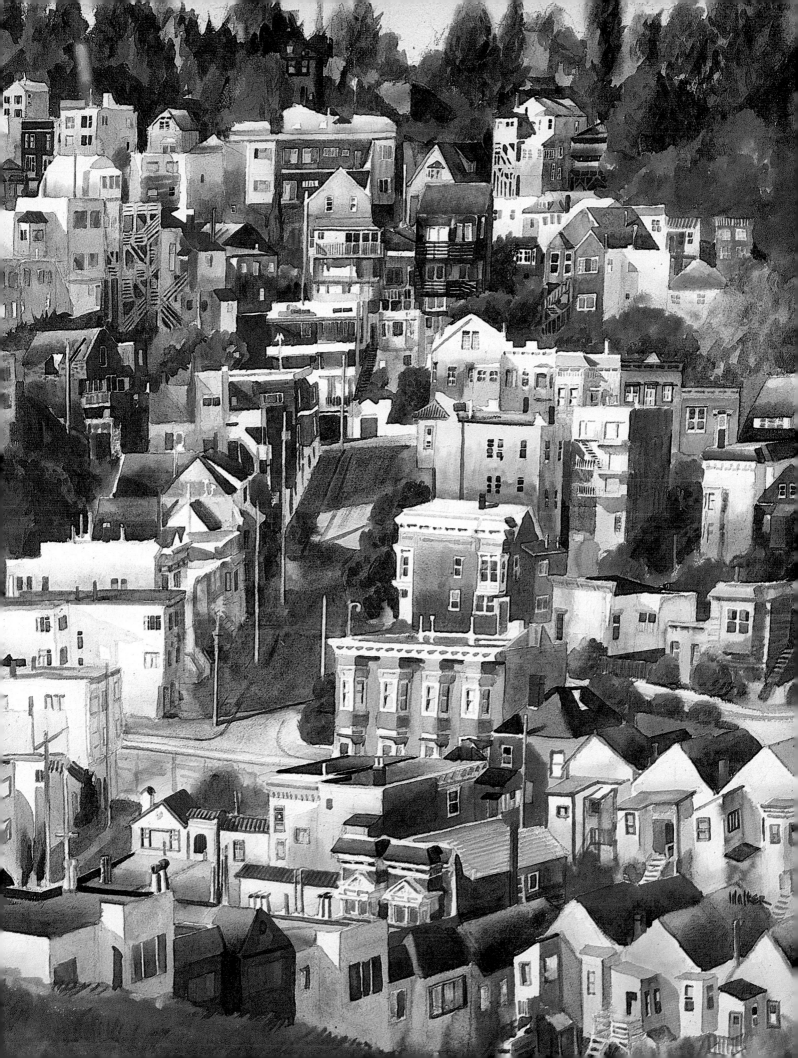

16·LANDSCAPE

"Work out the forms in nature," said John Singer Sargent. This is a special task for the watercolorist, given the immediacy of the medium.

For example, let's consider various ways to describe trees in a painting. Impressionistic dabs of color blended together can represent leaves. Whole tree *masses* with little or no distinction of leaves is also effective. So is a combination of these methods with broad wet-in-wet washes mixed with indications of individual leaves brushed onto dry paper.

Your approach to landscape is best determined by what it is about the subject that interests you, along with your technique preferences. *Working out the forms* means inventing representative symbols in the medium. Such simplistic symbols are sometimes valuable in modern art motifs. Images reduced to their simplest forms can be visually effective.

Hatch marks can represent grass across the bottom of a page; the same type of hatch marks used above a tree trunk might suggest branches or wispy leaf forms; on a

wall, these marks may appear to represent brickwork. In truth, your repertoire of symbols need not be extensive; just by virtue of placement, a few simple marks can be used for a great variety of effects.

In much the same way, a certain amount of experimentation with brush patterns over a base wash will familiarize you with the possibilities of descriptive marks.

Watercolors should not be so predictable that each tree looks the same from one painting to the next. Be careful to avoid repeating a successful combination to the point of developing a recipe for success. To avoid this, remember that each tree will be unique in its character and shape. Sensitivity to the nature of the individual tree will help you avoid this common problem.

TREE FORMS

In order to reproduce them well, the following suggestions should be noted:

1. Use impressionistic dabs of color to suggest each leaf. Allowing some to blend here and there can represent tree leaves just as effectively as broad washes grouped in clusters.

2. Suggesting tree masses with little or no distinction of leaves can present trees convincingly.

3. Use combinations of points 1 and 2 and wet-in-wet.

4. Use a dry paper rendering.

5. Another version, and the simplest of all, is the use of the child's stick figure that is easily recognized as representing a person, and which can be representative of a tree. All are viable approaches.

Every tree has a distinctive character. The trunk and reaches of the boughs and branches provide the major design network of some

trees. Others are distinctive for their leaf masses. Knowing the regional tree types helps make them convincing in your painting. Look for the growth pattern, following through from the trunk up through the boughs and the spreading branches.

PAINTING TREES

I find the most straightforward manner of painting trees in watercolor is by employing the wet-in-wet overlay procedures. Using the direct method, I lay a flat wash (usually olive green) and overlay this with short, dabbing strokes. While the flat wash is still slightly damp, dabs with a small brush will suggest leaves while the wash provides body, shape, and a sense of form. Using this method as a foundation, many variations are possible. The underlying wash can be graded in color and tone, or a varied color wash may be used. Achieving an exciting base wash variation is half the battle, or, as Ralph Waldo Emerson put it, "Well begun is half done."

When detail is desired or necessary, study the basic textures, crevices, knots, the foliage shapes, and spaces *between* these shapes. These spaces of shadow or revealing sky give a three-dimensional aspect to tree masses.

A common difficulty in painting a convincing representation of a tree is the transition of the tree from the ground. A poorly painted tree often looks as if it were cut off at the base and simply stuck into the ground. This may be remedied by flaring the base of the tree slightly, to suggest the continuing root base beneath the ground. Another problem is the abrupt hard edge at the base of a trunk or stump that looks as if it sits upon the ground, rather than growing up

from it. Adjustments of tone are usually enough to correct this. Bring the tree base closer in tone to the ground tone. Also, a softened, or graded edge at the base will unify the two if the transition is too abrupt.

COMPOSING ROCKS. To avoid a mechanical look to rocks and pebbles, vary the shapes and sizes, as well as the tones and colors. Combine hard edges with soft edges. Rock groupings should have a natural look about them. In order to preserve the arrangement the artist chooses and yet retain an informal, nonrigid appearance, it is useful to think in terms of grouping and overlapping numbers of rocks. Rocks and pebbles are not so well-ordered and separate-looking as they might appear at first glance. Close inspection reveals lost edges and uncertain shapes, irregular tonality, and usually subtle differences in the local color of each distinct surface.

I find that working into damp sections and combining this with some dry paper areas tends to add interesting variety to the overall impression.

PROCEDURE FOR *OAK TREES*. This oak tree, as with other ancient trees, has a particular personality that I wanted to capture. In order to express something that nature has produced, I feel more than just a reporting of facts is necessary. To make a statement about a living tree or a landscape, the dynamics of light and shade, and brushwork with a certain bravura, can be enlisted to infuse a sense of life into the work.

Here I have moved some of the surrounding rocks, mustard, and blue lupine, into the picture. The plain grassy area that was actually there seemed dull and uninteresting. Adding these to the composition also reflected the sur-

rounding area which was covered with wildflowers and assorted rocks.

I wet the sky area and brushed in pale mixtures of ultramarine blue (with a touch of violet and lampblack), reserving the space for the foliage. While this was wet, I continued brushing a variation of yellow-green, gray-green and blue-green mixtures into the reserved areas of foliage, producing a base wash on which to superimpose drybrush, descriptive leaf forms. I crinkled a small piece of paper and dipped it into the mixtures and stamped irregular patterns onto dried areas of the painting. I continued working on the background first and going around the network of branches, boughs, and trunks. I launched into the low-lying foliage with vigor, varying the greens and browns by wet-blended medium tones. During the drying time, I stroked in olive-colored leaf patterns of different tones.

At this point, I mixed a new variety of brighter colors to lighten the ground cover. The outcrops of rocks were completed first by laying in dabs of burnt sienna and ultramarine blue, with some brushstrokes of ochre and violet, blended into varying degrees of neutrality and purity. Over this, I randomly stamped crinkled-paper patterns carrying a darker version of these colors. I mixed a still darker version to strengthen the shadows, then laid in a wide variety of yellow, greens, olive-browns and blue-greens, across and down, to indicate grass. I reserved the whites in small dotted shapes to fill in later with lupine blues and mustard yellows.

Although it may be expedient to use a block-out solution to mask out whites, the easiest way is not always the most expressive way in watercolor painting. The irregular

Oak Trees 24x18 inches

I endeavored to capture the personality of the tree as I would in a person's portrait, but allowed myself more freedom. The rocks underscore the rugged character of the tree. The unlabored application of washes and brushwork contributes a lyrical quality to this active composition.

edge left by going around the whites, tiny as they may be in this case, is more under control in terms of being able to change the placement of each as may be necessary, or move them around as the backwash is applied.

As I proceeded downward and across, I looked back to see where horizontal shade patterns might be effective. I laid these in with forceful strokes. In fact, all brushwork was carried out with some zeal.

Such impassioned brushwork is best undertaken with no more or less verve than is natural. Forced brushwork and flair looks manipulated, but vigorous brushwork that is a natural consequence of your mood will ring true and look inspired.

I mixed three darks for the tree mass: one was brown (burnt sienna/lampblack); another a blue-violet-black, the other a true gray. Using a large No. 12 brush, I broadly blocked in the darks first to establish the main branches. I worked over the entire tree quickly alternating the three different colors (quickly in order to superimpose a still darker linear network over these darks before they dried). I used the handle of the brush in some parts to pick out a variety of light marks.

After all this fury of wet-blended darks had dried, I dry-brushed textural markings to indicate bark. Such suggestions of

Each and every tree has a distinctive character. The trunk and reaches of the boughs and branches provide the major design network of some trees. Others are distinctive in their leaf masses. Knowing the regional tree types helps make them convincing in your painting. Look for the growth pattern following through from the trunk up through

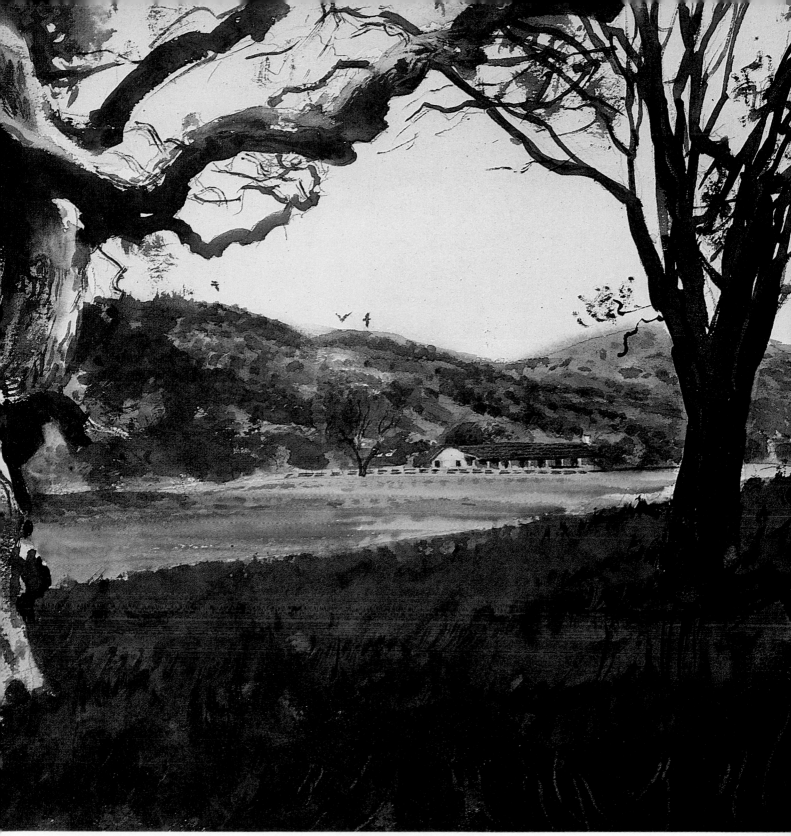

the boughs and spreading branches.
An eagle nests near this location and is seen frequently soaring high above the altitude of hawks. Even so, I couldn't resist suggesting three low-flying eagle shapes, lower than they would normally be seen.

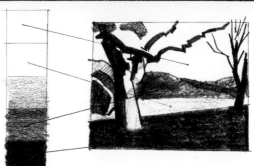

Oak Hill *11x14 inches*

Here are the basic tones of the picture. Look at the painting with squinted or half-closed eyes and you'll see these basic tones which give the picture its design and impact.

bark should not be overly regular, so I varied the weight of the brushline.

TREES AND FOLIAGE. To assess the shapes of trees, half close your eyes, as I have previously recommended, to simplify the general forms. Work out the cluster patterns of leaf masses and then delineate the single leaves, using great restraint. Suggestion is usually all that is needed to represent leaves.

PROCEDURE FOR *EUCALYPTUS GROVE*. The dominant characteristic of these trees is seen in their long trunks. To emphasize this I used a vertical format, with the trunks diminishing in size as they ascend. The Greek and Roman columns were designed along the line of the natural profile of trees. Called *entasis,* the slight swelling and then diminishing as it extends upward, with its largest dimension midway up the column, was designed as an optical correction from the clumsy look of a column that is the same circumference top to bottom. I mention this to point out the effect of simple elegance that such a small variation in tapering can have on columns of trees, pillars and the like.

A graded wash of equal parts of manganese blue and yellow ochre, with the addition of a slight touch of ultramarine blue, was laid in for the sky. The wash was thinned toward the lower tree line. I painted around the clusters of leaves as usual. While the wash was still damp, I brushed in an olive green mixture and a dark shadow of thalo violet, burnt sienna, and ultramarine beside this, to complete the formation of the foliage.

I prewet the tree trunks and brushed equal amounts of manganese blue, burnt sienna, and yellow ochre, with small brushstrokes of lampblack, allowing some colors to merge and neutralize, and others, such as the sienna, to remain pure.

Brushing in a base wash for the ground, I laid a burnt sienna to the left, blended next to a Winsor green-sienna, and blended into a flat pink-colored wash to the far right. I finished by strengthening the shadows here and there with single-stroked emphatic darks.

WHERE LAND MEETS WATER

PROCEDURE FOR *REFLECTIONS IN SPAIN*. The varied

The ghost-white boughs of the gum tree provide a natural network of vertical patterns. When painting a tree, analyze the pattern of growth: the contour and spread of the visible roots, trunk, boughs, branches, and twigs. Organize the leaf clusters into separate masses that go from light to dark. In this way the tree begins to take on a feeling of solidity.

Eucalyptus Grove 9x6 inches

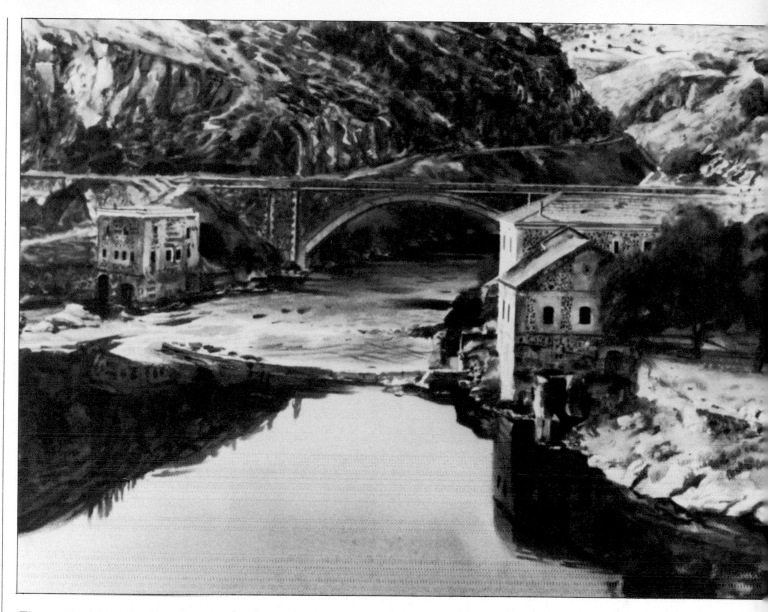

Reflections in Spain *22x30 inches*

The meeting of land and water, like that in Reflections in Spain, *gives an artist unique opportunities for contrast and variety.*

textures of this scene captivated me on a trip to Toledo, Spain. Here was an opportunity to express the contrast of rugged cliffs against clear, undisturbed water, with the accompanying mirror-like reflection.

I mixed the variegated washes of the hills on the paper rather than the palette, by intermingling burnt sienna and yellow ochre, then ultramarine blue to neutralize the first two pigments. I then added cadmium orange, manganese blue, and alizarin crimson in varying degrees of intensity. On the

shadowed side, I used more ultramarine blue and manganese blue. As the first application of washes dried, I continued to build form by defining the grassy brush and chaparral. The pink and ochre clay and earth provide natural color and textural relief from the rock and bush shapes.

I intensified the brightness and warmth of the sun in the foreground, to throw the Moorish mill into relief. The reflection here exemplifies the mirror image. Reflections in water are slightly darker in tone than the object being reflected.

On occasion, if my initial rendering of an area is not to my liking, I will immediately flood the area with water and blot the pigment off and then paint over this "ghost" image. I did that here with the river. A third chance to repaint the area is possible, if no heavy wiping has disturbed the paper surface. All the variations in the water are applied wet-in-wet.

For the involved panoramic landscape to be done on location, it is a good idea to plan the best time of day for lighting, then go for half-day painting sessions at the

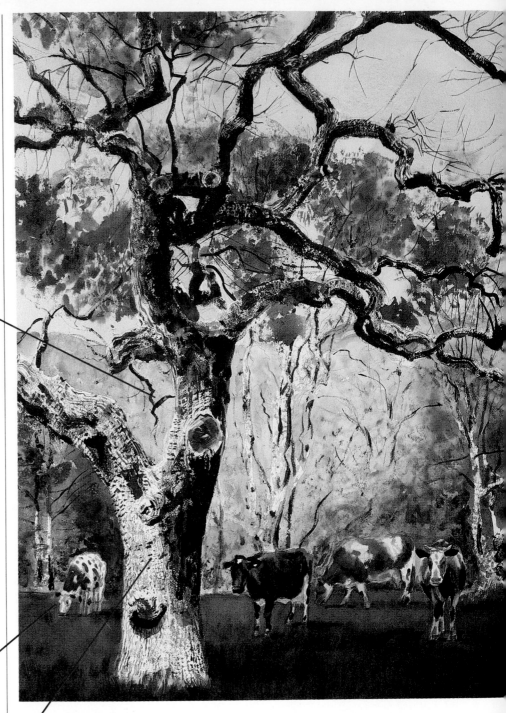

I've adjusted the palette to a high register of tone and color brightness in this foggy pastoral scene. I worked into the background base wash to achieve a controlled wet-in-wet. If I had predampened the paper, I would have missed the opportunity to design the distribution of branches as the painting developed.

I worked in sections, finishing as I proceeded, first the background, then the middle distance. Having preplanned the cows, as well as the overlapping tree, I could acquire a soft merging edge by painting the cows at the same time as the background.

The textural effects throughout were rendered while the particular area was damp. An old brush loaded with semidry lampblack and burnt sienna was used.

Silverado Country Stroll *30x22 inches*

Afternoon Shadows *22x30 inches*

This painting reveals the formidable canyon striations formed by subtle calligraphy or brush line. A base wash of light to dark was laid in by sections. While this wash was still damp, a darker tone was whisked in over it, achieving a soft-edged linear effect. Such an approach combines drawing with the handling of broad masses of watercolor washes. The solidity is imparted by this building up of planes and the strong light and shadow contrast.

same time each day to catch the same light.

PROCEDURE FOR *THE BAY AND THE HILLSIDE*. I used 140-pound cold-pressed paper. The top portion of the paper was dampened. I had the thought that any fragmented confusion in the sky would conflict with the patchwork mass of houses, so only three parallel streaks across the breadth of the sky were used. After the painting was finished, I decided that the heavens were a little too serene, so I rewet this area with two strokes of clear water and punctuated the sky with several clouds. At this time, the bay was indicated by a simple flat wash.

The same color should never reappear in the same painting in quite the same way. Subtle distinctions should be made between each color's intensity and tone. There are endless varieties to discover. Green is only one local color variation of a multitude of tree colors. With several mixtures of tree-related browns, oranges, grays, and greens, I painted the wet edges of the lower sky wash in order to use its soft-blending dampness.

Deeper-toned colors were mixed on the paper and blended into the light areas of various trees to give them contour and volume. Long shadows were described diagonally, adjacent to the trees, accentuating the light effects.

In reality, the houses were white, flat, and uninteresting, with little definition of shape. I used tonal gradation of color to enhance the structural diversity, and this further strengthened the sense of light. At the base of each of these graduated tones, the soft, rounded tree forms created an interesting contrast to the angular buildings.

Occasionally, I would turn the painting upside down to run the wash back into itself, thereby enriching these areas with granulated effects. The houses and chimneys were elongated to accentuate the vertical feeling that characterizes the hill. Each color wash was wet-blended into the adjoining one on dry paper. Several brushes, each

with different pigment, were used alternately to keep the washes clean and flowing. Each window was left white and defined at the last stages of the painting.

I was careful to control the possibility of *misplaced* emphasis by leaving too many flashing whites. One by one, each pure white area was slightly darkened with neutral, light tones and refined into windows and doors, until only a few pure whites were left as useful accents.

Each patch of color was balanced against the other. A color that appeared low in the picture would be repeated, with some variation, in the upper part of the painting. The same technique would apply to the left and right sides of the picture.

Now came the enjoyable finale! The final placement of the light red roof, sienna red chimneys, and the full range of roof colors that determine the path of vision. Along with the reserved lights, this directs the smooth passage of the viewer's eye through pleasing multiple focal points.

I use color as an expressive implement to charge life into areas that remain too passive. In this spirit, I have accented the orange passages at left center and the bright yellow house at top right.

A fine line separates scattered interest from a unified composition. The panoramic painting must be distinguished in unity and order, in this case, simplifying the bittersweet confusion of nature next to human constructions.

The elaborate drawing of *The Bay and the Hillside* serves as a typical example of compositional drawing for complicated panoramic works. Several houses from the actual scene were eliminated completely. Trees, shadows, and ground were drawn in to fill the gaps. I repeated interesting houses, with slight variations, where such recurring motifs might serve to fortify the theme.

I developed the drawing along the same procedure mentioned earlier. Holding the pencil at the

end like a brush and with sweeping movements of the arm, I lightly penciled in the major forms over the entire paper. This proportional drawing was refined and redrawn until I felt the basic elements were in place.

THE PANORAMIC SCENE

EXPRESSIVE INTENT. The nature of the artistic vision is such that the artist does not paint what is seen so much as what the artist looks for. Selection is paramount in painting. The paper can contain only so much, and unity of expressive intent defines the limits for the artist. A narrow focus does not indicate imaginative poverty, but in some cases, the panoramic states more by simply including more.

COMPOSITION OF THE PANORAMIC. When composing an outdoor scene, it helps to keep your focus general. Using your peripheral vision, take in your entire surroundings. Consider whether you should include most of the area in your picture. Would it be cluttered or could it be organized so that the whole would express more than its parts? Without a painting surface as wide as the great outdoors, we must organize and arrange components to include all interesting parts without crowding. On rare occasions, everything seems to fall into place; more often, however, change is needed. The next step is to redesign what you see into what you want to show—the most important features of the scene. These features may have to be moved and shifted.

In many panoramas there is a strong horizontal emphasis. This may not be what you want in your picture. One solution is to elongate the verticals. Some will take more extension that others. I find this adds a certain elegance, particularly to architectural forms. Also, you can eliminate many of the unnecessary elements along the horizontal plane. As you eliminate more and more elements along the horizontal and extend the vertical, you can

coordinate a composition that has the kind of emphasis you desire.

ORDER FROM CHAOS. The elimination of the unwanted, and selection of essential parts, is an individual choice. Let your guide be your own personal vision. Give thought to which elements are primary, which are secondary, and which can be eliminated entirely; however, remember that the elimination of certain obstacles, people, structures, etc., leaves gaps that sometimes need to be filled. How you accomplish this depends on your own creative sense.

PANORAMICS. The term *panorama,* used in this chapter, concerns the watercolor that gives the impression of continuous view or comprehensive survey of a subject. Such a view reveals the widened scope of the painter's vision, the illusion of surrounding the observer with a full-view representation of the scene.

In *Segovia,* a sense of air, space, and breadth exists between the figure and the chapel, and the chapel and the Alcazar. This is due, in part, to the contrast of each of these elements against its background, and the sequential graduation into the picture plane of each of them. Here, there are three points of interest.

Into a predampened sky I brushed broken washes of ultramarine blue, neutralized by yellow ochre, into the shadow areas of the clouds. I preserved the white of the cumulus clouds. I then warmed some of the shadows with the addition of burnt sienna and ochre. I separated the scattered clouds by brushing in patches of manganese blue and ultramarine blue sky. The resulting soft, wet-blended shapes help to convey a sense of a prevailing wind. By having the clouds diminish in size as they approach the horizon, a greater feeling of depth is established. The clouds also suggest the possibility of scattered sun and shade, giving me the opportunity to illuminate the terrain and structures with broken sunlight.

I used a predominance of warm yellows in the light areas

and, into this varied wash, brushed varying strokes and dashes of orange-to-brown-to-yellow green half tones, to indicate grassland. I suggested exposed rocks in the arroyo (gully) by painting around the base wash with a darker wash. Later I indicated some shadows to bring the stones into relief against the earth colors.

SKY

Sky affects the mood of a landscape and so can be employed to vitalize a relatively passive composition. The sky should relate in color, tone, and character to the land below it. For instance in *Segovia,* notice how the warm ground colors are reflected in the shadows in the clouds. Only a slight addition of a similar color will unify the ground and sky.

Cloud shadows can cast deep darks across the land. In addition, the kind of clouds you depict can echo the spirals, contours, or other features of the landscape.

A painting crowded with incidentals may undermine the sense of activity and animation by overkill. So when an already busy landscape exists, it is important to either play down the sky by simplification, or, as in *Segovia,* the sky should look organized and under control.

CLOUDS

CUMULUS. The dense, white, fluffy, flat-based clouds that billow in the sky are known as cumulus. As white as they seem, you'll find that most of them have a slight yellow cast. Considering most watercolor paper is a warm off-white, the paper, then, may be used as the whitest cloud white. A minuscule amount of yellow ochre added to the white of clouds will warm up and tone down those that you wish to underplay.

Cumulus clouds gradate from white downward to a blue-gray-violet. Their shadows show more blue as they get closer to the horizon.

Cumulus clouds float relative-

ly close to the earth's surface whereas cirrus clouds are higher. *Fracto cumulus* are broken and scattered in the sky. A fresh manganese-ultramarine blue, or pale thalo blue sky usually works best to offset these fair weather clouds. To paint them, I suggest you prewet the paper and wash the sky blue mixture around the white patches of clouds, to achieve a soft edge on each of them. To fill out the clouds and give body to them, underline each with level strokes of light blue-violet-gray and sometimes add a touch of brown.

STRATUS. Low-altitude clouds that resemble a fog bank are known as *stratus.* Such skies are usually gray to gray-blue, or gray-brown. These conditions create a diffused light.

Wash the entire sky with a light gray wash of lampblack, yellow ochre, and ultramarine blue thinned out. Use the largest brush that comfortably suits the area painted. For cloudy variations, stroke in a series of darker gray mixtures in desired shapes. Many varieties can be used: wispy strokes, streaks, or horizontal bands. Remember that these can be sequentially diminished as they recede toward the horizon.

The blue sky is ever present behind this veil of weather, so if you find a pictorial need to break stratus clouds up into fracto-stratus, let blue dashes, or spots of blue, occur here and there.

CUMULONIMBUS. These are thunderheads, white and billowing on top, and dark and dense in the body of the formations. The usual stark contrasts may allow for hard edges at the top, but these should generally merge into softer edges as the watercolor washes are brought down into the darker body of the clouds. I find that the dark areas of the nimbus clouds tend toward brown-grays.

Remember the possibilities that mixing cloud types offers within the same watercolor. For instance, stratus clouds often hover behind these mounting nimbus clouds. Patches of blue are some-

times seen, and cirrus clouds at the top distance can be painted in behind the ascending thunderheads to create stormy-looking watercolors. The fracto cumulus clouds, which are at relatively close range, can be painted as occurring in front of nimbus or stratus clouds.

CIRRUS. These high, ice-carrying clouds are white and fleecy. They are often broken up in rows. The ice they hold in the atmosphere gives them a very white appearance, with cool blue-gray shadows.

This panoramic relies on a well-ordered system of lights and darks to organize the many elements into a cohesive whole.

It is also an example of a controlled watercolor on dry paper over a precise drawing. The minute planes, softly wet-blended for the most part, are meant to give the scene a sense of expressive freedom.

The Bay and the Hillside *22x30 inches*

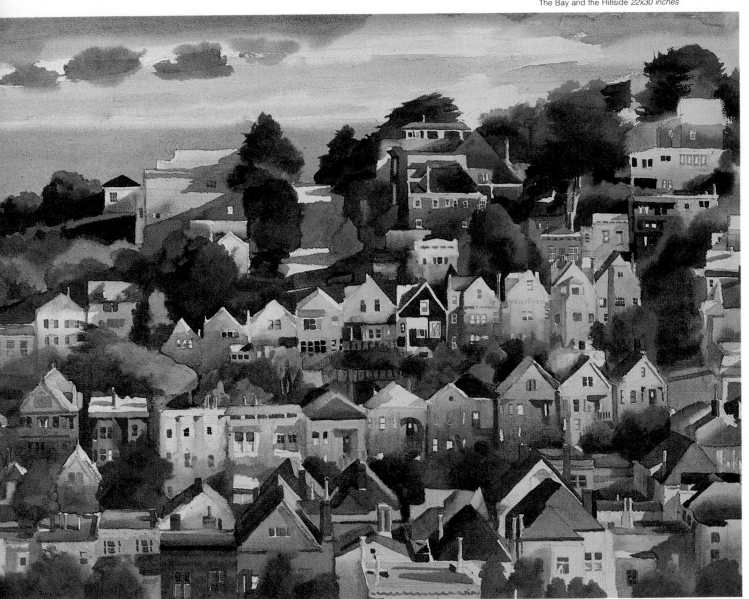

The subtle repetition of colors between ground and clouds can unify a landscape, as is done here in Segovia. Discussion is on p. 113.

Segovia *18x24 inches*

The rough-textured white of the road beyond the river mirrors the long stretches of stratus cloud in the background in Toledo, Spain.

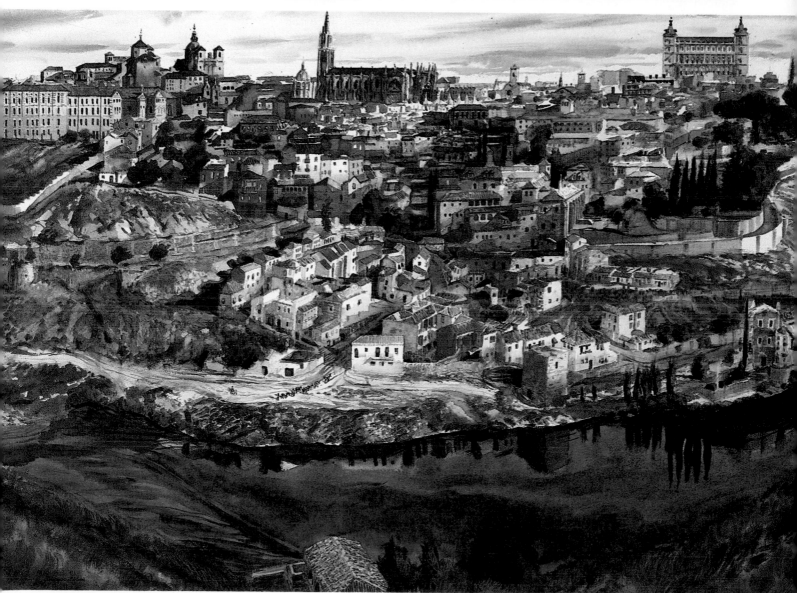

Toledo, Spain *22x30 inches*

17·MEMORY PAINTING

Envisioned painting is the painting of subjects from memory. I prefer to use the term *envisioned* painting, because the creative process generally includes designing paintings that are never exactly like the scene that inspired them. The most expressionistic of these types of works can be purely imaginative.

Memory painting has quite an illustrious past, dating back to mythology, scriptural, and lyrical works. Paintings in watercolor were often designed from poetic passages. Joseph M. W. Turner, Thomas Girtin and John Sell Cotman created the *Sketching Society* in nineteenth century Britain, where watercolors were used to paint from memory.

I often make detailed sketches after the fact, but while the matter is still fresh in the mind's eye. I use models where possible, and arrange cloths, replicas, and other details for lighting.

Lighting must be consistent, and when designing without models this can be a tricky thing to achieve. A simple, single light source is the most straightforward, with *all* surfaces defined and sculpted by the *same* light quality throughout. I used this means of lighting *Observers of the Taos Deer Dance.* Sunlight from the left illuminates everything in the picture.

To produce the view of the facade with its shallow depth and relatively similar-sized figures, I flattened out the tiers of the pueblo and sustained a flat wash (although mottled in texture) within each wall section.

I used models for several of the blanketed arrangements; others were "envisioned." All were designed to create a rhythmic flow that would not be too calculated, or too obvious, but still interrelated.

These adobe communal houses were built some 700 years

ago. The Spanish called them *pueblos,* or villages, when they arrived in 1540. The open-sided frameworks below are used for drying hides. In this painting, an implied narrative is instilled by the attitude of scattered figures, suggesting the ongoing event. I preserved the white network of the antlers that depict the Deer Dance. Compositionally they create rhythm and movement that supports the dance theme.

The gray cast is meant to suggest winter light on the pueblo wall. If an unvarying gray were used, it might have appeared flat and unrelated to the eventual multicolored foreground.

I reserved the whites by painting around them. Later, I returned to these areas to suggest folds only slightly, but I wanted to retain a maximum of undisturbed white paper. I feel that these white areas relieve the insistent colors and provide the basis for a striking contrast.

I had made numerous sketches of rugs and blankets from the Santa Fe Wheelwright Museum in New Mexico, and from various pueblo merchants. Memory plays a major role in envisioned work, so I work at sharpening my powers of observation. My family and I had the opportunity to visit Marie Orlando Ortiz at her pueblo home at the Ildefonso Pueblo. We were graciously shown around her modest home to see the blankets that hung on the walls and the ancient artifacts that reflect this rich cultural heritage. At such a time note taking, sketching, or the intrusive camera, would likely appear disrespectful.

However, the experience is not lost to the mind. These impressions can be used in paintings whenever appropriate. Keen observation is one of the most useful

assets the artist can develop.

The proud and gentle features of the pueblo people are a somewhat intangible element that has to do with facial expression and gesture, aside from high cheek bones and an earthen gold complexion. These notations are products of observation. It is useful to attempt memory sketches of recent events and fill sketchbooks with memory drawings to sharpen these skills that dull without practice.

Pueblo Blankets *22x30 inches*

This scene was envisioned from various sketches I made in New Mexico. I chose to fill the page with the figures, balancing the whites within the confines of the paper. I used a slight difference of tone and local color for each person. A suggestion of a plain pueblo wall as a backdrop allows the emphasis to be on the figures. I have developed some areas; others are merely suggested. Employing this means of selective detail gives the impression of more detail than there really is.

This watercolor was painted from a combination of written notes, mental notes, and models who posed in the studio later on.

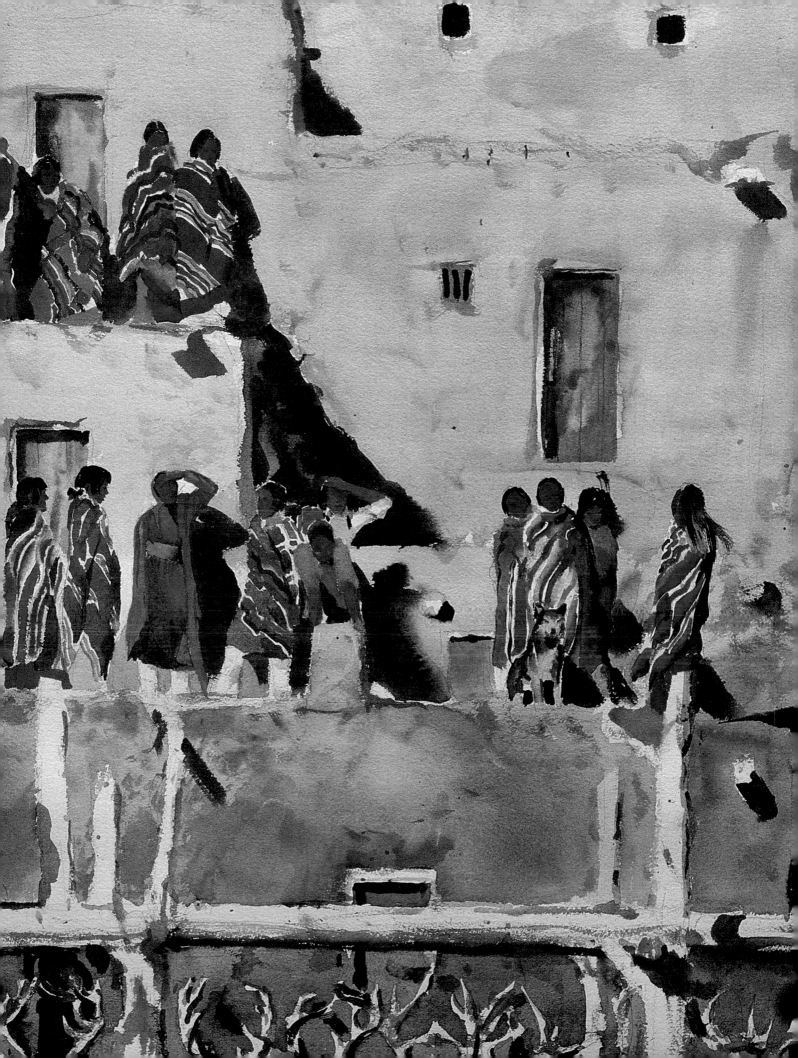

THE LOW-KEY INTERIOR

Interior lighting is usually "keyed down," i.e., darker in tone than outdoor light. Bright highlights emanating from outside lighting (through a window or door) are usually cool while artificial light, by comparison, is usually dimmer and yellowish.

I use both ends of the value scale—the light range and the dark range—with few middle tones, in the value scheme of interiors. To achieve dark and dense colors, I charge extra pigment into all of the shadow washes, floating additional pigment into the middle-tone washes as they dry. This procedure also creates a granulated effect that adds to the density of the color. Note the lower right tablecloths in *Interior Reflections.* Soft edges and lost detail within shadows are typical of interior illumination. I use black in some of these shadows, but never from the tube—always mixed with other colors. There is a variety of ways to depict a black area in order to avoid the lifeless darks of straight tube black. First, I find that a direct wash with no overlapping of other washes gives the best transparent dark. Secondly, blacks mixed with two colors enliven the sense of color in black. Crimson mixed with thalo green produces an excellent black. So do burnt sienna, plus cadmium red, and alizarin crimson with lampblack work well. Ultramarine blue and lampblack create a rich, cool dark.

In *Interior Reflections,* the interior of Chez Frances in Paris might serve to illustrate my procedure for approaching an involved interior. Here is how I planned this large watercolor:

To begin a complicated piece, the first thing I do is observe the area with half-closed eyes to sim-

A camera's view can be more distorted than that of a painter. Simplifying objects, adjusting shapes to a more normal-seeming perspective, and muting contrasts can be an effective approach to complicated scenes like Interior Reflections.

Interior Reflections *30x40 inches*

plify the tonal structure of the scene before me. I look for light patterns. These patterns of light afford a good starting point for the drawing, as well as, later, the painting, because they will encourage you to look for the big, important shapes without being distracted by small details.

The first stage, as I mentioned in *Design and Composition,* is one of organizing, rearranging, adding elements, and subtracting anything unnecessary. I consider whether I want two figures or one,

and where they will be positioned.

I will often lengthen horizontals as they vanish away to the imaginary horizon line, because too critical a slant can distort the true appearance of things. I had to lengthen the bar stool legs at the far end in the painting. Although, in reality they were long, they were not long enough to give a substantial presence. Had I painted them as they actually appeared, they would have inclined upward at too critical an angle.

In addition to this adjustment,

Diagram A contains the typical distortion of perspective a photograph of the bar would show. Notice the exaggerated difference in size between the nearest stool and the one farthest away—also the difference in heights of the near and far corners of the bar.

I made the tables and figures slightly larger to make them more important in the overall composition. I've always felt that interiors look strangely vacant without figures, unless they are otherwise filled with considerable interest in terms of light effects, shapes, patterns, and so forth.

To convey soft, diffused light throughout, I softened the edges and blurred the features of the figures by soft-blended washes. Such blurred passages also give a sense of movement to the figures.

In grading the washes on the ceiling, I used the entire range from white to near black. The sheen is due to the strong contrast. To provide a contrast in surface texture, I kept the shine to a minimum in the foreground.

I felt much of the detail was necessary, but merely suggested the smaller, minute details rather than confuse the major shapes with "finicky touches."

Diagram B eliminates this distortion and makes the bar and stools appear more normal.

The multiple light sources allow an opportunity to cast a varied light coloration and arbitrarily illuminate areas of significant interest. For instance, the light emanating from the left window (which was actually a mirror that I changed in order to provide this effect) casts a cool tinted light, whereas the main interior chandelier casts a warm yellow light. I forced color into dim shadowed parts to animate otherwise dull areas.

In this predominantly yellow-orange color scheme, the blue accents occurring in the bottles, the flowers, and the blue dress at the right background, extend the range of color.

Using a minimum of overpainting preserved the freshness of the initial washes. Some of the lights are carved out of the dark passages with the pointed end of the brush. (An example of this is seen in the lines in the buffet cabinet at the extreme right.)

REMOVING A FIGURE

In *Interior Reflections,* I felt that the waiter was too prominent in the picture, imposing a barrier to the sense of depth into the room. I decided to remove him, by using the method of "scrubbing out," which I have described under "Lightening a Too-Dark Wash" in Chapter 4.

Here, the direct method is a plus in that the pigment remains on the surface of the paper without a great amount of absorption into the fibers and so is more easily removed than when overlaid washes are used. Still, the process requires patience and careful attention to avoid disturbing the grain of the paper. In the case of dark washes or high contrasts, often found in interior lighting, you must consider the ever-present possibility of ruining the painting with well-intentioned attempts to improve it.

I used a softer brush than usual—an old sable. Working in stages, I first lifted out all the dark areas of the figure until almost arriving at white paper. Then, I dampened the entire area of the figure and floated the new dark areas into place. I let this dry before drawing in the vertical strips and bevels of the mirrors. When this dried, a slight ghost image remained in isolated areas. I delicately scrubbed these areas and lifted out the pigment with a paper towel. The natural opacity of cadmium yellow and cadmium yellow orange disguised any ghost image that remained.

Interior Reflections *30x40 inches*

When faced with complex, multiple light sources and such a profusion of detail, the best approach is: suggestion and simplification with a minimum of overpainting.

Crepes 22x30 inches

The warm glow of the firelight is reflected along the length of the arms. This line was described with a cadmium red and orange stroke into a damp yellow ochre wash (the skin tone). The polished sheen of the stationary copper pot was created by wide contrasts of warm colors into a predampened base wash of clear water. These hues include Winsor yellow, cadmium yellow, orange, red, permanent rose, and burnt sienna.

A natural gesture and expression are important in a convincing painting of figures at work. Here, the concentration in the face is evident, but an unruffled calm is imparted by the easy flexing of the wrists, weight that is shifted to a relaxed hip, and a balanced center of gravity.

The fire itself combines crisp and soft-blended areas. The upper reaches of the flames are of Winsor yellow, cadmium reds, and oranges. The lower source of the flame is a cooler red—a mixture of scarlet and crimson.

There is a barely visible checkered pattern on the apron. This pale stippling provides detail without disturbing the general light value of the garment. It is often the subtlest additions to a watercolor that will elevate it from a flat rendering to an artistic statement with solidity, character, insight, and sensitivity. The crepe appeared believable enough with the first yellow ochre wash. However, my decision to overlay this with a darker tone made it even more convincing.

Combining two light sources can add interest to interior illumination. The undisturbed whiteness of the blouse suggests light from a source other than the firelight, possibly a natural light from a window. I lightened this area purely for the resulting contrast, keeping in mind that it must be possible for such lighting to exist.

PROCEDURE FOR *CORDO-BAN MOSQUE.* Quite obviously, the brilliant sunlight which streams through the skylight and strikes these rhythmic arches provides the theme of the painting.

I made many careful notes and location sketches of this impressive scene, which accounts for the detail in the shadow and the appearance of convincing natural light.

The white of the paper graded slightly to pale yellows, infuses the back arches with a sunny illumination. This throws the near arches into relief and considerable physical presence. Accompanying these effects are the increased detail from sun-blanched parts to the textures of shade. Again, I referred to the many detailed notes and sketches I completed on location in Spain.

Each capital is slightly different, as are the marble and alabaster pillars. I predampened each area and then floated paint in, moving it around, working light to dark. I was careful to preserve valuable lights. Notice the reflected light effects that give curvature to the columns on the right.

The arches themselves are put together with wedge-shaped marble and red jasper bricks, called *voussoirs* in architectural terms. Such repetition should be varied in color and tone to make each *voussoir* slightly different. In the same way, each of the columns should be slightly different.

The floor was done with a flat wash, using a few darker tones to imply shadow variations. Just before it was completely dry, I put in the obvious cast shadows with em-

The confusion of superimposed arches to the left and right is unified by the clear line of sight down the middle, leading to the scrollwork and stained glass window. The off-center focus keeps the picture's perspective from seeming mere, sterile geometry.

Cordoban Mosque *22x30 inches*

phatic brushlines. This helped to anchor the pillars to the floor.

The two seated figures go almost unnoticed at the end of the colonnade, and are suggested only by black and white tonal shapes.

WINDOW LIGHT AND SKYLIGHT. The diffused yellow-orange glow that emanates from the skylight is rather exotic. The white of the paper and wet-blended lemon yellows, yellow ochres, and cadmium oranges, were all used to emphasize its warm qualities.

The *Queen's Horses,* and *Cordoban Mosque,* illustrate skylights and their accompanying brilliance of light. I generally blanch out areas nearest to the light source, and intensify the yellows. The white of the paper is a useful highlight in this case. Notice how it becomes more brilliant as it is graded gradually into the interior darks. Bright, clear yellow-oranges are used as transitional colors.

FILTERED LIGHT. Interiors often have diffused light sources which soften the shadows. It is helpful to decide on a light direction and radiate the shadows from this source at key points in the composition, as I have across the walkway in *Queen's Horses.* Then, considerably more freedom can be used in putting in the reflected light areas.

LOST EDGES. In reality, there is not always a clear distinct edge between the shapes which we see or paint. Painters are aware of this when they refer to "lost and found edges." There are several examples of lost edges in this picture: The shadowed underbelly of the near horse is "lost" against the equally dark tone of the wall behind it. Notice, also, how the nearest stableman's white-edged shirt sleeve is lost against the sheen of the horse—white against white. We see another example of lost edges where the pillars overlap the white railings and the arches above them overlap the skylights.

When you observe, notice that you don't always see clear, sharply defined edges all around each object you see. Be aware that lots of edges are obscure. Then, when you transfer your seeing to your painting, be sure to *lose* these same edges in your picture.

COLORED LIGHT SOURCES. The yellow light of most interior illumination affects all the colors it strikes—giving them a consistent warm hue. I frequently use a warm color scheme to achieve this effect—predominantly yellow to red-orange, with burnt sienna, lampblack, and violets in the darks.

INTERIOR PERSPECTIVE. This diagram shows you the basic perspective used in this picture. Notice that *all* of the lines that are level in the actual room at Versailles appear to converge to a single vanishing point at the far end of the hall. This point is on the horizon or eye level of the viewer looking at the scene.

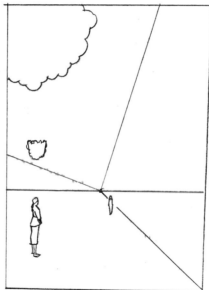

This picture is also an excellent example of the basic perspective principle—things appear to become smaller as they move farther away. Notice the great difference between the size of the windows, chandeliers, and figures in the foreground and at the end of the hall in the painting. It is these size differences that create the illusion of three-dimensional space on the flat paper surface.

Details also fade with distance. The parquet flooring, chandeliers, and figures become less detailed, simpler shapes as they recede in depth.

In Queen's Horses at the Royal Mews, *I began with a high-intensity color on dry paper. I started with the upper left rafters, using three parts crimson to one part burnt sienna, and shadows of violet and ultramarine blue (equal parts).*

Moving to the right, I used cadmium yellow and cadmium orange mixed equally with violets, and lightened the tones as the area approached the light source.

Then, I dampened the skylight area and washed in a pale violet (neutralized here and there with a touch of burnt sienna). Next to this wash and touching it, I stroked in the window arches on dry paper with a brush loaded with water and cadmium orange (with a touch of lemon yellow), catching the damp edge of the vaulted skylight and leaving a soft edge. The gold-like color I use is created by this addition of lemon yellow to cadmium yellow.

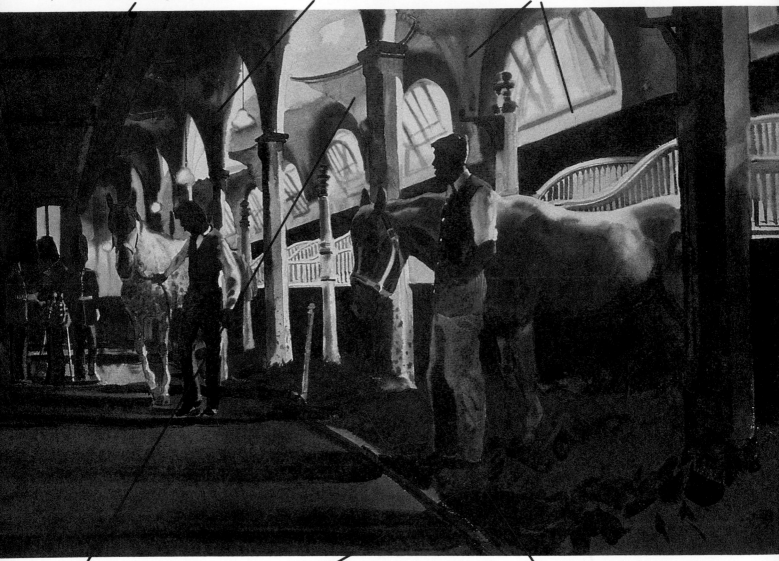

The majestic flood of light is as much due to the addition of pale violets and blues as it is to the gold, orange, and red surfaces—colors reminiscent of royalty, I thought, and appropriate to this subject.

Although straw in shade generally becomes a brownish green, I warmed it to a vibrant red, graded to a dark crimson, towards the back of the stall. Descriptive shadows were brushed into this.

As the straw moves back toward the rear of the stable, it changes to a brighter orange as the light hits it.

Queen's Horses at the Royal Mews *22x30 inches*

Versailles—Hall of Mirrors *15x11 inches*

At first glance, this painting appears to be full of carefully painted detail. Actually, this detailed effect of sumptuous decoration is only implied *by a variety of abstract splashes of tone and color merging and blending wet-in-wet throughout the painting. The dramatic window light is primarily white paper. The intensified colors of the ceiling murals were done with small brushes, working in a mosaic-like fashion with thick-pigmented washes throughout the vault of the ceiling. Intensifying the colors will often help to simulate the liveliness of the color we see in the real subject. Consider that the color intensities in real life are caused by the interaction of light. To capture this effect, I usually use a little more pigment in my wash. Or, a slightly purer color-mix will create a sense of life in an interior where darks predominate.*

The basic principle of perspective— "things appear to become smaller as they move further away from our eye"—is dramatically seen in this picture.

Although the two chandeliers, like the two figures, are actually the same size, those at the far end of the hall are only a fraction of the size of those in the foreground.

Notice that the same thing takes place in the windows in the right hand wall.

In watercolor the deep, transparent darks can be powerful and stirring when contrasted with the pure white of the paper. I often use this factor in the painting of night scenes to increase the drama.

Night paintings need not be painted at night. Observation of night lighting, tone, and color can be adapted later in the studio. A few purists paint on location by the light of the moon, street lights, or some other dim light source. Night paintings may be accomplished while looking out of a window from an adequately lighted room onto a street-lit scene, cityscape, or the like. I generally prefer to paint such works from memory in daylight.

VALUE IN NIGHT PAINTINGS

The tonality of night light is obviously keyed lower than daylight, but is not necessarily lower in color intensity. Light sources have an effect on the dimness or brilliance. For night scenes, I intensify the color by adding more pigment to the washes, to give them more body and to give a certain "presence" to the dense lighting of night. Fine detail is usually lost in night shadows. Whether you recapture this detail or obscure it depends on how important this detail is to the rest of the painting.

In *Night Wings* I merely suggested the details in order to maximize the impact of the lights and darks of this bold, powerful eagle.

Rarely do you see a spotlight or isolated light on a night subject, as the moon's glow diffuses the light; however, in painting, the artist may force the light and still achieve a plausible effect. I have forced the contrast, and fashioned the aura of a spotlight around the eagle to increase the graphic impact in *Night Wings*.

The light of the nighttime sky ranges from the deep half tones of blue-greens, ultramarine blues, blue-violets, grays, and even orange, to a tone as black as ink. This latter sky of pitch black can be mixed out of lampblack and given a greater transparency with the addition of ultramarine blue.

Light sources can be an area for creativity and originality. Contemporary statements using neon lights, car lights, street lights, are effective. One of the more inventive light sources I have seen recently was in a painting by James Wyeth with the portrayal of a mushroom picker illuminated by the flood of light from a miner's helmet. Night lighting offers an opportunity to illuminate subjects with a wide range of possible sources.

Using sketches of horses I had made in Monument Valley, I fashioned the composition you see here. The horses I had sketched were galloping more away from me than toward me. For the mechanics of the horses' motion, I relied on Eadweard Muybridge's great reference book *Animals in Motion* (Dover Publications, 1957).

In *Midnight Horses,* page 132, I used an arbitrary light source, in this case a flash of light from an unknown source—a decision based on design impact rather than on realistic fact. By using great contrast of warm and cool and of dark and light in *Midnight Horses, Night Wings,* and *Venice After the Storm,* the thematic drama is underscored in each of these watercolors.

COLOR IN NIGHT PAINTINGS

I use the same palette for night scenes as I do for daylight, but add more pigment to each wash. This charging of the color has a dual effect of intensifying the hues and

Addition of highlights and subdued, inconspicuous haloing effects can add vividness to night paintings like Night Wings.

deepening the values.

I tend towards the yellow side of the color spectrum when I want to pick up the tint of artificial light or warm sunlight, but the white of the paper produces the most brilliant contrasts against watercolor darks. I use this frequently in staging dramatic light effects such as *London Storm Breaking Up.*

Some of the most effective night paintings might not even have an all-dark sky. *London Storm Breaking Up* employs almost black obscured detail in shadows, but with selectivity of detail in the highlights that gives the impression of oncoming night. These lyrical clouds give the hint of night in the dark concentration of rain clouds. I used burnt sienna and lampblack with a small amount of ultramarine blue as the predominant hue, and varied this with a touch of violet and cadmium red in a paler mixture. The white of the paper becomes a brilliant illuminant against the dark (lampblack and cadmium red) structural details that, in turn, appear nearly black. Although the double decker bus is an accent of

Night Wings 18x15 inches

red and the clock face an ultramarine blue, the color is secondary to the light and dark pattern. I feel the simple, white concrete post in the immediate foreground breaks up the foreground horizontals and leads the eye into the picture, but, most importantly, is an unpredictable element included in an unusual place.

SUNRISE AND SUNSET

Some of the most dazzling coloration in painting and, indeed, in life itself, is produced from the "invading tides of light" across land and sea at dawn, sunrise, dusk, and sunset.

In the artist's desperation to emulate these luminous colors in pigment, they are frequently overstated in a heavy-handed way. The sunset is also the most overdone of painting concepts. Should that

discourage us in our pursuit of these wonders? No! This should in no way discourage us from attempting, and succeeding, in producing a successful sunset watercolor. A sunset that is perceptively and creatively handled can be a consummate artistic statement beyond simply the picturesque. We should be aware, however, of the challenge that we have in this regard. It is helpful to go to the source and study the sunset under different weather conditions.

I have noticed a predominance of yellows at sunrise, and a tendency toward intense reds when the sun sets. Also, generally speaking, the high sky is deep purple or blue, grading down to midpoint reds and yellows of the highest contrast. I will often include deep reddish browns throughout these areas. As the wash moves

down to the horizon, the brightest lights will often occur with less contrast of tone.

EXERCISE. A simple sunset gradation that uses the full sunset color spectrum can require some practice: start at the top with a thick mixture of deep blue-violet. Bring this down into a thinner mixture of cadmium red and crimson. Add still more water with a slight amount of cadmium orange, and more water with a very slight amount of cadmium yellow. When this is dry, paint a horizontal row of low, rolling hills in a deep violet-to-black, and level it off at the bottom with a hard edge. Now, starting with pure white at the base of this bottom edge, *reverse* the gradation to depict a water reflection mirroring the image above. This exercise is by no means simple to perform, but it will give you the basic skill required to grade the smooth transitions necessary for sunset and sunrise scenes.

DAWN AND DUSK

Both of these times have a unique light that will often cast a tint across all things in its path—many times a warm pink or yellow orange in the highlights, with a cool shadow behind each highlight. Sometimes I will portray the sky yellow (pale lemon yellow, cadmium yellow, and yellow ochre); other times, a pink to orange (Winsor red and cadmium orange thinned out with ample water). This pink-orange is the veil of color often shone across landscapes at dusk. I've noticed that, in a cloudless sky, before this pink light occurs in the morning, and after it occurs in the evening, a clear pale violet-blue tint will fill the sky. I use thalo violet, ultramarine blue, with a touch of lampblack to neutralize, diluted to a very pale wash to indicate such a sky.

I lived in Texas through tornadoes and in Okinawa, Japan, through typhoons, but the most spectacular electrical storm I have ever experienced was one October night in Venice, Italy. To depict the dramatic aftermath of the storm, I contrasted the brilliant, cool cloud highlights with the yellow street lights. I used vigorous brushstrokes to encourage a sense of turbulence left in the air after the storm.

The difficulty in painting the reflection was the changing tone and color while maintaining soft edges throughout the area of the water. I laid in the light areas first—the warm yellow tones of the building reflections and the light blue areas reflecting the gondolier and sky. Then I quickly laid in the darker blue water wash next to it. This created a soft, blended edge, but more quick work was needed to lay washes over the rest of the water before the light areas dried and created hard edges.

Although the vanishing point for all the horizontal building lines ends in the middle of the picture, our eye is not riveted there because the vertical shapes of the buildings and their reflections dominate the painting.

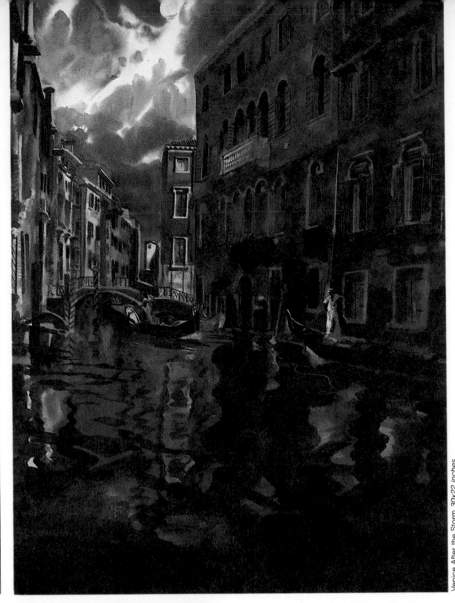

Venice After the Storm 30x22 inches

All the upward-pointing elements in London Storm Breaking Up *draw attention toward the sky, where the tumble of lights and darks and the scraps of blue sky add to the picture's dramatic effect.*

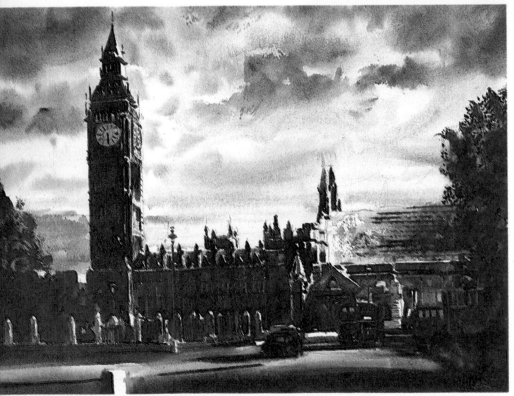

London Storm Breaking Up 11x15½ inches

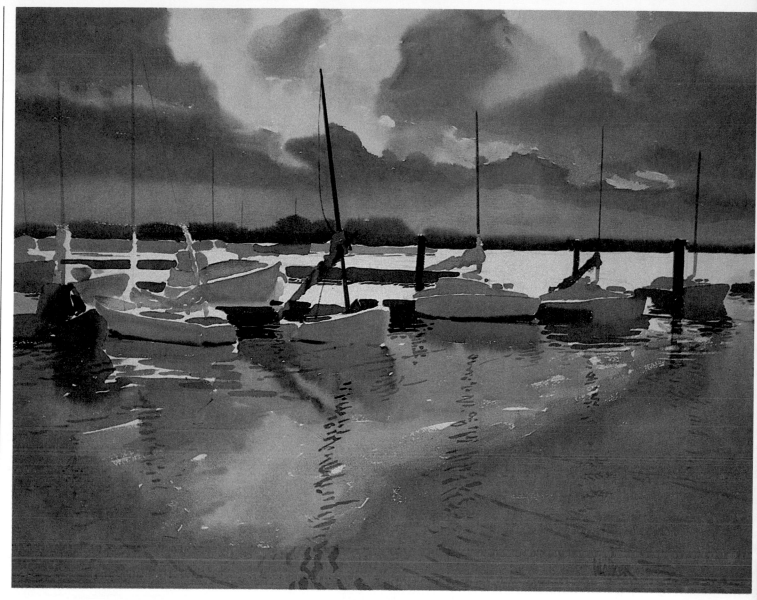

Sunrise *was painted entirely on location in minutes early in the morning as the sun broke through the clouds. It is essential to arrive on location very early and station yourself and equipment facing the sunrise. This places the inclined easel in the necessary shade, but as the sun breaks through low on the horizon, it is blinding, so I find that I must draw the scene quickly, before the arrival of the full force of the sun's glare.*

Glowing beams of sunlight are revealed on cloudy mornings and I glance at the effect to imprint it on my mind, then transcribe the images quickly in watercolor. I work from the memory of the mental image. If there are many clouds they will be ever-changing, as well as the light, so at some time relatively early in the watercolor, it is necessary to make a decision as to the arrangement of the painting's cloud formations and stick to it.

Sunrise *22x30 inches*

There is an eternal link between people close to the land and their animals. The illumination of blazing crimsons, burnt sienna and the suggestion of the ochre mane of the horse recalls the hues of sundown. The characters are set within a field of black and sienna mixtures. The edges are lost in part and defined where needed for emphasis.

The underlying pencil lines reveal a candid understanding of the drawing development and contribute to the relaxed nature of the watercolor sketch.

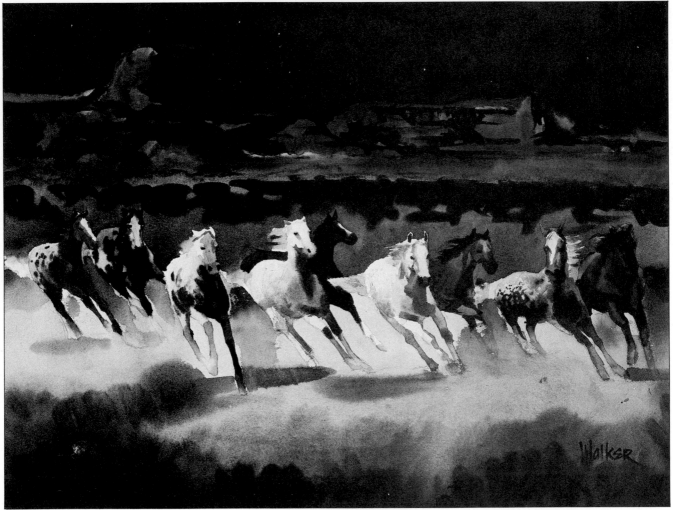

Midnight Horses 22x30 inches

Aside from the galloping horses, the sensation of motion is encouraged here by the short strokes of the brush that blur into the underlying wash. Motion diminishes the optical capacity to observe with any clarity and, similar to a glance, will imprint only an impression on the mind. In this regard, I kept detail to a minimum to achieve a sense of the fleeting glimpse.

The contrasting horses interplay with the tonal regularity of the background. The white notations punctuate the scene with an element of drama. I frequently use this white design element in the same way one might use a color accent. The stars were picked out carefully with a single-edged razor blade's tip.

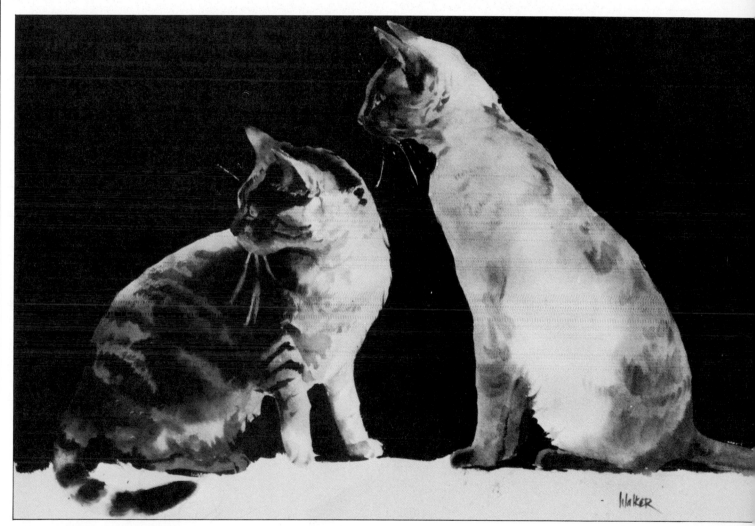

Cats, as well as other animals, are generally alert at night. Depicting such night behavior with dramatic contrasts can have a telling effect that daylight might not have with the same subject.

Two Cats in the Night *22x30 inches*

STATEMENT AND CONTENT

More can be said or implied with the addition of a figure to a painting than practically any other element. Our eyes are drawn to the human figure in painting. As an artist, this can work for you as well as against you. Once the attention is received, it must be secured with continuing interest. Too often, figures are used to fill up a space, or without direction or context with the rest of the work.

Consideration of the *attitude* and *activity* of the figures will add to their significance. Even when figures are secondary to the main theme, they should not appear aimless or without purpose.

Figures should give the impression of solidity. Attention to shadow masses will contribute to the sense of weight and mass of figures. Regardless of the overlying clothing, your painting should convey the feeling of a solid body beneath the clothes.

The beginning for all work in painting the human figure is the study of human anatomy. Sketch the live figure. There is no need for a paid model for sketching the clothed figure. Sketch the people around you, until the natural gestures of the figure become second nature to you. I prefer a large sketchbook for figure drawings.

The first watercolor work with the figure should be loose and simple. Attempt to capture with two tones, a base wash and a shadow tone, the planes of the figure. If you introduce a third tone it should be equally free, and used to indicate suggestions of features of the face and definition of the hands. In this way, you can begin by stating the essentials without laboring away at parts of the figure in order to mask a poor drawing with a high level of finish.

Figures in a landscape can provide more than scale. Careful selection of detail and pose can suggest individual character and attitude and help a picture make one unified statement about its subject.

Paisanos *22x30 inches*

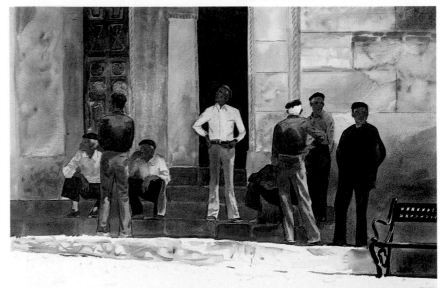

GROUPING FIGURES

UNITY OF DESIGN AND PURPOSE. There should be a consistency in the statement being made, along with an order to the design. The painter should avoid putting things in the painting just "because they were in the photo or at the location." In *Paisanos,* there was a figure (a lady sitting on the wrought-iron bench) that I eliminated. She diverted the viewer's attention to the corner and detracted from the theme established by the other figures. The somewhat syncopated heads of the paisanos (not unlike notes on a musical staff) have a similar expression and community of interest that I wanted to preserve. There are, of course, no hard and fast rules for organizing a group of figures, but *consistency* within the framework constructed by the artist provides its own criterion for what works well and what does not work.

In *Paisanos,* I overlapped the figures. I also changed the shirts to blacks, whites and grays, in favor of putting what little color I chose to use in the skin tones and the marble facade.

There is, in the restful gestures of the figures, a unity of purpose and design. Potentially distracting elements have been eliminated. The bench adds interest without intrusion, and I added a carved door in the background that was not actually there.

PLACEMENT. There are natural and posed figures, active and inactive, but the figures should look relaxed and balanced for their activity. Certainly there can be more

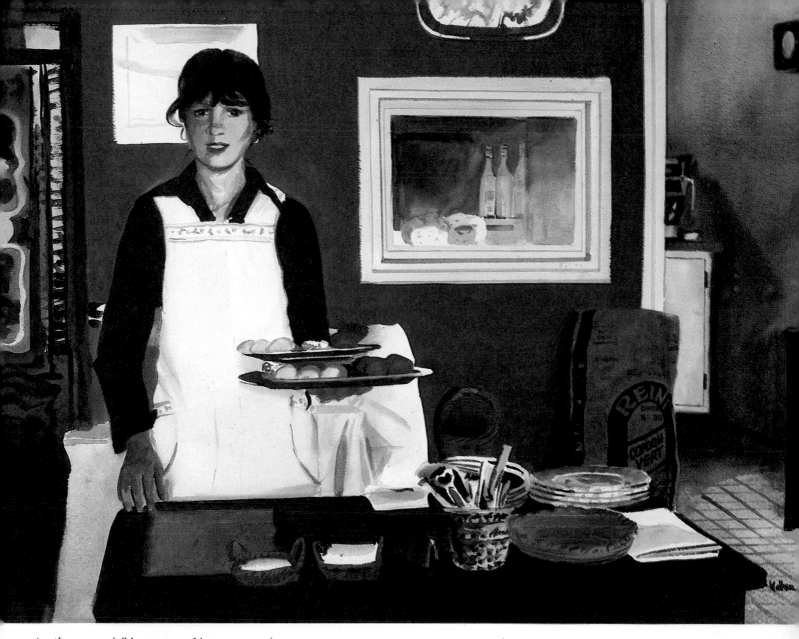

Le Matin *22x30 inches*

than one visible center of interest in a painting, but be aware of potentially misplaced emphasis. When an odd placement is introduced for a purposeful effect, to build tension or some other design, be sure that this is an element that will indeed add to the overall effect. The dark center door and center figure in *Paisanos* make an unusual placement that seems to be in order because of the groups of figures flanking this center figure. Without the outer groups, the figure would be disturbing in the center. A disconcerting arrangement can be an effective and striking arrangement, but remember that an odd place-

To me, there is an intrinsic beauty in the combination of black, white, and red. Although I rarely use a straight black, this composition, with its possibilities for an equal distribution of white, a strong half tone (red), and black, allowed this striking combination to be used. The red wall is cadmium red and burnt sienna, with touches of alizarin crimson and lampblack.

I posed this Brittany waitress behind the table and holding a tray, to call attention to the working order of the kitchen. With this arrangement, the figure becomes less a portrait and more a genre painting.

Sometimes the details of a face in even a genre painting can be refined to real portraiture, adding vividness and interest to the rest of the composition.

ment included in a painting suddenly becomes a painting about that odd element.

As you become skilled with the development of figure work (or if you already are) then the figure can be introduced into landscapes and other scenes to add scale and interest. The following are a few essentials that may assist you in the convincing addition of figures:

COLOR SIMILARITY. It is helpful to integrate some similar color from the surroundings into the figure colors. A slight tint will do the job. Such color-integration is not always necessary, but it is a way to tone down the figure or otherwise relate it to the rest of the composition.

LIGHTING. There should be a similar environmental light on the figures and elsewhere in the painting. Figures still may be "spotlighted" or otherwise accented, as long as the light effect appears to be from a plausible source. Fortunately, there is some degree of license to play with in lighting.

OVERLAPPING FORMS AND GROUPING. Overlapping figures, or grouping them, will tend to keep figures from appearing isolated or "stuck onto" the picture surface.

POSTURE AND ATTITUDE. These, together with gesture, should interrelate the figures as well as fit the context of the scene.

STRUCTURE. The figure should have weight and a sense of form and solidity. Development of the tonal structure, more than the level of detail, is essentially responsible for the sense of form.

FINISH. The hands, head and figure itself should be brought to the same level of finish. Figures that are featured may be developed slightly more than the background. Figures that are developed less than their surroundings tend to look like an afterthought and, as such, do not "ring true."

CATCHING A LIKENESS

I caught a likeness in the face of the waitress, although of course

the observer will never have the opportunity to judge this. A watercolor portrait presents difficulties only in the sense that the face must appear to be a spontaneous act of painting; not an overworked series of changes made in a desperate effort to create a likeness. This makes the face one of the most difficult of all things to paint in watercolor.

In order to solve this problem I drew lightly and with great care in the area of the features, gently erasing and refining the drawing until a likeness was captured in pencil. Tone is helpful in assessing whether the structure of the face is accurate, so I very lightly indicated pencil tone to mold the planes of the face to check the likeness. I then carefully brushed the eraser over this to remove the graphite before painting. If you leave the pencil tone in, it will be picked up and affect the watercolor washes. With only the ghost image of the pencil showing, I wet the entire face with clear water; then, dropping a pale yellow ochre into this, I let the wash dry to a damp stage. During this stage I brushed in, with controlled deliberation, the shadows of the face. These shadows consisted of a light shadow tone and a darker tone mixed with burnt sienna, yellow ochre, and very slight additions of cadmium red and thalo violet. I used a No. 8 brush. Use the largest brush that can comfortably be used to lay in the shadow shapes. This insures the least amount of finicky touches in brushing.

I have arranged the model for this pose in a position behind the table, thereby setting up a series of overlapping elements: the table, the figure, the background wall and the sack overlapping the doorway. The tray adds yet another overlapping element. This all sets up a unified whole, where each part relates to another as it appears to recede into the picture plane.

I have consistently used high contrast, following the precedent set by the figure and garment. Working on dry paper for the most

part insured maximum control, as I painted around all the reserved whites. Note that there are subtle tones across all the whites.

THE FIGURE

FLESH COLOR AND TONE. In watercolor, the palest lights and darkest darks often give the most trouble. Here, I will give some help with the elusive tints of pale flesh tones. Wet a swatch of paper and, using a merely damp, not wet, brush, mix the palest form of equal parts ochre, cadmium red light (with just a touch of sienna and crimson for the medium tones) that you can. Allow the pale pigment to float onto the wash. What you want is to merely tint the area (get out of your mind the idea of coloring the area). As it dries it will lighten, so watch to see where you will want to float on a little more pigment to establish the middle-light tones. Finally, the darks should be laid in with only one or two more strokes to define the form. The less fiddling with a wash, the clearer and more transparent it will be when finished.

In the course of my travels here and there, I am often asked about my figure paintings and about skin color mixing in particular. This subject is so diverse I hardly know how to answer, but I think the questions are valid and I would like to include a few color notes that I have observed along the way. These are far from scientific, and are loosely stated, but will serve as a guide for the lost:

Apart from the differences of skeletal structure and features, color and skin tones of different cultures are noteworthy for the watercolorist. *Asian* skin color, by my observation, can be mixed with burnt or raw sienna and yellow ochre. *Native American* and *Middle Eastern* skin tones are a deep tan. I use the same color mixture for these two cultures as I do for Central and South Americans, a mixture of yellow ochre or cadmium orange highlights with yellow ochre and burnt sienna as a base wash,

and with thalo violet for shadows. The hair of these dark-pigmented cultures is a true black, often with blue highlights (on occasion, brownish-gray highlights).

Other highlights, such as the rich burnt siennas, ochres, and reflected bluish light on some *black* or *African* skin, to me is an elegant graded color. When represented in the transparent medium of watercolor, the highlights are most effective when wet-blended from soft graded tones of the highlights and middle values to the deep sienna and violet-brown shadows. In my travels I have observed that the Australian aborigines appear to be so true a black that their highlights are often almost gray.

Caucasian skin has as many variations as the others. For the milky-white or "peaches and cream" English skin, I wet the paper and float equal parts of a pale crimson and ochre, with a slight tonal change (three parts violet to one part ochre), pushing these colors about on the page to vary the effect as desired. (See *Sunshower,* pg. 38.) The addition of a touch of Winsor green to the brown skin tone (equal parts ochre and burnt sienna) accurately depicts the Mediterranean coloring. This addition of green is also often needed in indoor lighting on skin tones.

I can only state skin color as loosely as this or run the risk of being misleading. Skin color is extremely subtle, influenced by reflected light and other conditions, such as weather. There are no recipes for skin tones in watercolor, only guidelines.

Analysis of skin and surface quality is important, and so are the different facial features of each proud race. (Mohammed Ali returned one of his earlier trophies because it had a sculptured figure with Caucasian features.) Study the different features and depict them with the sensitivity that you would your closest friends' (if they aren't already), and you will be halfway to grasping the essence of their individual appearances. Portraiture is art relative to all humankind.

The Fountain 30x22 inches

ACTION PAINTING

I think of detail in action painting like the fleeting glimpse from a train, i.e., we see less detail with things in motion. I therefore tend to simplify details that are featuring action. A well-worked or exceedingly deliberate rendering of a passage seems to call out for a longer look and slows down movement. This knowledge can be useful from the point of view of designing an interruption of the natural flow of things to feature some aspect of a composition.

The movement of figures is a way for the artist to imply that something *has* happened, and to suggest things that *will* happen. By implying movement, we communicate a sense of "time" within the painting. Here, literal fact is of less importance than *suggestion* of details, and the gesture or posture of figures will give a directional rhythm that implies movement. *Sugar Ray Leonard,* page 71, exemplifies *suspended action,* or midaction. There is the sense of obvious motion in the attitude of the

figures. *Candle Lit Flamenco* depicts a figure poised in an action just about to take place, or having just taken place.

If a straight line is drawn from between the legs up through the midneck region, the figure will seem balanced and generally not in motion. Tilting the figure from this vertical line causes the sense of action. I used this factor in *The Hunters,* page 143, to sway the figures in a slow amble, and in the *Candle Lit Flamenco* painting in a similar manner. The front figure leans one way, and the back figure the other way in both of these watercolors, producing a counter-directional sway. These inclined elements within the painting imply motion or impending action in a subtle manner, much in the same way as the slight rake of a ship's mast can suggest a gentle pitch of the sea.

Wet-blended passages and *suggestion* of detail are factors that enhance the portrayal of motion. Most of the action watercolors in this book use a blurred suggestion, a simplicity, along with quick

The white stucco wall sets up a natural backdrop for a variety of characters. In actuality, none of these figures were in this locale, but some were in the general vicinity. I grouped the figures close and overlapping, to tie them into the setting in a natural and candid manner.

Portal to the Fez al-Bali 22x30 inches

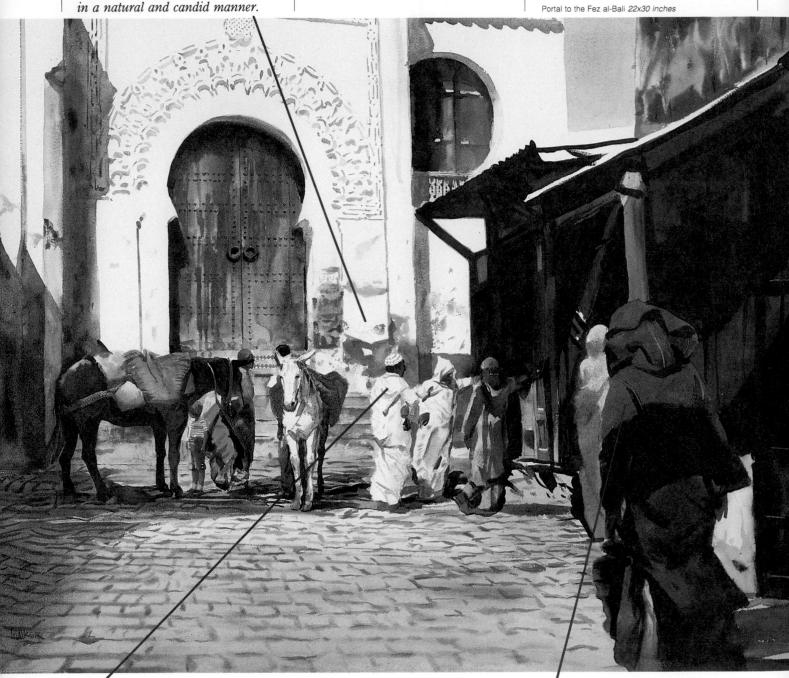

There is a sense of solid form beneath the garments of the figures, due to the lighter tones on the hood and shoulders, which blend softly into the very dark-toned shape that represents the rest of the body.

The near figure is of sufficient size to moderate the monumental door, as well as tie the foreground in with the midground.

Overlapping boats and figures, these children are interrelated also by their similar postures.

The base wash for each tree is of a different color and tone. I dabbed irregular strokes of a darker tone over this undertone to suggest leaf forms. This application of descriptive strokes is controlled, but carried out quickly and expressively.

There is the appearance of a low, pervading sunlight casting long shadows despite the rain clouds in the near distance. The high contrast, lengthy shadows, colorful reflections, bright yellow dress, and the subtle gradation of the sails, all contribute to the quality of light throughout.

Melody at the Tuileries *22x30 inches*

brushstrokes, that tends to animate a painting.

The folds and pleats of *Candle Lit Flamenco* were accomplished on a slightly dampened underwash of equal parts cadmium orange and yellow ochre, with a thick-mixture shadow tone of equal parts lampblack, and thalo violet, with touches of cadmium orange, yellow ochre and cadmium red. These colors, with the occasional addition of alizarin crimson and ultramarine blue, account for the entire color scheme. The technique is similar throughout—that of applying an undercoat and placing a dark color over this while the underwash is damp. This direct method of painting is particularly suited to action paintings, where directness in the handling of the medium enlivens the sense of activity in the work.

In a relatively passive watercolor, brisk brushwork such as that in *The Hunters* may help accelerate the tempo or dynamics of the composition aside from the narrative itself—in this case the narrative being the casual hunters with their alert dogs. There is a contrast of tempos in this painting—the stillness of the water, the suggestion of a breeze in the grass, and the amble of the men and the active dogs. These contrasts, together with color and tone, establish a mood. The attitude of the men is relaxed, but it shows a sense of purpose.

CENTERING THE ACTION. As a general rule, action that occurs at the edges of the painting tends to lead the eye out of the picture, unless offset by action towards the center.

PROCEDURE FOR *THE HUNTERS.* I started at the top, bringing the pale lampblack, blue, and ochre wash down to the distant land strip. While this was damp, I brushed in the foliage with pure cadmium orange and yellow, blending this with a brownish green mixture (burnt sienna, ochre, and Winsor green in equal proportions). I had strategically placed the hat shape to catch part of this dark area and still show the profile of the hunter's face below the land mass. (From the outset, preferably in small thumbnail sketches, I like to plan these dynamics of design, as well as the directional movement, if motion within the characters is going to play a significant part in the composition.) The wedge of land masses and the shotguns provide a striking horizontal to the vertical figures. The guns are slightly inclined to encourage the sense of motion.

I brought the large gray wash representing the water down and around the figures, with only a few ripples indicated, to maximize the contrast. Immediately applying patches of color to the foreground, the wet-blended light tones were defined as patches of grass by the dark shadow shapes that I brought around each of the clumps of foliage. The series of wispy strokes, representing grass, were carefully planned, but carried out briskly and directly. The gray overcoats consisted of a variety of colors mixed on the paper to a deep tone. Only two applications of paint were used: a graded half tone undercoat and brownish-black brushstrokes to indicate creases.

A rich mixture of burnt sienna (two parts), cadmium orange (one part), and yellow ochre (one part) was used for the skin tones. When I had completed the painting, the top derby-style hat was left white. I decided to add form to this shape by wetting the area and gently flowing in a yellow ochre and cadmium red neutral tone.

The Last Word is essentially a portrait of three figures. I wanted authenticity, so I discussed the matter of events within a typical day of law proceedings with Attorney Peter Turner, on the left. Pete and his father, John Turner (also a lawyer), agreed to pose. I then arranged to meet a striking figure, Judge Donald P. McCullum. Judge McCullum agreed to pose and invited me to take photos within his chambers. I was interested in depicting a realistic account of the final arguments about a point of law behind closed doors, as well as making the figures appear natural and convincing.

PROCEDURE FOR *THE LAST WORD.* I started this watercolor (after a painstakingly accurate pencil drawing) working from the background to the foreground, leaving the figures until last. The heads and the hands were the last to be painted. This allowed me to state the entire color and tonal backdrop before committing myself to the exacting skin colors.

I worked on dry paper for better controlled washes, starting at the top left and working down and across. I painted several books at a time to acquire soft edges and a certain uniformity in the volumes that were similar. I softened the edges of all the books, sometimes going back with a slightly damp brush and dabbing the edges until they were soft.

The books in the middle area were, in reality, a newer variety of blue books than I have painted them. I have darkened them so they would blend in more with the background and acquire a slightly antiquated appearance.

There is a window (out of the picture area at the left), that casts a light blue highlight on the left side of the figures. This is subtle, but is the type of seemingly insignificant highlighting that conveys a sense of solidity and three-dimensional form in objects. I have lightened the right side of the judge's robe with a warmer variation of black (brownish-black) in the same interests of form and solidity. If the shadow were painted as black as it seemed, the area would appear flat; lightened, it is given form as well as detail.

The parallel lines of the pin-stripes in Peter Turner's suit were scratched out of the dark blue wash by the pointed end of the brush.

THE PORTRAIT

In painting a portrait, we have a unique task to fulfill, capturing a likeness and a typical "look" about a person. This is complicated by

Moonlight Shower 9x5 inches

Figure work on smooth paper affords the opportunity to push the paint around and remove washes relatively easily. The reflected light enhances the sense of form in this spontaneous and translucent watercolor.

the fact that everyone has his own idea of what another person looks like. The problem is that we don't see people in "frozen frame," suspended at a moment in time. We see them, usually, in conversation, slightly moving the head, with subtle changes of expression.

An integral part of painting a successful portrait is establishing a typical look for the person involved; that is, a pose that brings out the positive and most identifying features of the person. We all have had snapshots of ourselves which we do not feel are typical of us. Some only slightly resemble the way we see ourselves. The task of the portrait painter is to analyze the face to such an extent that he or she can determine what distinctive features are typical and what distinguishing marks, wrinkles, lines, and so forth, are essential to establishing the whole character.

Some things should be played down if they are *not* typical. For

instance, the tilt of the head downward sometimes brings out a double chin. If a double chin is only noticeable at that angle then it should be avoided and the pose altered to reduce the chin excess.

SUBMITTING THE FINISHED PORTRAIT. When people are called upon to give their opinion of the portrait, be ready for this personal interpretation from each viewer: "It's the nose," "The lip's wrong, somehow," "His eyes look tired," or worst of all, "That doesn't look like him at all." These are just some of the remarks that can be made about a poor portrait or a perfectly executed portrait. Everybody becomes an expert in the field of portraiture when it involves someone close to him. This is, indeed, an area where honesty prevails and unsolicited opinions pour forth.

I feel that I am a better portrait painter today because of such comments heard years ago. One suddenly realizes how important

Women in Mexico is full of movement. The woman toward the left turns for a second look at the earthenware pots; the woman at the right leans to see better; the woman to her left calms a fretful girl while another girl saunters away, basket balanced jauntily on her head. The young pot-vendor, far right, turns her head attentively in hopes of a sale. The idle men in the background are a static contrast. All these individual attitudes add vividness to this street scene.

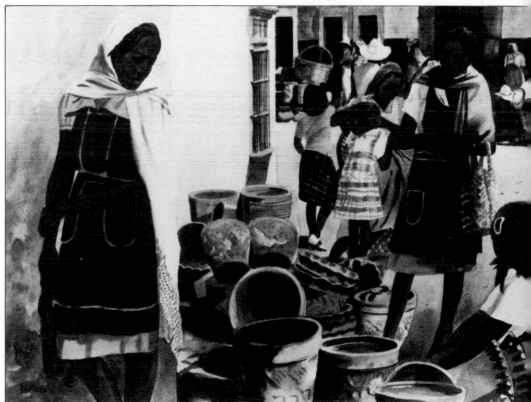

The Women of Mexico 22x30 inches

capturing not just a likeness but the essence of the person is to all those who know the subject. My portraits are now successful because I take the time to know the *person* behind the visual image. I discuss the type of portrait the sitter is expecting as well as share my own ideas.

If you have any doubts about the work, consider yourself not finished with it, and continue until there is no doubt in your mind. The portrait is one of the most difficult of watercolor works and it must appear fresh and unlabored. Do not hesitate to start over if the first is overworked. Even the premier portrait painter John Singer Sargent suffered bad reviews at times, so remember, beyond any host of critics, it should ultimately be the sitter who decides when the portrait is right and then the artist.

My Florentine friend and framer of local renown in Berkeley, California, Gino Frosini, told my wife and me a story when we were last in Italy. Michelangelo was presenting his finished statue *David* to the clergy, whereupon the Pope remarked, "The nose is wrong—it's too big." All those present agreed the nose should be changed. The stern Michelangelo dutifully ascended the scaffold and hammered awhile, as the marble dust dropped about the base of the sculpture. The audience applauded and agreed that this was much better; this was a nose of "remarkable subtlety." Michelangelo had, in fact, taken a handful of marble dust with him up the scaffold and dropped it, little by little, never touching the nose with chisel or hammer.

I prefer portraits that reveal something about the person aside from a head-and-shoulders likeness. A depiction of some activity of the person, familiar surroundings, or at least enough of the individual showing to suggest the whole figure. Including the hands in the portrait is helpful in giving a sense of the entire person.

HOW DO YOU BEGIN? You must first determine if you wish

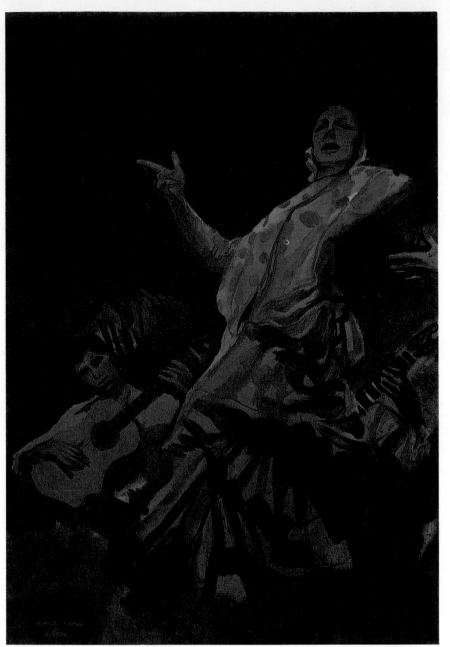

Candle Lit Flamenco 30x22 inches

In Candle Lit Flamenco, *I used a rather spirited color, the attempt being to imitate flickering candlelight and bathe the figures in this warm light. I mixed a thick black, burnt sienna, and cadmium red background wash and applied this first. This enabled me to estimate the values that grade dark-to-light-to-dark from top to bottom in the figures.*

I almost gave up on this midway through, having never before attempted such a dark and fluid subject in watercolor. As I painted, it appeared to be out of control. Persistence prevailed, although I was sure it was simply an exercise from which to learn. This feeling of lost

hope did have the effect of "loosening me up." Three-quarters of the way through, I found myself regaining the sense of control and realized I had been utilizing my instincts—more often than not the way to solve problems that arise in midpainting.

The diagonal tilt of the dancer is a countermovement to the dancer's arm and the guitarist's head. The parallel direction of the guitar underscores the central figure's angle. These rhythmic patterns, along with the flowing folds of the garment, add a sweeping movement and assist in avoiding the frozen or static suspension that sometimes plagues action paintings.

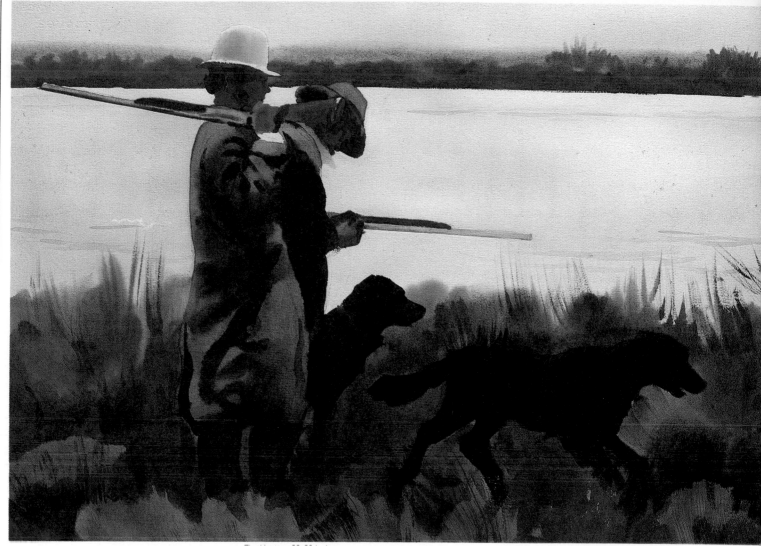

The Hunters *22x30 inches*

In this picture, the hunters are the center of interest even though their shapes (relative to the shapes of the dogs) are fairly static and unexciting.

The more active dog shapes could have easily confused and weakened the overall picture pattern. To avoid this I darkened their background so the emphasis shifted to the hunters. Only a part of each dog's head shows up in contrast with the background.

The diagram shows how the dogs would detract from the hunters if their background was light.

the model to sit for the portrait or whether you will work from photos. Many of the first portraits an artist will paint will be self-portraits and relatives. Sitting for the entire portrait then becomes relatively uncomplicated. In today's busy world, the commissioned portrait is often not accomplished with the model posing the entire time. Photos taken by the artist take the model's place. The subject may then only be required to sit for the last session, or not at all.

PAINTING FROM THE MODEL. Compassion for the model is my first thought. Posing is gruelling, and the painter must remember that frequent stretching and breaks will keep the model from looking tired. My experience has been that portraits painted from life are somewhat more spontaneous in appearance and tend to

capture the moment, as well as the way a person appears "that day."

In contrast, paintings from photographs taken by the artist often appear less spontaneous, but I find they will capture a more general likeness of the individual if the proper skill with the camera is utilized. It is sometimes a good practice to work from photos to a certain stage and finish with the model present. In watercolors, it is easy to overwork that last stage.

I take photos in different light, standing, sitting, and from different angles. It is then helpful to borrow favorite photos of the person involved from their own snapshots of the past. I find that comparing how a person looked a few years ago, and what he or she perceives to be a good likeness, together with my photos, will provide me with sufficient information to capture the essence of a person's general appearance. Usually, one photo will stand out as the key pose to follow. If it is full-face or three-quarter face, then a profile shot is helpful in showing the configuration of the nose. Optical illusions of the shape of the nose from the front are frequently factors to overcome. A nose may look larger than it should if the light is hitting it at an awkward angle. A soft light is usually the best.

The dark, dim portrait is also a thing of the past. Certainly, low key portraits may be fitting for some personalities, but this lighting will not do for everyone. Outside light, with the figure becoming a part of the greater picture, is acceptable. For instance, if the subject is involved in boating or ranching, a boat scene or the subject's ranch may provide the right background. However, the background should not be distracting. Like a stage for actors, the background scene should support the main character, not dominate him or her. *Le Matin*, (page 135), and *The Elements*, (page 81), are paintings of people involved in their daily work, and so combine fine art and portraiture. Some of the finest portraits are also works of art.

Beneath the details and textures that fill this picture is a basic pattern of light against dark that ensures the dominance of the judge as the picture's center of interest.

The light papers on the desk form an enclosing arc around the judge, whose head is framed, or bracketed, by the light shapes of the two lawyers. The line of glance from the right hand figures also guides our eye to the central figure.

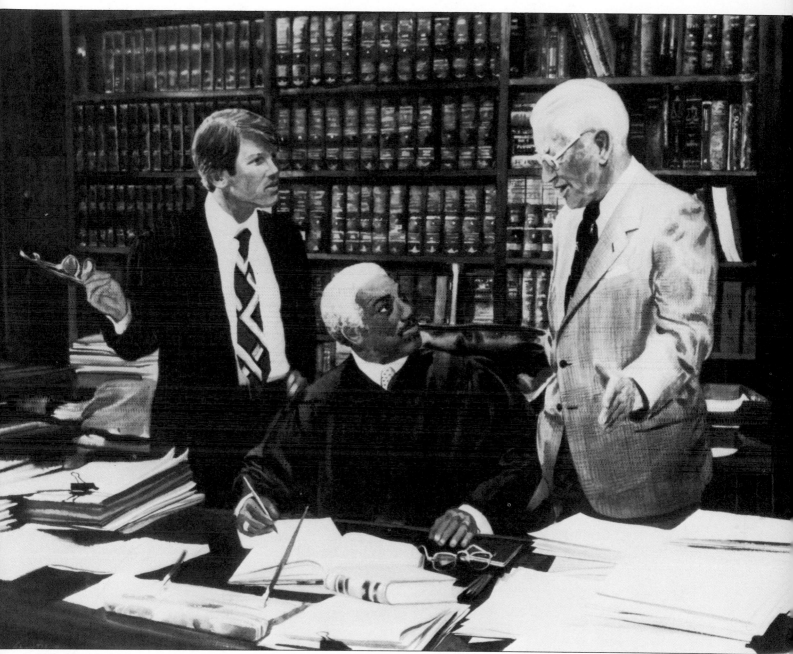

The Last Word *30x40 inches*
Published in the Encyclopedia of American Law, West
Publishing Company

Drawn from a photo, The Last Word *is a portrait of the three figures. I worked out all the surrounding details and colors first so that I could then choose the best skin tones and render details of the faces, the picture's chief points of interest.*

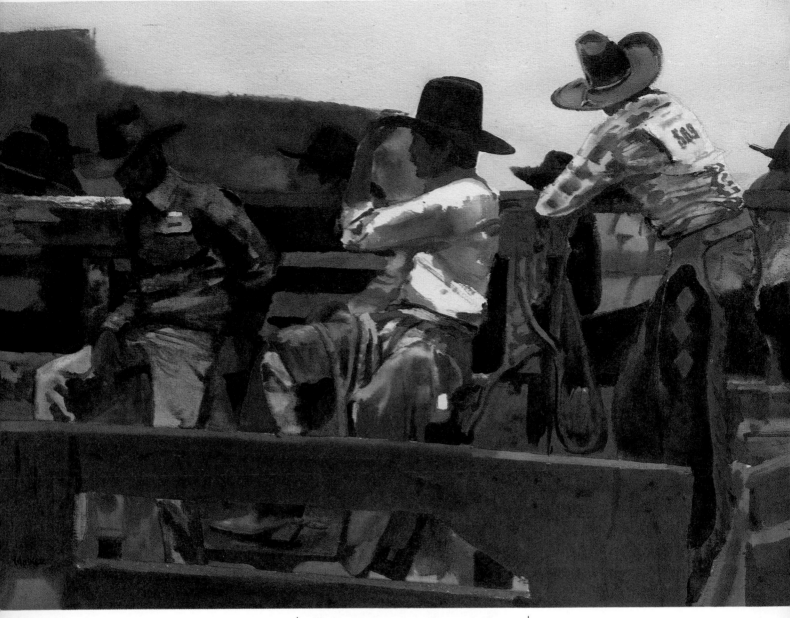

The central gesture, the man's firmly settling his hat, suggests both a salute and preparation for the gruelling experience of a bull ride. The walled-in chute gives a sense of constraint, events narrowing to a confrontation; the men's attention, turned away both from one another and from the viewer, emphasizes the individual nature of the test and locates the picture's source of drama outside the picture itself: the unseen bull.

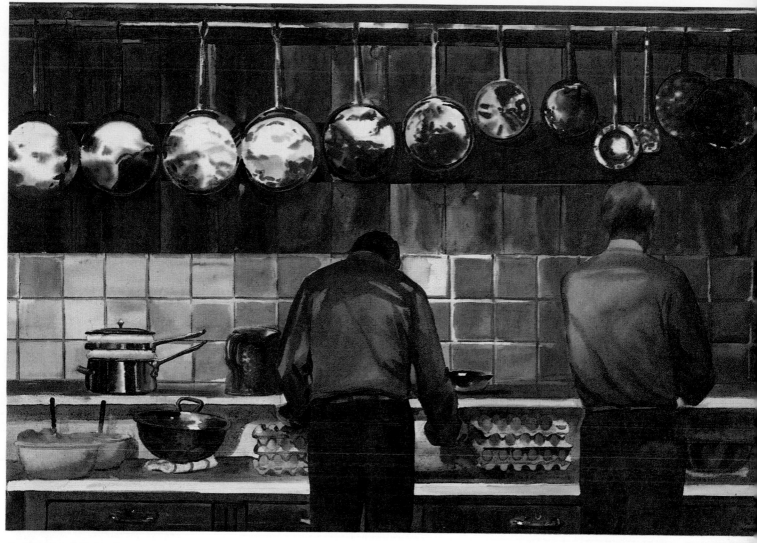

In the tinted light of this French kitchen, all of the colors are influenced by the warmth of the light source. Still, I introduced cool notes of blue and gray into the redwood wall, the tiles, etc., to relieve the essentially monochromatic color scheme. The source of the diffused light is generally from above to the left, with a subtle darkening of tone to the right.

The figures, with their backs to the viewer, are engrossed in work that is discernible to some degree. This allows the observer to enter into the scene without feeling entirely isolated from the events taking place. The man on the left cleans with a sponge; the other appears to be cutting or chopping. The contours of the figures are reinforced with brushline to convey muscularity beneath the shirts. Swiftly, the direct, varied brushstrokes delineate folds in the material and also help define planes of the body beneath each shirt. If this underlying form is lacking, the sense of realism is lost.

Although similarly dressed in the kitchen uniform, the figures retain their individuality by exaggerating the difference in physiques and by changing the treatment of the hair. In the figure at the right, the hair is light against the dark background, but the hair is dark against light in the other figure.

The linear rhythms of the figures form basically curved, soft human shapes that contrast with the dominant geometric angularity of the background, the perpendicular wood grains, tile grid, and rectangular drawers. The more fluid lines of the figures play an important part in the convincing distinction between living form and inanimate objects.

21·PAINTING ANIMALS

Animals and birds, domestic or wild, whether incidental to the scene or used as the main theme of the picture, should always be well researched and carefully painted. Even though a mere suggestion of form is often all that is needed for a bird or animal, the form should be anatomically correct. It should be a *precise abbreviation.* Too often birds are used simply to fill a space in the sky and appear with no reason, or worse still, the forms are clumsily drawn or out of scale. It is the responsibility, if not part of the challenge of the artist to acquire some fundamental knowledge of a subject before attempting creative statements about it.

As I have mentioned when discussing my procedure for painting figures in watercolor, I generally develop the background first. I lay in the areas around the central characters, without using blockout solutions. In this way, I establish surrounding tone and color that allows me to more accurately determine the color and tone of the figures or animals. If the central figures were painted first, they would be in danger of "changing" color as the background is laid in.

CHALLENGES IN PAINTING ANIMALS

The task of incorporating animals into watercolors will be eased somewhat after you have achieved a working knowledge of animal anatomy. So, the first thing to do after you have decided to paint animals is to study their anatomy. If possible, sketch from life. On various locations, traveling, or at the zoo, I have filled literally hundreds of sketchbooks with drawings. I try to sketch the subject from different angles. An excellent reference book on moving animals is *Animals in Motion,* Eadweard Muybridge (Dover Publications, 1957).

Perhaps, after correct drawing, the most difficult aspect of including an animal into a watercolor is the smooth transition of the animal into its surroundings without having it appear *struck on* the paper. Other problems with the depiction of animals are: (1) they appear to float without being anchored to the ground; (2) they are two-dimensional-looking without form or solidity; (3) proportionally, they appear too large or too small in relation to the background or relative to each other; (4) they are scattered, with no relationship to each other; and (5) they are unrelated to their environment in color or tone.

SOLVING THE STUCK-ON LOOK.
Animals that appear to be "stuck-on" or "cut out" are often faulty in color or tone relative to the background. They may also have the more common problem of hard edges or abrupt value changes at the edges. The solution most often entails softening those edges. In *Mother Lode Cat,* p. 150, and *White Geese,* opposite page, the edges are softened in some areas and allowed to be crisp in others. Some edges are also lost in the shadows to integrate the animal form with the background. There is a clean, crisp look to hard edges in watercolors that is certainly desirable. In some areas, however, in the interest of realism, soft blending or "losing" edges into shadow or light areas will integrate the subject with its background. In *Navajo and Friends,* the horse on the left almost loses its light areas against the pale desert.

RESOLVING THE FLOATING PROBLEM.
The simplest way to resolve the appearance of floating is to anchor the animals or other objects to the ground with an appropriate shadow. *Navajo and Friends* avoids floating by casting solid shadows that follow the contours of the ground. *Distinguished Citizen on Marble Steps* requires no shadow (in fact, a shadow would probably intrude on the design), but the dog remains solidly grounded by two subtle variations: (1) a softening of the minute space between the ground level fur and the marble, with a half tone; and (2) painstaking attention to the exact shape that the wavering, not-quite-straight line takes along the ground.

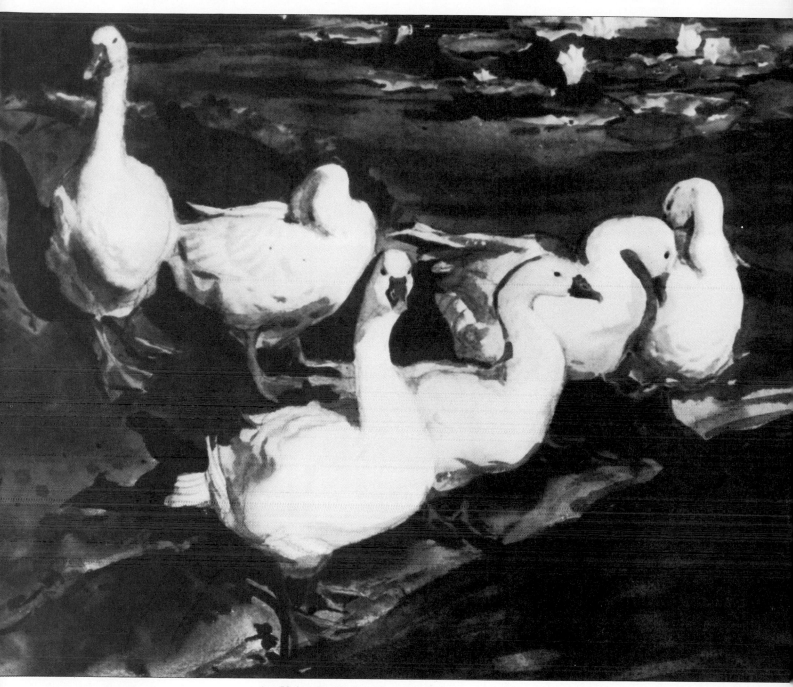

Using hard edges in some places and softer, more blurred edges in others keeps the figures from looking as though they've just been stuck onto their background.

White Geese *11x14 inches*

When I saw these cans, there was no cat to be seen, but I visualized that it would make an interesting, story-telling addition to the scene.

I first drew in the solid, over-lapping milk cans. Then I decided how big the cat should be in relation to them. The main problem then was to create a pattern of light and dark tones that would emphasize the theme of the painting. I decided on a dark background to bring out the cans. I mixed deep reds and yel-lows, Winsor green, and burnt sien-na (in approximately equal parts), varying the tone just enough to cre-ate the shapes of the grass clumps.

While these tones were damp, I charged in the darkest shadow areas and further emphasized the detail of the grass. I darkened the shadow side of the milk cans to create a strong light-against-dark pattern and also to avoid the "stuck on" look they might have if their shadow sides were too light.

I was careful to place the dark shadow side of the cat against the light-struck side of the milk can. The silhouette of the turned head and tail say "cat" immediately.

Mother Lode Cat 15x22 inches

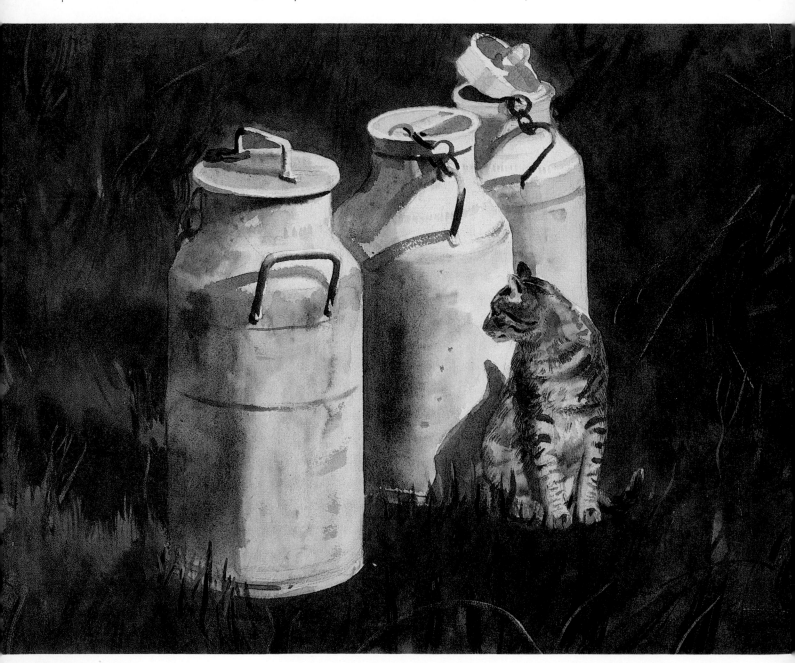

The light hat was placed against the dark hindquarters of the piebald mare to focus attention on the figure. The working dog is bathed in shade, and edges are lost and found throughout the painting. Textures are descriptive rather than decorative.

This gentleman posed for me on a recent trip through the reservation. Whenever I paint the native American people, I am inspired to paint them as close to reality as I can.

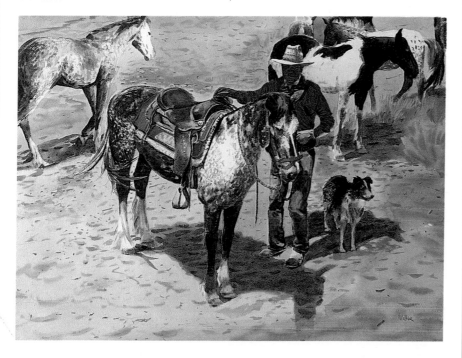

I completed each block of marble separately, rendering each of the patterns individually. Each block was predampened and worked to completion during each section's particular drying time.

After the background was completed, I brushed in the broad washes of this dog I saw in Pisa, Italy. I spent a considerable amount of time with a small brush, softly delineating the subtle eye colors and the mouth. Attention to these important features will go far in breathing life into paintings of animals.

Animals that continue to "float" after introducing a stabilizing shadow along the supporting ground, might be out of perspective. Analyze the angle at which the animal is situated in relation to its surroundings in order to determine whether the *shoulders, limbs, feet, eyes, ears*, etc., are correct in drawing. All figures and animals in representational painting must appear to be resting on a logical ground plane.

GIVING FORM TO FLAT SHAPES. The most difficult things to give form to in watercolor are those which are white or black. In *White Geese*, page 149, reflected light and wet-blended brushstrokes that carefully conform to the contours of the anatomy, create a sense of form and substance in these white birds.

In *Distinguished Citizen*, I lightened even the blackest areas and swirled some shape and definition into the fur. I have noticed that the modern method of working from photographs instead of life has encouraged many painters toward a lack of detail in the darker areas. Direct observation will reveal more detail and often a more solid image can be conveyed if shadow detail is developed.

ADJUSTING PROPORTIONS. Proportionally incorrect animals can be avoided by a few preliminary measures. I cut separate scrap sheets of paper and draw out the shapes, placing them in the picture to assess the relative sizes.

UNIFYING SCATTERED AND UNRELATED GROUPINGS. A number of animals in a painting may look unrelated and scattered. If I find the arrangement unduly spread out or unrelated, I add a few more by grouping several together in clusters. If they are still too widely dispersed, I unite them further by more overlapping.

Sometimes, overlapping animals, as in *Navajo and Friends*, pg. 151, will unify them. In other cases, I overlap them with bushes, grass, or trees, to unify them with their surroundings.

INTEGRATING COLOR OR TONE. This factor involves allowing the environment to affect the subject by light and a reflection of color. To unify the color relationship, I will sometimes integrate reflected light from the environment into the shadows and highlights of the central theme.

Animal motifs are commonly used in distorted ways in semi-abstract forms. Even in expressionistic, idealistic, or romanticized versions, I have always felt the most successful works appeared well drawn with a basic understanding of the anatomical aspects of the animal painted. It is always glaringly apparent when the artist does not feel comfotable with the animal forms he paints.

Realistic, or representational, painting of animals requires a refined anatomical observation, and any additional research into characteristics of breeds and various animal types and habits usually pays off in that extra level of noticeable authenticity.

The field of wildlife painting, where watercolor holds a rare historical distinction, requires a specialized knowledge. Many of the watercolors of Alexander Wilson (1766-1813), John James Audubon (1785-1851), Louis Fuertes (1874-1927), and Abbott Handerson Thayer (1849-1921), are considered not just documentation of theoretical scientific and historical renderings, but excellent works of art.

ANIMAL PORTRAITS

Portraits of animals require attention to *typical* behavior patterns of the animal; an appropriate setting must be established; the pose, whether formal, informal, or candid, should show off the subject to advantage. Spending time with the animal is helpful, as is conversation with the people who take care of it. In dog, cat, and horse portraits, knowledge of the breed or breed mix is helpful, and knowing what to look for in the breed type; for instance, "wall eyes" are acceptable in Boston terriers, but in most oth-

er dogs are not considered a good trait. The head and conformation of the Morgan stallion is considerably different from the thoroughbred racehorse. Before trying to paint close-up portraits of animals, a brief study of the type should precede the work. Such refined observances as correct fur direction and subtle distinguishing features that reflect a knowledge of the breed, as well as the particular animal, will add to the confident control of the medium. Knowing what to look for is an invaluable aid to perception.

I urge all this preparation and quest for understanding of the breeds and types because you will most likely avoid the common problem of becoming "stiff" in the pursuit of achieving likeness. Your confidence, or lack of it, will be evident in the manner in which you handle the medium.

I've attempted to capture the essential nature of these hens with their rather humorous contours. I included this painting in black and white to emphasize the pattern of brushwork and tonal structure that underlies the color. The placement of dark against light contributes to the strength of this direct watercolor. An energetic feeling is conveyed by swift brushstrokes in the background and the counterdirectional positioning of the subjects. The textural work takes the form of soft-blended brushmarks that also lend a painterly quality to the watercolor. The deepest darks occur within the primary subjects contrasted against the walls. This strength of tone and careful modulation of the feathers gives shape and solidity to the focal points.

The background was predampened with graded washes into which abbreviated brushstrokes were placed. The unpredictable directions of these marks imbue vitality and spontaneity. Detail is simplified to mere suggestions.

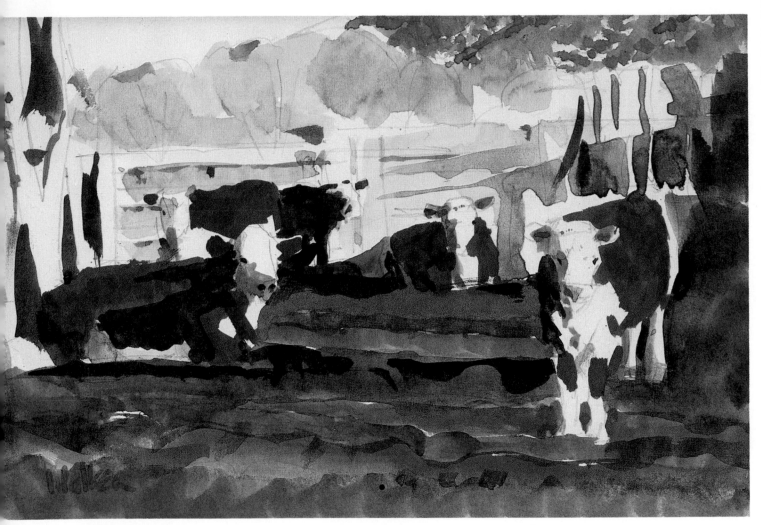

This small, quick location sketch ex-
plores an all-pervading winter sun
and its cool, emphatic shadows. In
this kind of free, expressive water-
color it is best not to tamper with the
initial statement if the quality of
freshness is to remain. I prefer a
sketchy approach for a subject such
as this.

Taos Cattle 5x7½ inches

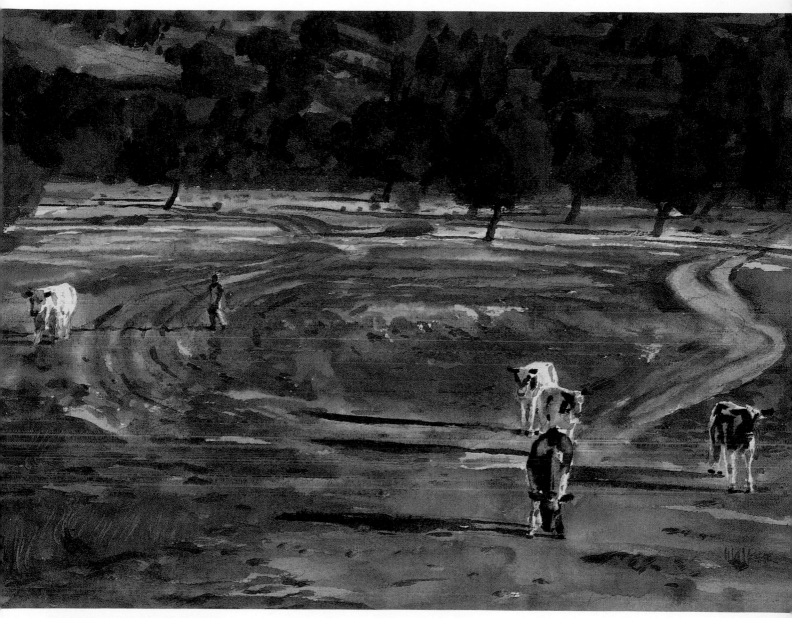

The light tones of the distant hill were put in first. While they were still damp, the thick, dark pigments of the tree forms were modeled into this background wash. The two values that existed at that point enabled the darkest shadow areas to be readily brushed into the shady side of the trees.

Using several brushes, each loaded with a slightly different color and tone, I applied the horizontal strokes of the middle ground alter- nately, depicting the varying subtleties of the grass and ground. While the descriptive wide ranges of color were still damp, I swiftly brushed in the darkest shadows and road curvatures. All the background was painted in this direct method around the figure and cows. Some rock and grass shapes were lifted from the still-damp wash and scraped with the stick end of the brush. The preserved white of the paper was left to indicate highlights on the cows.

Cows Coming Home *11x14 inches*

22·SEASCAPES

Coastal paintings have always been a favorite subject of watercolorists. I enjoy listening to the music of the pounding surf and dipping my water container into the surf, or a tide pool, and using the salty water to paint with. There is no advantage to painting with salt water, but the purity of it all is truly refreshing. The ocean spray is so pervasive that the paper remains constantly moist, and wet-blended effects are a natural consequence of the mist. The surest deterrent to developing a cliché for seascape watercolors is painting on location. The vista of the sea changes every hour, day by day, and the rolling surf changes from instant to instant.

THE RUN OF THE SEA

CHOPPY. A windy day reveals white caps (or "white horses") and often the sea turns a brownish-green; on *calm* days, it is the familiar blue and blue-greens that postcards portray. Overcast days reflect the grays of the sky. I state these generalities to encourage you to choose your form of expression from any number of typical aspects of the sea without resorting to the predictable scene as the only worthwhile statement.

The power of the waves that sculpt the rocks of the headlands, is remembered by all who witness them smashing against the shore.
SHORE WATERS. These, by observation, are often lighter in tone, and deepen as the depth increases out to sea.
RIPTIDE. Oceans, lakes, and bays have crosscurrents that cause an interesting phenomenon in the movement of water. These currents that run in opposing directions, causing a crisscrossing net pattern, are called *riptide*. The net-like patterns are suggested in *First Light*, page 161.

SEA HORIZON

The horizon should be perfectly level, parallel to the top or bottom edge of the paper. To assure levelness, I run my brush along the edge of a 24-inch ruler to indicate the horizon.

When the sun breaks through the clouds onto the distant water (*Sunrise,* page 131), a blazing white occurs, with a crisp line at the horizon. I use the white of the paper and grade this into the darker local colors of the sea or bay.

Attention should be given to the placement of the horizon. If it is right in the middle of the painting, it will tend to cut the painting into halves which can be dull because it lacks *variety*. In *Sunrise,* the masts of the boats and other verticals also help break up the formidable stretch of white at the horizon. I made this painting on location at the break of dawn. Conditions changed so fast I had to look closely, make decisions, then get it down!

SOFT LINE OF THE HORIZON.
Where sky meets water presents unusual challenges. The contrast may at first appear sharp, yet when observed at length it reveals a soft, blurred edge that is difficult to achieve in watercolor. *Incoming Tide,* page 159, contains an example of a soft-edged horizon line.

To achieve this soft line, I bring the sky wash down to the horizon and pick up all excess water several times. Moments before this dries, I run a loaded brush of darker, thicker pigment with little water, across the horizon with one swift motion of the brush, picking up as I go the edge of the sky wash. This will bring about a soft, blended edge. I continue, then, across and downward with another loaded brush, and so on.

NO HORIZON. Often, there is no horizon evident on foggy days. I will sometimes suggest a sense of perspective across the flat planes of the sea by ripples that diminish in size as they recede out of sight.

PAINTING WATER

It is ironic that water is often overworked in *water*color. A simple, untampered, graded wash of blue-green will look like still water. (*Reflections in Spain,* page 109.) If, while this wash is damp, horizontal bands, dashes, or marks are indicated in a darker tone, ripples will be created. A variety of colors may be used: olive and brown, blue-grays, blues, blue-violet, greens, and other colors. I work by the principle that you need far fewer brushstrokes than the number of ripples you see. After placing in a few ripples, I will step back and assess the need for more. I try to avoid recipes and slick abbreviations of water patterns by attempting to express the unique characteristics of the particular scene I am interpreting.

I often work into the damp underwash, but individual strokes may also be brushed across a dry underpainting. The effect may appear stiff at times, or lack the necessary fluidity of water patterns, if used excessively.

The fog, coming in on waves that appear to break, inspires a sense of wind throughout the watercolor, as well as the obvious accompaniment to the real waves below. The composition is based on alternating bands of tone that create the horizontal windswept look.

Mendocino Fog *11x14 inches*

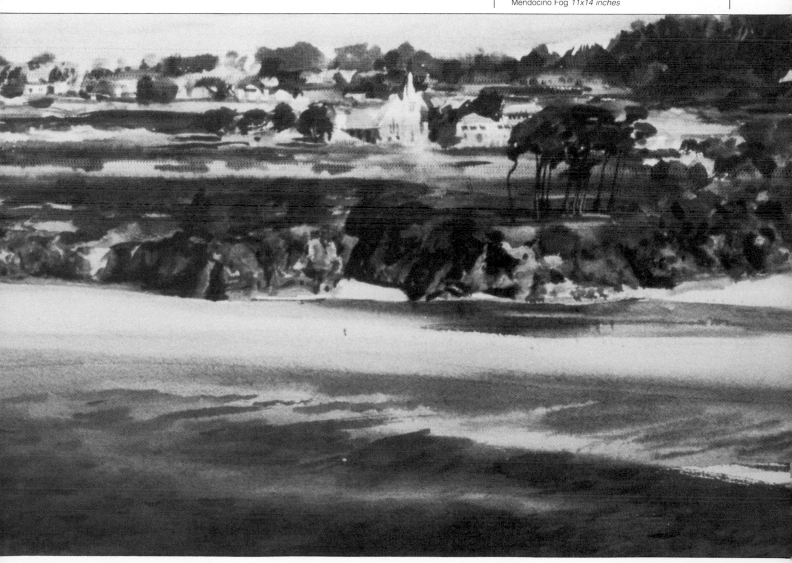

Every surface need not be textured to be convincing. It is the combination of realism, suggestion, and abstraction that endows a scene with a sense of reality, because the eye simply cannot take in all forms throughout nature with equal clarity at one time.

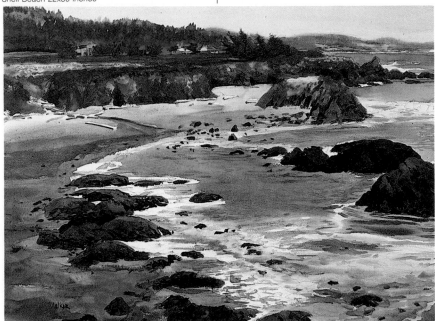

Shell Beach *22x30 inches*

Diagram A creates the illusion of greater depth or three-dimensional space because one, the rocks and waves become smaller as they recede into the distance and two, because the rocks and waves overlap.

Diagram B disregards these principles and even reverses them, making the elements larger as they get further away. Although the rocks could *appear* this way in nature, the arrangement clearly flattens out the picture and destroys the sense of depth.

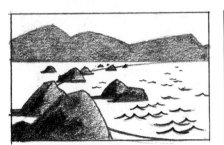

Diagram A.

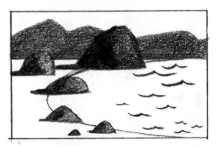

Diagram B.

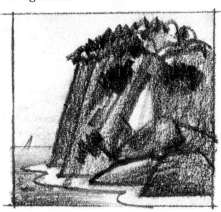

Diagram C.
Sometimes, as you are painting, a distracting image (a face in this case) may appear in your picture.

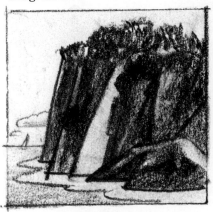

Diagram D.
You can easily eliminate these images by changing the position or shape of the elements that create them.

The sense of movement and transparent spray of the water here is directly attributable to the economy of means: a few spirited strokes onto paper predampened with clear water. The outer reaches of the cliffs are close in tone. The moss and ground cover merge with the earth and rock forms, but contrast dramatically with the sky and water. Still, soft edges occur along the ridges to avoid an otherwise hard-edged meeting of light and dark.

I began by laying a varied wash over the cliff area, and over this the descriptive brushwork. The light shapes were laid in with equal amounts of granulated manganese, Winsor green, cadmium orange, and sienna. I used ochre to neutralize areas that seemed too intense. Superimposed suggestions of rock striations were drawn in with brushstrokes of varying thickness. The cliff forms are sculpted with bravura brushwork in a simple and direct manner.

Incoming Tide 22x30 inches

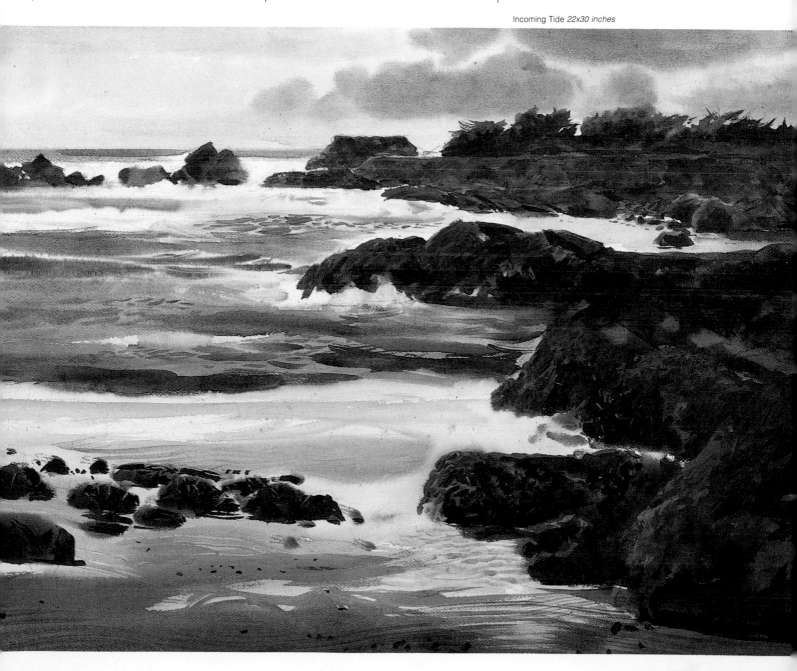

COASTAL SCENES

The natural design and color of ledges, embankments, cliffs, steep promontories that tumble down to the water's edge, retain a singular sea-worn character often unique to their own geographical area. Look for dominant shapes and characteristic groupings. Note the gradations of color and tone from seaside foliage and ground cover (bushes, wildflowers, grasses, etc.), to the outcropping of rocks.

A common problem with the design of rock forms is a scattered, unrelated-looking assortment of rocks. You can avoid the spotty look, yet retain the general appearance of the area, by overlapping some of the rocks, as I did in *Incoming Tide,* page 159.

When painting, you should endeavor to group the rocks together with attention to their relation to each other *and* the space between them. Awkward spaces should be closed up or redesigned. Distracting shapes should be changed, but distracting should not be confused with unusual or odd. Some of the seemingly bizarre shapes may add to the interest and faithful representation of the area.

OPTICAL ILLUSIONS

When painting nature's random distribution of rocks as they appear on location, as in *Shell Beach,* page 158, there is always the possibility of creating the illusion of reverse perspective, or worse, that the artist's perspective drawing is incorrect. Placing larger rock forms in the foreground offsets this illusion.

Occasionally, with the variations of tone within the rock forms, or through an unfortunate coincidence of rock striations, faces or other images may appear on the rocks. Scan the forms for such distracting illusions. Simple adjustments usually remove the problem. Of course it is possible to perceive faces and other illusions in almost any rock texture, just as people often see images in clouds; but be aware of inadvertent distractions that may interrupt the visual statement you wish to project.

CLIFF AND ROCK STRIATIONS

Generally, I look for characteristic rock striations in a broad sense before rendering the closer variations—the broad planes broken by various cracks that veer off in deep chiseled grooves and shadowed undercuts. These are obvious linear patterns in the boulders—but don't settle for these alone; there are lesser details that are not so obvious. I look for more subtle textural patterns—scratched, scored, and crisscrossed patterns against smooth passages—that may give further distinction to the rocks.

I generally use hard-edged linear brushstrokes on dry paper to depict the darker striations and the crevices between the rocks. When I render the textures, I dampen the rocks and work in various dots, dashes, splatter, and further descriptive intervals of line and tone, to define the rocks and cliffs. A suggestion of these patterns is all that is generally needed to impart convincing rock textures, together with broad shadow masses that will contribute shape and solidity.

MARITIME PAINTING. EXAMPLE: *FIRST LIGHT*

BACKGROUND. I began this painting with a large (1½-in.) flat brush loaded with a manganese blue-ochre mixture, and blended it onto a prewetted sky. The subtle irregularity of tone was desirable because I intended to suggest movement of fog. In watercolor, wet-in-wet application is the key to painting fogged effects.

The wash was brought down well into the tree line. While still damp, the darker tree mixture, related in color to the sky, was applied with a crosshatched motion. This was a drier mixture than the sky. The shapes of the lighthouse and harbor houses were avoided. Halfway through the drying time of the trees, the light tones of the buildings were added with as little excess water as possible, so they'd blend with the soft edge but not "bleed" into the darks.

LIGHT TO DARK. The warm, neutral tones of the harbor walls were painted during the same drying time as the buildings. I placed in the walls' darker tones before the lighter tones were totally dry. In this way, I could establish a soft, atmospheric effect. (It should be noted that similar results can be attained by letting the light tones dry totally, then rewetting the area with clean water before adding the superimposed, darker tones. This manner of working, although not the direct method, can be carried out with less urgency.)

The water of the bay was then mixed a little darker than the sky (but related in color) and washed in with a large, flat brush. As the wash dried, ripples in the bay were stroked in, using a crisscrossing pattern. They were diminished in size as they receded into the distance. A neutral, medium-toned backdrop was thus established, over which the main subjects could be featured.

ACCENTS. The predominantly cool colors enable the addition of light red at the top of the lighthouse to be a welcome accent. A variation of this red was echoed in the boat stripe. I added accents at this point, introducing color slowly and judging the effect.

PAINTING THE PRINCIPAL FEATURES. No masking solutions were used to block out the boats, man, or lighthouse. I brought the background wash around the figure on the left and the drifting sailboat on the right. These edges were softened at a later stage. The fishing boat was painted light-to-dark, with the nuances of color and tone manipulated into the first application of paint while the washes were still damp.

FINAL DETAIL. At this stage, the important rigging was added. The amount of detail required depends on the subject and the expressive intent. However, in the

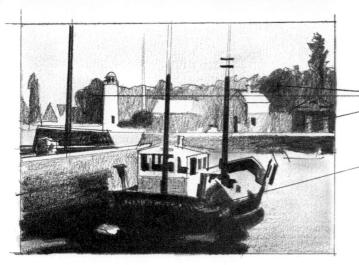

Although these areas beyond the wall appear very dark, they are actually much lighter than the darker tones of the hull and the water around it.

First Light *22x30 inches*

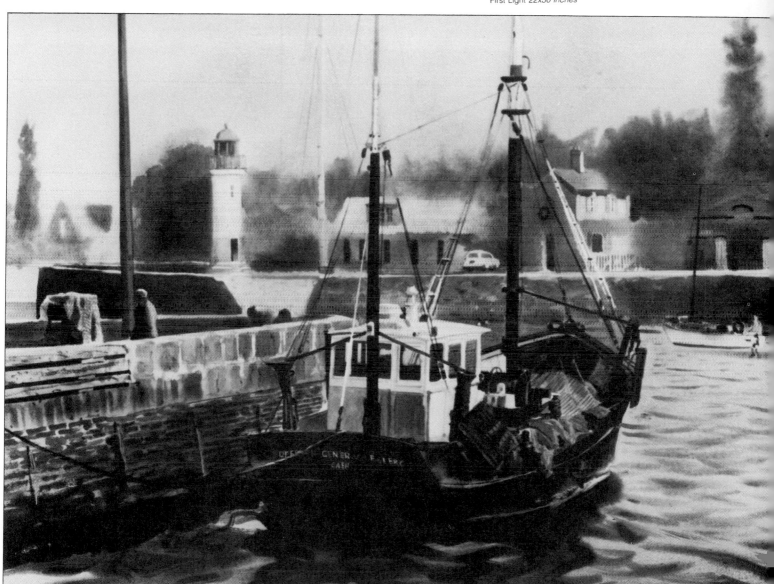

This high vantage point provided the opportunity to show the entire bay and the tall, elegant buildings that border it. This view from St. George's Castle showed most of the bay, and I felt its quiet waters would provide sufficient relief from the intricacies of the building shapes that make up the town. Although the buildings were tall, I elongated them still more. From this high viewpoint there is some foreshortening of the vertical facades which hinders the tall, elegant feeling I thought they deserved.

I darkened *the lush foliage from its actual appearance to provide more contrast with the roofs. In keeping with this, I lightened the roofs to pale yellows, and in some cases used only the white of the paper. I should mention that these adjustments were made on an overcast day where a pale, shadowless scene was confronting me. This day, it rained on and off, with a fine mist. I felt the depiction of the foggy as-*pects of the day would be too flat and lifeless considering the festive traditional colors of the town.

I painted the background foliage wet-in-wet, but the structures were done on areas of dry paper. I used overlying washes to convey the variety of architectural features. On the predampened paper I applied a pale, patchy wash of equal parts of thalo green, lampblack and burnt sienna, mixed to a gray-green, as the undercoat on which to build the tree forms. As I put down the wash, I was aware of just where the darkest parts of the foliage would be.

I gradually built up the mass of individual trees into the damp wash with ever-increasing dark tones, leaving the initial, paler parts of the wash as the lightest parts of the trees. Then, I applied a still darker tone (made up of a darker version of the same colors), brushing this into the shape of clusters of trees. This is the inventive and descriptive stage. Then, with the dark tones, I drew out the eventual shapes of various palm trees, cedar trees, etc. I felt that the cedars were important because they echoed the vertical shapes of the buildings—so I added more of them than there really were.

I then lightened the faces of the buildings and awnings, and strengthened the shadows. I took two days carefully painting the architectural features of the buildings; still (by conscious effort) they appear unlabored and without meticulous detail.

I painted the bay around the boats without benefit of blockout solutions, working light to dark, dampening the entire water area first. I then floated a mixture of manganese blue and ochre into this area and during the drying time, brushed in the ripples and suggestions of currents. I darkened the deepest blue-grays of the bay as a final design decision. This was also suggestive of deep reflections of the dense hill above.

Portofino Bay *22x30 inches*

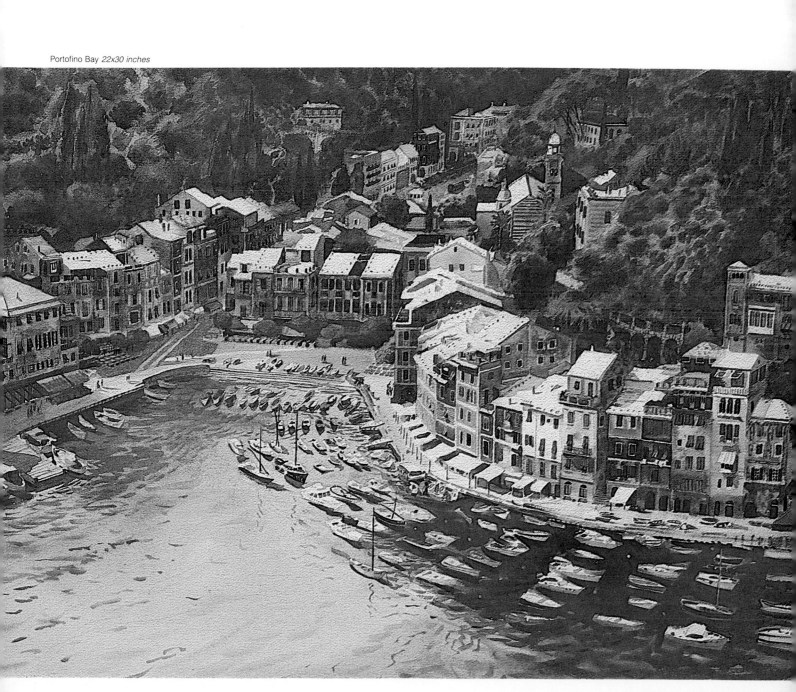

case of boats at close quarters, attention to distinctive equipment, shrouds, and rigging, as well as other gear, adds convincing realism to the fishing vessel. I accentuated the rising line of the bow to give it additional character and to show more of the wooden deck.

Knowledgeable and decisive handling of prominent boats is generally necessary to give conviction to a harbor painting. Discussing the boats with the "locals" can be invaluable. A brief study of rigging is also helpful. Sketching and on-the-spot painting is the best groundwork for this type of painting. Later, work in the studio summons forth memories of the sights, scents, sounds, and other intangibles that provide an extra depth and dimension to harbor scenes.

In *Setting Sun in Honfleur*, the buildings are clearly lighted by the radiant red-orange colors of the lowering sun. Instead of showing the classic sunset I chose the twilight sky, which has none of the colors of a sunset but glows with the intensity of light that occurs as the sun lowers across from it. The sinking sun casts intensely warm highlights and cool, dense shadows across the harbor.

REFLECTIONS IN WATER.
When the water becomes still, the resultant inverted mirror images are the most difficult water reflections to paint. Consider the problems: The image must be related in color, deeper in tone, but not muddy; the inverted reflections must also conform to the movement of the ripples on the water's surface; and finally, the whole business must be painted smoothly, with a wet-blended character.

I find that keeping the entire water area dampened as I work the reflections from light to dark, is helpful. If the paper is too wet, however, the effects will spread out of control, so an occasional swipe with a damp sponge will keep the soon-to-be-painted areas sufficiently moist.

KNOWING SHIPS AND BOATS. Learning a little about boat rigging helps in the translation

Setting Sun in Honfleur *divides the swirling planes of water and of clouds with the solidly geometric row of houses across the middle. The central object of interest, the steeple and its reflection, provides a vertical line balancing the otherwise strongly horizontal composition.*

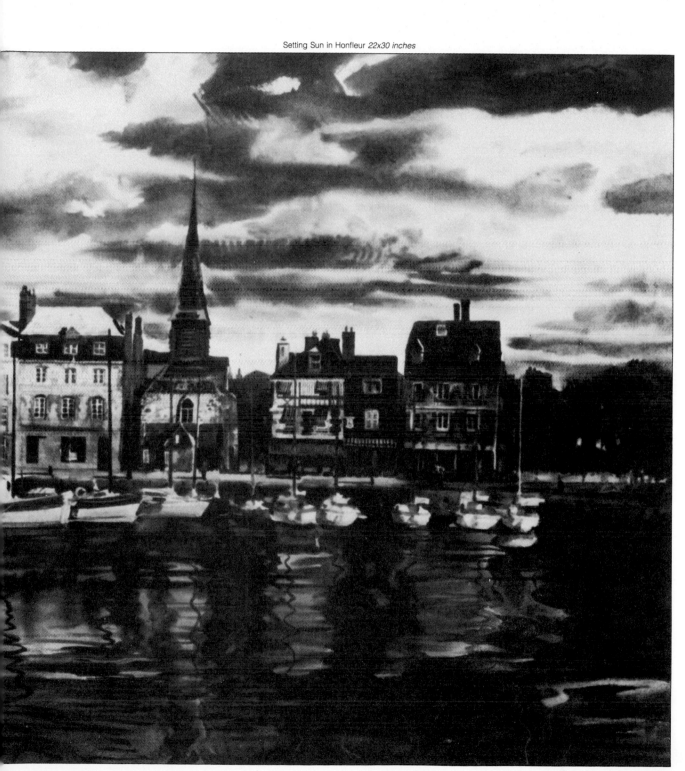

Setting Sun in Honfleur *22x30 inches*

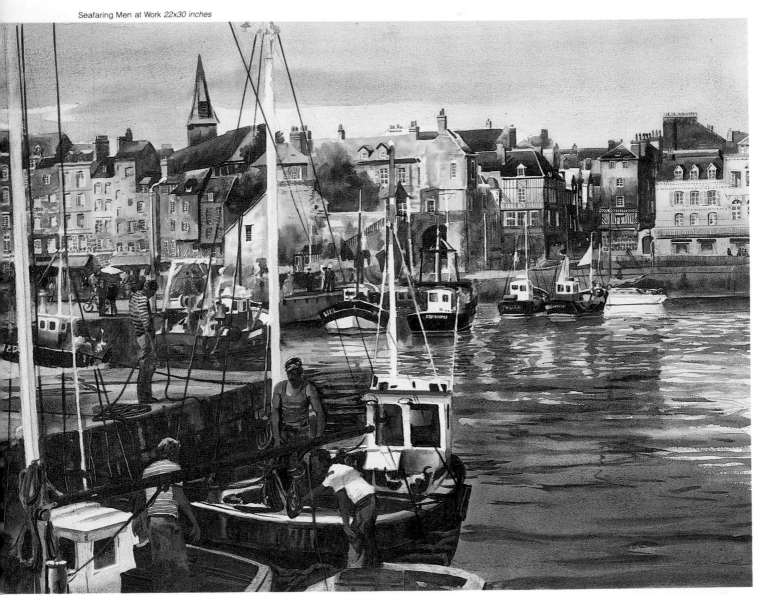

I had postponed doing this watercolor, anticipating the enormous organization I felt would be necessary to include all that I wanted, without the picture appearing too busy. I had determined that I wanted foreground boats with men on board engaged in work. In addition to this, I wanted to fill the painting with the unique harbor activity and architecture of Honfleur.

The difficulties lie in the fact that an overly active composition may end up competing with itself for a focal point. My solution involved the determination that the small in-tricacies of the background would, together, provide one horizontal band of activity. A similarity of neutralized color would assimilate all this activity to read as a unified whole. By contrast, the foreground would involve larger elements and a greater diversity of color changes, together with stronger contrasts. I wondered whether the masts would intrude upon the background until I realized that blanching out all fine detail in the masts—making them clean, solid-white verticals, separated them nicely from the background. This actually enhanced the three-dimensional aspects of the work and served to tie in the lower foreground crafts to the middle distant activity.

The tanned and windburned color of the deckhands becomes a warm color accent in this predominantly cool color scheme. This lower grouping of vessels and the men who work them remains the central theme because of these color accents, despite their position so close to the lower border.

I prewet the background and washed the broad masses of the structures in with a half tone comprised of warm and cool variations of gray (a mixture of lampblack, blues, ochres, and burnt sienna). I reinforced the shadow masses once, before this area dried.

I then placed in strokes of brownish-gray to indicate the windows seen through the mist.

I kept the flat upper portion of the landing very light, with a faint yellow tone predominating, to suggest encroaching sunlight. While this was still damp, I suggested the subtle reflections of the figures on the wet landing surface.

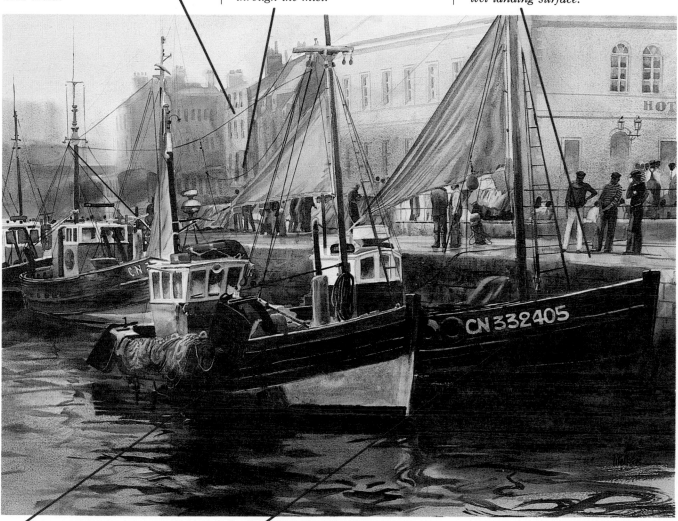

I left the white of the paper to represent the bright sheen along the rails of the boats.

I dragged the pointed end of the brush handle through the black-brown hull to suggest the wooden planks.

First Grey Light of Dawn *22x30 inches*

Extensive depth is generated in this three-plane division of composition: The boats make up the first plane, which recedes into the second plane of the dock. The dock, with nets and figures, vanishes back into the third plane, represented by the buildings; these structures, in turn, gently vanish altogether into the distance.

of details into the expressive medium of watercolor. In *First Grey Light of Dawn,* the tops of the deckhouses, as in all fishing vessels of this type, are curved to drain off water. The masts are raked, leaning slightly backward. Occasionally I will slightly accentuate the slant if I cannot discern the incline by sight. Often the pitch of the boat in a seaway will disguise the rake of the masts. Care should be taken to keep the masts in the proper position in relation to the hull. Too often I have seen ship paintings where the mainmast and the mizzenmast appear broken or unduly tilted. If there is a question about the angle, I will construct a simple model (a flat ruler, using a pencil as the mast, will do), and incline the model to observe the adjustments I will need to make to straighten the masts.

There are a great many lines, shrouds, and stays that make up the rigging of ships. The artist may elect to suggest some of these, or delineate each of them, depending on the degree of finish in the rest of the watercolor. I usually indicate the shrouds that run up either side of the mast(s) and the jib stays. On schooners and fishing boats, the ratlines and other rigging should be indicated.

What do nautical terms have to do with watercolor painting? No more than any other specialized terminology the painter may encounter, but familiarity with the *fundamentals and basic parts* of a given subject will prove a great aid to the powers of observation.

Familiarity with maritime painting should include a working knowledge of aquatic birds and regional varieties of various gulls, pelicans, grebes, cormorants, herons, etc., that are peculiar to the area. (It wouldn't do, for instance, to replace the great western sea gull with the eastern variety of herring gull.) This also applies to the awareness of the surrounding trees, shrubs, plants and their names, even in the most general way. I wouldn't want to leave the thought that one has to become an

authority on a subject in order to paint it. I certainly am not, nor are most watercolorists, but there is an important place for worldly knowledge in the painter's expression of the visual world. The authority that the finished watercolor conveys will be dependent on the artist's confident application of the skill *and* knowledge he or she has of the medium *and* the subject.

MARITIME ATMOSPHERE. Mood is important in maritime painting. The light and shade, color, and attitude of the people are often responsible for achieving mood or atmosphere in watercolor. Crisp or softened edges, flat or graded tones, deep transparent darks, or faint, transparent passages further contribute to the mood of the painting.

In *First Grey Light of Dawn,* the pervading fog on this November morning established a ready-made atmosphere. At this early hour, there were actually no people on the dock and the sails were down. These two elements I added to the composition—the seafaring-type men were drawn in from sketches made on location the day before this painting was begun.

I decided to maintain a muted palette. I used the full range from white to almost black to generate a sense of increasing light overcoming the morning fog. The vessels in the foreground are shown most clearly, because they are the central theme of the picture. I prewet the background and washed the broad masses of the structures in with a half tone comprised of warm and cool variations of gray (a mixture of lampblack, blues, ochres, and burnt sienna). I reinforced the shadow masses once, before this area dried. I then placed in strokes of brownish-gray to indicate the windows seen through the mist.

I kept the flat upper portion of the landing very light, with a faint yellow tone predominating, to suggest encroaching sunlight. While this was still damp, I suggested the subtle reflections of the figures on the wet landing surface. Next I put in the dark shadow masses of the

dock. The background and, now, the dark wall of the dock were painted *around* the sails and wheelhouses.

Having established a strong dark value, I commenced work on the hull of the boats, making them still darker in value. I left the white of the paper to represent the bright sheen along the rails of the boats. I dragged the pointed end of the brush handle through the black-brown hull to suggest the wooden planks.

I then placed in the orange life preservers and the maroon color of the deckhouse. These hues were of low intensity in keeping with the muted color scheme. Using a large flat brush, I mixed a thick wash of ultramarine blue (two parts), lampblack (one part), and burnt sienna (one part) on the paper itself. Over this I described, with an ink-like mixture of lampblack and burnt sienna, calligraphic swirlings for ripples.

At this point I went back to define the pale washes of the sails. These, as well as the figures, had to be consistent with the fogged light and neutral color scheme. I graded the mainmasts and mizzenmasts from light to dark, and delineated the prominent shrouds and ratlines.

To bring the watercolor to a realistic conclusion I focused in on each element, to define, without overworking, each of the many interesting details that I felt were important.

Some upright lines in Sea Wall *are subtly tilted, like the central ship's masts, or curved, like the sea wall, from true verticality. Similarly, the horizon rises just slightly, from left to right, departing from a true horizontal plane. The boats' curves, the diagonals of the church, the visual line between mast-top, steeple, and lighthouse, and the downward slant of sand to either side of the wall combine to lead through the angles of the picture.*

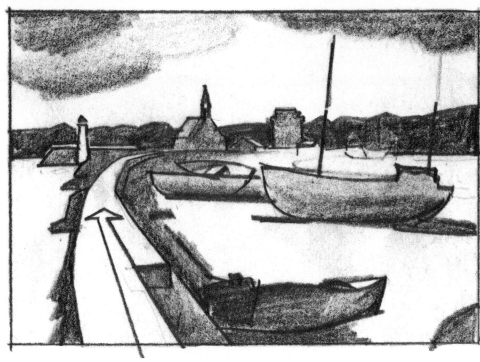

Sea Wall *22x30 inches*

Notice that the upper third of the picture contains no tones darker than this (except for minor accents—masts and figures).

While the lower two-thirds is generally this dark except for the light shapes of the cabins.

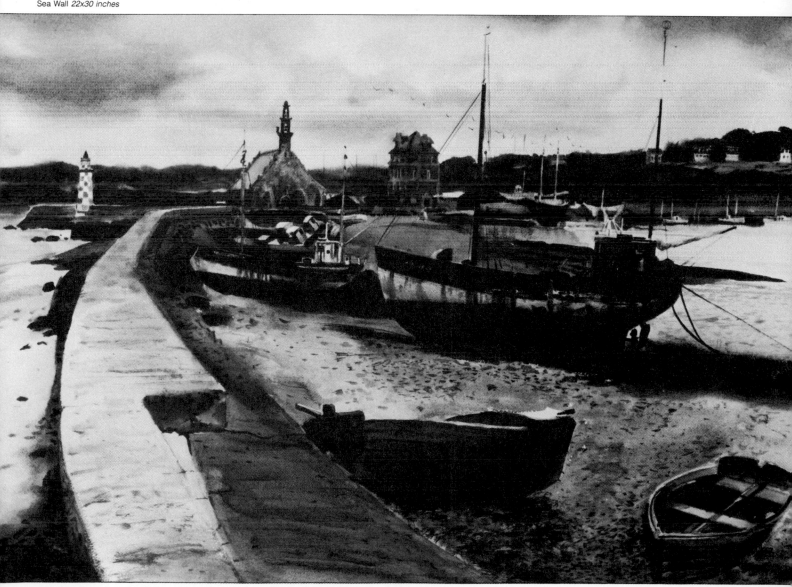

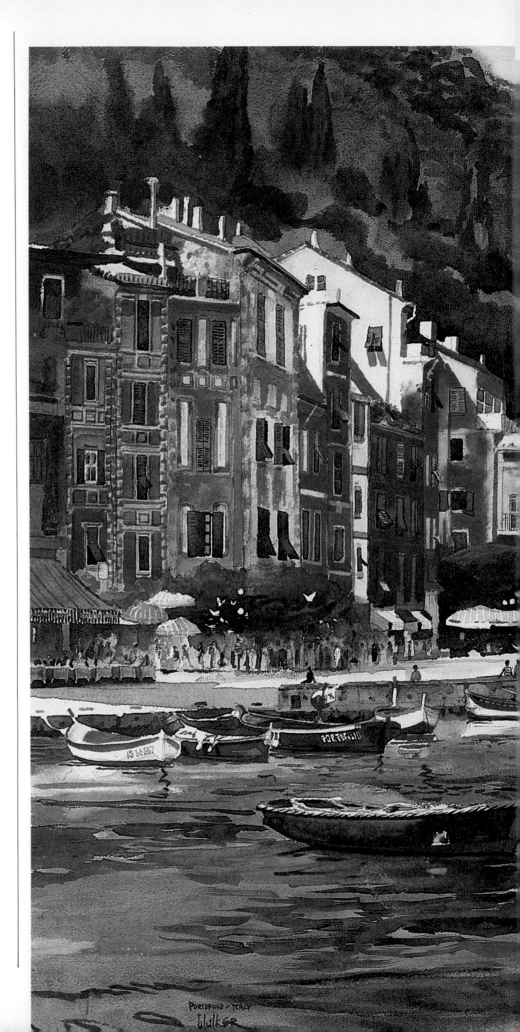

I rely on color rather than explicit detail in this version of Portofino. *A few suggestions here and there imply further details without having to complicate the clean, flat washes. I fashioned a row of boats in the foreground. Compare this graphic, straight-ahead composition with the more fluid approach used in* First Grey Light of Dawn, *page 167.*

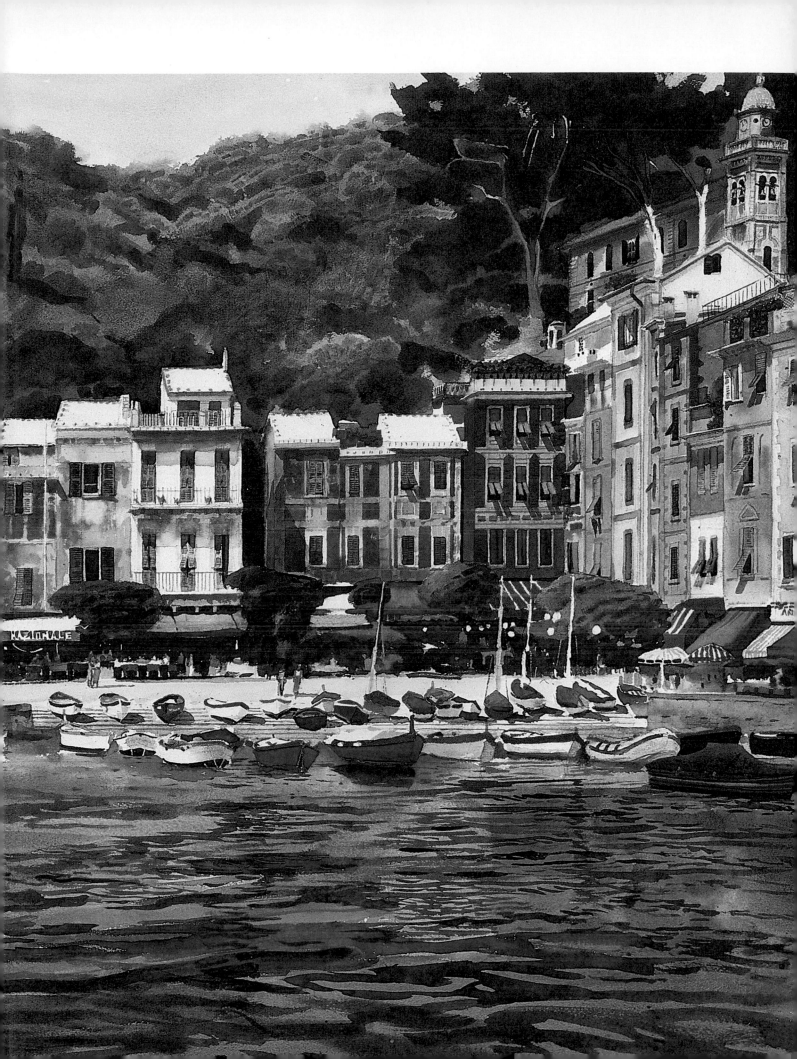

STYLE

Style refers to a painter's manner of expression in art. A brief glance through art history reveals as many possibilities for watercolor styles as there are movements in the history of art.

Any one or combination of such watercolor procedures as: wet-in-wet, drybrush, direct approach, use of tone, color, design, or decorative, will provide methods for expression in watercolor.

After achieving some degree of facility with the medium, style will start to develop, cultivated in time out of an individual's striving for self-expression. Style will emerge as a natural consequence of painting. It is one's unique effort to express or interpret an idea, the surrounding world, or the environment, that allows your individuality to surface.

Style is an area of concern that is best left to grow as a natural by-product rather than a forced effort. Borrowing someone else's style does not make it your own! There are no suitable shortcuts. Beginners traditionally have copied freely to find their way and learn. This is fine as a learning experience. However, when you begin to exhibit work, copy work is considered unethical, and some kind of originality is required.

If there are influences on an artist's work, they should be general, not specific. It is true that painters will sometimes have a similar viewpoint or feeling about things. Creative ideas will cross and overlap with others' ideas. You'll see painters who will have insight or vision into a particular subject that will resemble another's. However, if you stay true to your own convictions and point of view, there will always be a stamp of individuality in your work that will make it unique. Being different is of no value in itself, but there is truth in what Picasso once said: "All one really has is one's self."

If art were merely decoration, then a deep understanding of the nature of things would not be necessary for the painter; if art did not at times touch the human spirit deeply and possess the potential to state those intangibles that remain unsaid, then technical facility would be all that is needed to become a master watercolorist. The fact is, the simplest of sincere statements may achieve the greatest depth of feeling.

A grasp of the medium, empathy with a subject, and something to say about it, are all that is really necessary in order for the watercolorist to translate experience into watercolor.

As a final thought, I leave you with a statement by Leonardo da Vinci:

"It is a poor student who does not surpass his master."

American Hillside 22x30 inches

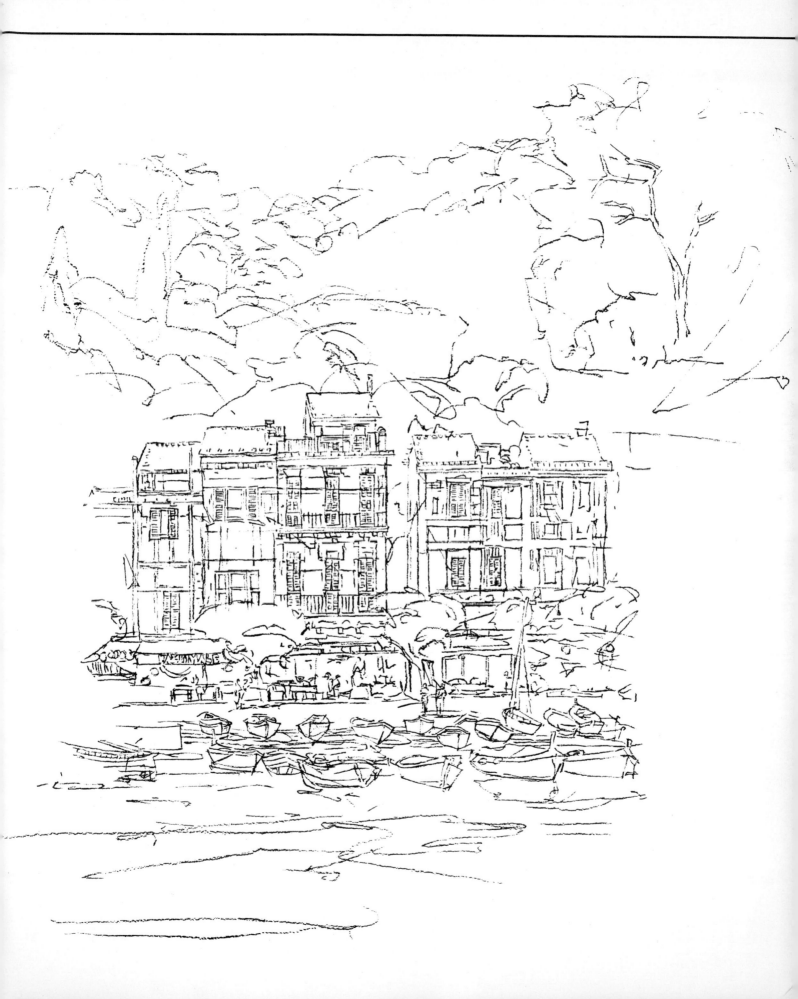

INDEX

Acrylic: brushes used with watercolor, 12, 14, 24; paint used as watercolor, 22

Animal painting: anatomical precision in, 148, 152; integrating into painting, 148-49, 152; in night scenes, 132-33; studies for, 128, 148, 152

Architectural painting: and angle of portrayal, 97, 162-63, 170-71; vs. architect's rendering, 96; capturing character in, 97, 101; with elaborate ornamentation, 100-01; fine arts approach to, 96; and historical accuracy, 97, 101; researching styles for, 96; seen as light and shadow shapes, 96. *See also* Detail

Background: cool color in, 64; moving forward, 64, 100; pushing back, 64

Brushes: No. 4, 24, 58; No. 5, 89; No. 7, 58; No. 8, 25, 51, 58, 92, 134; No. 10, 92; acrylic and oil, 12, 14; author's preferred, 12; flat, 12, 25; round, 12

Brush techniques: bravura brushstrokes, 20, 73, 84, 105; brushline drawing, 24-25, 77, 111; with brushtip (handle), 73, 78; and descriptive patterns, 69, 104; drybrush, 20, 73, 77, 104-05; forceful, 106; over washes, 25; rough brushing, 20, 78, 110; stipple, 73

Circles, painting, 25

Color: density, 48; discordant, 42; influence of, 42, 90, 112; lightening of, 24, 121; local, 43; mixing on paper, 62, 80, 89, 93, 109; neutralizing, 44, 85, 89, 109; reappearance of same, 112; terminology, 42, 44; thematic consistency of, 90; tonality of, 48; translucence of, 48; trial swatches of, 44, 61

Composition: balance in, 112; center of interest in, 52, 166; defined, 52; exceptions, 52-55, 91; remedying, 52-53, 56, 112;

stages of, 120-21; terminology of, 52, 64; through tonal structure, 97; unity in, 76, 93, 100, 166

Contrast: of land and water, 111; of light/dark pattern, 27, 29, 66-67, 70-71; by minimizing middle tones, 85; reducing, 143; of tempos, 140; of warm/cool colors, 80

Counterpoint, 61; defined, 68; illustrated, 61, 68, 71

Detail: in author's procedure, 36, 97; obscured in shadow, 81, 99; in painting trees, 105; primary, 97; secondary or supporting, 97; simplification of, 97; subject to artist's decision, 97, 99, 101

Direct approach: author's, 51

Drawing: author's procedure in, 36, 112; and solving problems before painting, 36, 50, 57, 112

Drybrush, 20, 73, 77, 104-05

Ellipses, painting, 25

Entasis, 108

Envisioned painting: from earlier sketches, 116-17, 124-25; and memory development, 116; and night scenes, 128; and observation, 116; and use of studio models, 116-119

Exaggeration in painting, 58, 64

Exercises: drawing ellipses and circles with brush, 25; experimenting with textures, 72; painting a sunset, 129

Flesh tones, 136-37, 140

Human figures: in architectural painting, 98, 100; composing with, 134, 136, 138, 147, 166; effect of, in paintings, 134; in landscape, 57, 58, 64, 89; postures of, 146; and skin tones of different cultures, 136-37; studying anatomy of, 134

Interiors: lighting characteristics of, 120, 123, 125; and simplify-

ing the scene, 120, 122; value analysis of, 120

Landscape painting: approach to, 104; brush and chaparral in, 109; cliffs in, 109; hills in, 109, 112, 114-15; light in, 109; rocks in, 105; sky and clouds in, 113-14; water in, 109

Light: in architectural painting, 96; and backlighting, 81, 85; and crosslighting, 80; at dawn and dusk, 129; diffused, 84, 86, 87, 125; direction of, 80, 125; on figures in painting, 124; fogged, 84, 157, 167-69; and frontlighting, 81; and haloing, 128; and highlights, 80; in interiors, 120-21, 125; in memory painting, 116; reflected, 80, 82, 89; in sky and clouds, 113-14; from skylights, 124-26; source of, 80; summer and winter, 82; in tonalist painting, 84, 87; warmth of, 80

Line, weights of, 25

Masking: fluid for, 14, 106; rubber cement for, 14

Materials and equipment: art bin boxes, 14-15; atomizers, 13-14; block-out solutions, 14, 106; blotters, 14; drawing boards, 14; easels, 14; erasers, 13, 36; paper towels, 13; pencils, 13; razors, 14, 24; rubber cement, 14; rulers, 14; salt and sand, 14; sponges, 13; student and artist grades in, 12, 15, 45; table, drawing, 14; tape, 14; toothbrushes, 14

Mixed mediums, 22

Model, painting from, 144

Mood in painting: through color, 90; through composition, 91; through contrasts, 94-95; and day or night skies, 88; defined, 88; dramatic, 27, 92; and the elements, 88; and high or low key, 93; and light patterns, 93; in maritime painting, 168; restful, 70; and shadows, 93;

Other Fine Art Books from North Light

Watercolor

Basic Watercolor Painting
by Judith Campbell-Reed $14.95 (paper)
Capturing Mood in Watercolor
by Phil Austin, $21.95 (paper)
Controlled Watercolor Painting
by Leo Stoutsenberger $15.95 (paper),
$22.50 (cloth)
Croney on Watercolor
by Charles Movalli and Claude Croney
$14.95 (paper)
Opaque Watercolor
by Wallace Turner $19.95 (cloth)
Painting Flowers with Watercolor
by Ethel Todd George $16.95 (paper)
Painting in Watercolors
edited by Yvonne Deutsch $18.95 (cloth)
Variations in Watercolor
by Naomi Brotherton and Lois Marshall
$14.95 (paper)
Watercolor Energies
by Frank Webb $16.95 (paper)
Watercolor for All Seasons
by Elaine and Murray Wentworth $21.95
(cloth)
Watercolor Options
by Ray Loos $22.50 (cloth)
Watercolor Painting on Location
by El Meyer $19.95 (paper)
Watercolor—The Creative Experience
by Barbara Nechis $14.95 (paper)
Watercolor Workbook
by Bud Biggs and Lois Marshall $22.50
(cloth)

Mixed Media

American Realist
by Stevan Dohanos $22.50 (cloth)
The Animal Art of Bob Kuhn
by Bob Kuhn $15.95 (paper)
A Basic Course in Design
by Ray Prohaska $12.95 (paper)
**The Basis of Successful Art:
Concept and Composition**
by Fritz Henning $16.95 (paper)
Catching Light in Your Paintings
by Charles Sovek $22.50 (cloth)
Drawing and Painting Animals
by Fritz Henning $14.95 (paper)

Drawing and Painting Buildings
by Reggie Stanton $19.95 (cloth)
Drawing By Sea & River
by John Croney $14.95 (cloth)
Drawing for Pleasure
edited by Peter D. Johnson $15.95 (cloth)
Encyclopaedia of Drawing
by Clive Ashwin $22.50 (cloth)
Exploring Color
by Nita Leland $26.95 (cloth)
The Eye of the Artist
by Jack Clifton $14.95 (paper)
The Figure
edited by Walt Reed $14.95 (paper)
Flower Painting
by Jenny Rodwell $18.95 (cloth)
Keys to Drawing
by Bert Dodson $19.95 (cloth)
Landscape Painting
by Patricia Monahan $18.95 (cloth)
The Mastery of Alla Prima Painting
by Frederic Taubes $14.95 (cloth)
On Drawing and Painting
by Paul Landry $15.95 (cloth)
The Painter's Guide to Lithography
by John Muench $14.95 (paper)
Painting & Drawing Boats
by Moira Huntley $16.95 (paper)
Painting Floral Still Lifes
by Joyce Pike $19.95 (paper)
Painting a Likeness
by Douglas Graves $19.95 (paper)
Painting Nature
by Franklin Jones $17.95 (paper)
Painting with Pastels
edited by Peter D. Johnson $16.95 (cloth)
The Pencil
by Paul Calle $15.95 (paper)
Perspective in Art
by Micahel Woods $12.95 (cloth)
The Pleasure of Painting
by Franklin Jones $13.95 (paper)
Putting People in Your Paintings
by J. Everett Draper $22.50 (cloth)
The Roller Art Book
by Sig Purwin $11.95 (paper)
6 Artists Paint a Landscape
edited by Charles Daugherty $14.95 (paper)
6 Artists Paint a Still Life
edited by Charles Daugherty $14.95 (paper)

The Techniques of Wood Sculpture
by David Orchard $12.95 (cloth)

Oil Color/Art Appreciation

**An Approach to Figure Painting
for the Beginner**
by Howard Forsberg $17.95 (cloth)
Encyclopaedia of Oil Painting
by Frederick Palmer $22.50 (cloth)
Controlled Painting
by Frank Covino $14.95 (paper), $22.50
(cloth)
The Immortal Eight
by Bennard B. Perlman $24.95 (cloth)
Painting in Oils
edited by Michael Bowers $18.95 (cloth)

Commercial Art/Business of Art

The Art & Craft of Greeting Cards
by Susan Evarts $13.95 (paper)
**An Artist's Guide to Living By Your
Brush Alone**
by Edna Wagner Piersol $9.95 (paper)
**Artist's Market: Where & How to Sell
Your Graphic Art, (Annual Directory)**
$16.95 (cloth)
**Complete Airbrush & Photo
Retouching Manual**
by Peter Owen & John Sutcliffe $19.95
(cloth)
Graphics Handbook
by Howard Munce $11.95 (paper)
How to Draw & Sell Cartoons
by Ross Thomson & Bill Hewison $14.95
(cloth)
North Light Dictionary of Art Terms
by Margy Lee Elspass $10.95 (paper)
Print Production Handbook
by David Bann $14.95 (cloth)

To order directly from the publisher,
include $2.00 postage and handling for
one book, 50¢ for each additional book.
Allow 30 days for delivery.
North Light Books
9933 Alliance Road
Cincinnati OH 45242

Prices subject to change without notice.